THE PRETORIA PIT DISASTER

A Centenary Account

ALAN DAVIES

AMBERLEY

First published 2010

Amberley Publishing Plc
Cirencester Road, Chalford,
Stroud, Gloucestershire, GL6 8PE

www.amberleybooks.com

British Library Cataloguing in Publication Data.
A catalogue record for this book is available from the British Library.

ISBN 978 1 84868 924 4

Typesetting and Origination by Amberley Publishing.
Printed in Great Britain.

Contents

Acknowledgements

David Owen, Mining Engineer (rtd) of Westhoughton, Andrew Schofield and the North West Sound Archive, Clitheroe Castle. Tony France, Mining Surveyor and Consultant Geologist. Staff at Westhoughton Library, Bolton Museum & Archives, Lancashire Record Office (Records of the Hulton Colliery Company, NCHU, are reproduced with kind permission of the Lancashire County Archivist, Bruce Jackson). Peter Wood and especially Pam Clarke have been very helpful and generous with access to their Pretoria and general Westhoughton local historical research. Others deserving a mention include Clare Staveley and her research into the Staveley family genealogy. Harry Forshaw of Westhoughton for allowing me to photograph Sergeant Brown's pocket watch. Mike Pain for the use of his hand-drawn plans. John Hayworth. Dennis Sweeney as ever for railway information.

About the Author

Former Lancashire Mining Museum curator for fifteen years until closure in 2000, Alan Davies brings his practical experience of working in five coal mines, studying mining and also six years as a local authority archivist together. He has previously written *Coalface (Mining and Art)*, *The Wigan Coalfield*, *The Pit Brow Women of the Wigan Coalfield*, *Atherton Collieries* and most recently *Coal Mining in Lancashire & Cheshire*.

Introduction

Many people have approached the subject of the Hulton No. 3 Bank (Pretoria) Colliery disaster since 1910 from a variety of angles: from family connections, from mining historical interests, or due to the various anniversaries when the event has been remembered. Others have focused purely on those killed and the effects on their families. Sadly, large losses of life in disasters also attract those with a morbid fascination (for want of a better term) for the ways in which people actually died.

Some accounts since 1910 have been farcically inaccurate, even eccentric, in style (at the same time, I would add, often written with the best intentions), others have been written by that strange breed that feels the need to associate themselves personally with a tragic event such as the *Titanic* disaster with an element of self-promotion attached. At the other end of the scale, other research accounts (Wood and Clarke, for example) have been undertaken from an intense sense of duty, painstakingly careful to check accuracy and verify sources used.

I decided to produce an account, firstly, because the centenary approaches of the largest colliery disaster in the annals of the industry in Lancashire – an industry recorded at least back to the late thirteenth century – and, secondly, as my grandfather, who worked for Westhoughton Coal and Cannel Co. Ltd at Stotts Pit was involved in rescue and clearing operations at Pretoria Pit, where he lost many of his friends. Apparently, he became depressed as a result of seeing so many friends and others he knew killed at Pretoria and went to work in coal mines in Pennsylvania for a few years, returning to Stotts Pit afterwards.

I felt the wider historical picture of coal mining in the Hulton area, the techniques and technology used, along with the geology of the area should be described to give a fuller picture. As someone who has both worked in and studied mining over thirty-five years, researching the disaster has led to my own definite opinion as to why such a disaster *could* occur at Pretoria Pit, one which anyone who has worked in mining or studied mining would probably agree with, and one which the Chief Inspector of Mines, Redmayne, was probably fully aware of early on in the inquiry. I will leave the reader to possibly arrive at the same conclusions.

In this study, I have brought together material from a wide variety of sources, ranging from geological and mine-working plans to newspaper accounts, government and medical documentation to photographs (of which, sadly, only a few often poor images have survived).

The pioneering and vital work of Ken Howarth at the North West Sound Archive in the 1970s recording survivors and family members is for me the real 'meat on the bone'. To hear these people speaking in local dialect in a manner I recognise was for me a direct link to those events of 1910. With the end of deep coal mining in Lancashire by 1993, Ken's work has indeed been seen to be timely.

The main descriptive account of the course of events immediately after the explosion and the methods used previously to work the colliery has to be the Home Office Inquiry, along

with press accounts from miners involved in rescue or actually below ground at the time. The Inquiry gives a full picture of the mining operations in place at the pit and a record of the course of events. Until the disaster brought the colliery to international attention, Pretoria was a fairly standard coal mine – other than perhaps in its relatively modern surface layout, use of electricity and coal cutters – so little documentation survives. The records of the Hulton Colliery Company deposited by the National Coal Board at the Lancashire Record Office, Preston, document mainly financial aspects of the colliery's life. Much-needed minutes of the various working groups or committees normally associated with the establishment of a new colliery, plus miscellaneous and personal documentation have not survived. Perhaps they never existed. The culture of the company appears to have been one where extensive documentation was not always felt desirable, even the very basics of mining safety and ventilation reporting, a feature which would be noted by the Chief Inspector of Mines, Redmayne, at the inquiry.

Rather than purely reproducing large tracts of the enquiry without explanation, as many have done in the past, I have tried to explain selected important pieces of the evidence given as well as technical aspects the general reader may find puzzling.

The press and personal accounts add emotion to the formal record, and I have often wondered during the research how legal, mining and government professionals related to these ordinary Lancashire working-class mining families whose lives had been shattered. Few lowered their guard to indicate a genuine empathy with those involved in their accounts, the mines inspectorate, clergy and doctors excepted.

The indecent haste of the company to restart coal production before the final few bodies had been recovered, while donations were still flooding in, is astonishing to say the least – disgusting some may say. Life certainly came cheap in 1911 as the compensation records show, and the way the dependants were treated in the years afterwards was at times patronising and insensitive. The manner, though, in which the Mayors of Bolton, Manchester and Liverpool and certain outside bodies across Britain and Europe responded by raising funds for the dependants was admirable.

People will continue to write about the Pretoria disaster for generations ahead, but there are only finite resources from which to produce those studies; these will no doubt provide the basis for a variety of interpretations. Peter Wood (living in New Zealand but a former Athertonian) and Pam Clarke have recently made best use of the internet with their exhaustive and painstakingly researched data on those killed in the disaster. The web address is http://www.lan-opc.org.uk/Westhoughton/Pretoria/index.html at the time of writing. Their detailed findings do not need to be reproduced in this volume and could not be due to lack of space. They are available in printed form at Westhoughton Library.

But for the geological composition of the Arley seam dust extinguishing the explosion in that district of the colliery, I could have been writing about the second-largest coal-mining disaster in the world with 890 killed. One thing is certain: 345 men and boys died as a result of the Pretoria disaster and thousands of people's lives were never to be the same again. Other than those in the disaster, we should also remember the twenty-three other men who died while working at Pretoria Pit over its thirty-four-year working life. This colliery indeed took a terrible toll of human life.

Hulton Park, Mining Within an Ancient Estate

A minor Roman branch road from Manchester passed by Walkden Moor towards Street Gate, near Peel, and then on to Little Hulton. At that point, it was seen to be paved and only about ten feet wide. Slight remains between Little Hulton and Four Lane Ends have occasionally been discovered. The road then passed through Over Hulton, Chequerbent, Westhoughton, Wingates, and Blackrod.

Certainly, no evidence of Roman knowledge of coal or the working of it around Over Hulton has ever been found, but the many outcropping seams north of the A6 may have been shallow opencasted for smithing purposes; the Romans are known to have used coal when they came across easily accessible deposits. They also used coal away from active mining areas, at Castlefield, Manchester, for example.

The Hulton Estate (just purchased as I write by the giant developer Peel Holdings for approximately £8.5 million) was one of the best-preserved ancient estates surviving in Britain, owned by the Hultons for centuries. An ancient pedigree of the Banastre family, preserved in a petition on the Rolls of Parliament, begins with Robert Banastre, who came over during the Conquest of 1066. His role was to hold Prestatyn, one of the hundreds of Flintshire, under Robert de Ruelent. The Welsh regained possession in 1167 during the reign of Henry II.

Robert, the son of Robert Banastre, withdrew with all his people into Lancashire, where they were found land by the Earls of Chester. Madoc Hulton settled in Bolton. It has been suggested by Victorian historians of Bolton that they were coming to join family who may have been there already, as early as 989. In 1304, Richard de Hulton is recorded as having freehold of lands in the districts of Hulton, Ordsall, Flixton and Heaton. At Over Hulton, he built the first Hulton Hall, which, by the late nineteenth century, was surrounded by a 1,316-acre park of plantations and pleasure grounds with 4 acres of water.

CONCESSIONARY COAL

Coal mining was doubtless taking place within the ancient Hulton Park long before an award to Elizabeth Hulton was made in 1556, ensuring that she received coal for the rest of her natural life after the recent death of her husband. The miners who were to ensure this coal was produced are actually named with surnames familiar today:

Eddard Chetam [Edward Cheetham], Thoms Worthyngton [Thomas Worthington], Oiliuer Cromton [Oliver Crompton], Adam Pendulbere the elder [Adam Pendlebury the elder], Thoms Meloner [Thomas Milner] and Roger Turnor [Roger Turner].

HARVESTING THE COAL

The lease of a farm at nearby Little Hulton in 1595 included a phrase that gives a fascinating insight into the understandable geological suppositions related to coal formation of the time. The lease reserved the lessor the right 'to come with horses, carts, carriages and workmen to dig and carry away all such coals as shall be found growing within or upon the lands to be leased'.

More and more people were becoming aware of the location of and value of coal, at times ignoring land ownership. George Hulton of Hulton Hall complained in 1598 that certain persons were intruding on his lands in Farnworth and Kearsley and digging coal pits there.

William Hulton the younger, described as 'of Manchester, gentleman', died on 6 September 1613 holding Harpurhey and other lands near Manchester, Hulton, Farnworth, Heaton, and Wigan. In 1610, he engaged that, before Whitsuntide 1612, he would provide for his wife Katherine, daughter of Robert Hyde of Norbury in Cheshire, mention being made of 'mines of coal and cannel' on his land.

Miners and their special skills were much in demand by the late seventeenth century. William Hulton, in around 1680, secured his men working at his Hulton and Denton mines with a bond of £40, 'that they will well and truly serve for a year in the coal mines of Hulton and Denton'.

STAKING A CLAIM

William Hulton was a devious character to say the least. He had ample reserves of coal within his Hulton estate, yet in 1787, it was recorded that he decided he had the right to take coal at Halshaw Moor, Farnworth, not offering any evidence to support the fact!

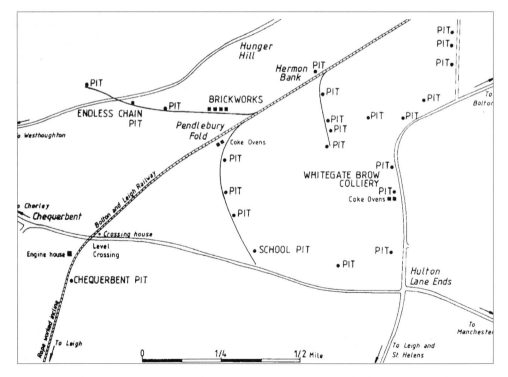

The old collieries within the Hulton estate around 1840. Some of the shafts shown were probably ladder pits, others wound by horse gins, one even by endless chain. The unnamed pits would be the older ones, late eighteenth century to early nineteenth century and probably short-lived. (Plan by Mike Pain)

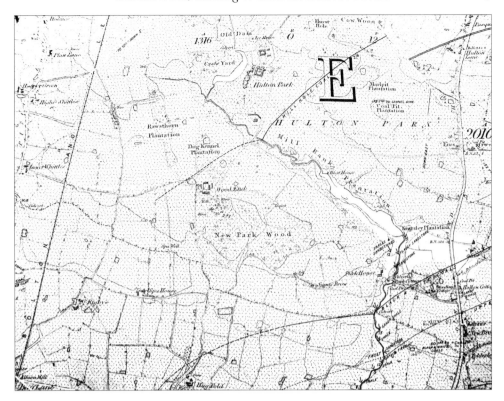

First edition 6 inches to a mile geological survey of 1862. Far left is the Bolton to Leigh railway line, top centre Hulton Hall. The lack of geological knowledge for the estate can be seen when this plan is compared to the 1929 edition. Near the entrance lodge is 'Coal Pit Plantation', containing a shaft 178 yards deep to the Cannel seam. Pretoria Pit was to be sited below the eastern end of New Park Wood.

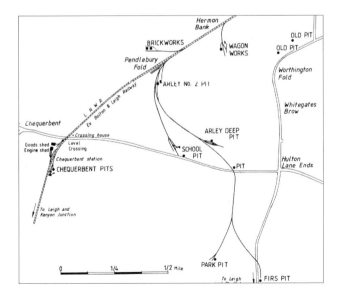

The collieries *c.* 1870, the addition being Park Pits within Hulton Park itself and Deep Arley Pit. Note Firs Pit opposite the entrance to Hulton Park, just north of the bungalow standing today, working the Cannel seam at 279 feet and Hell Hole seam at 342 feet. By now, the old small pits north of the A6 had closed. (Plan by Mike Pain)

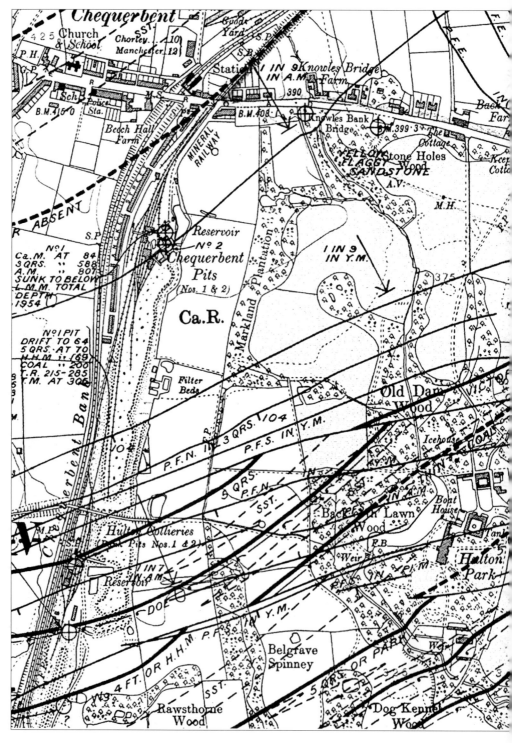

Sheet 94NE 6-inch geological survey of 1929. Top left is Chequerbent Pit, below that Bank Pits Nos 1 and 2 (Klondyke Pit), top right School Pit and Deep Arley Pit. Recent shaft sinkings within the estate have now supplied the full geological picture. Coal seam outcrops and faults along with old (circle with a cross in) and working shafts (circle with a line across) are shown. Coal Pit Plantation is now named Park Pits Wood.

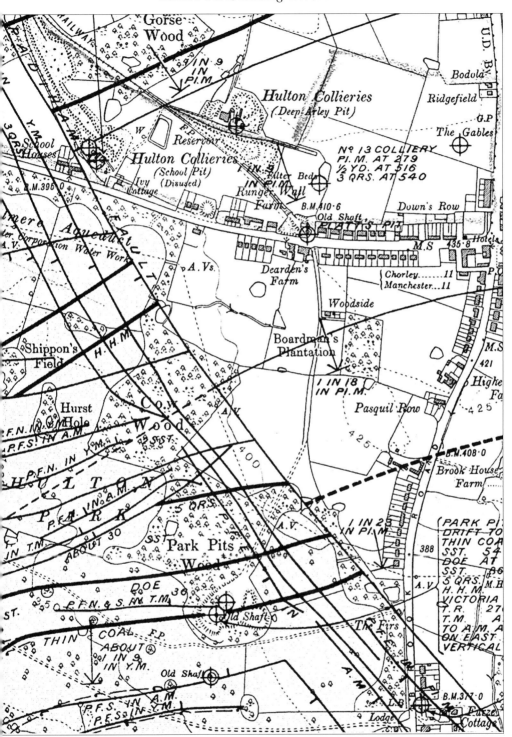

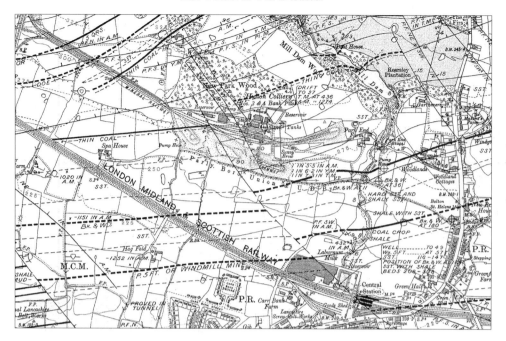

Sheet 94SE 6-inch geological survey of 1929. Pretoria Pit lies between the edge of New Park Wood and the Atherton boundary, which was only 200 yards to the south. The colliery tipped right up to the boundary fence. Note the reservoir, which survives today, and the four old shafts (probably ladder pits) aside Mill Dam Brook to the east.

> William Hulton, esquire, of Hulton Park, claims the lordship of the waste of this township [Halshaw Moor, Farnworth near Bolton]; hath frequently exercised the right of driving the commoners and hath gotten coal under Halshaw moor; but he holds no court.

The family tradition carried on with his son, yet another William – William Hulton, the son of William and Jane Hulton, born on 23 October 1787. In 1812, he arrested twelve men for setting fire to a weaving mill in Westhoughton. Four of the accused, Abraham Charlston, Job Fletcher, Thomas Kerfoot, and James Smith, were executed. By 1819, he had a reputation for dealing severely with working-class people arguing for political reform. He was appointed as chairman of the Lancashire and Cheshire Magistrates in July 1819, a special committee set up to deal with social unrest taking place in the new industrial towns. On 16 July 1819, William Hulton and nine other magistrates met at a house in Mount Street, Manchester, to discuss what they should do about the planned meeting at St Peter's Field that day. Hulton had already arranged for a military force to be in Manchester to deal with the large number of people expected to arrive to hear Henry Hunt speak on parliamentary reform. This included the Manchester & Salford Yeomanry, the Cheshire Yeomanry and the 15th Hussars. Hulton read the Riot Act. While the military attempted to make specific arrests, eleven people were killed and over four hundred injured. After the Peterloo Massacre, William Hulton was severely criticised for the way he dealt with the situation. John Hobhouse, the radical MP for Westminster, accused him of lying about what had taken place. Hulton's popularity (if it ever existed in the first place) was not improved when he claimed that 'the 16th of August 1819 was the proudest day in my life'.

Hulton also insisted that only two people had been killed in St Peter's Field and that one of these was a special constable.

In 1831, the Truck Act was passed, outlawing the practice particularly used at William Hulton's collieries (he denied this) at Over Hulton of payment in goods, tokens or credit

notes that could only be redeemed at the employer's shop. In March 1831, Hulton's miners at Westhoughton went on strike. Hulton was furious and argued (in his typical contradictory manner) that they had betrayed him:

> I have amply rewarded you for your labour relieving your families in sickness or distress and educated your children. What has been your conduct towards me? You have wantonly injured me in my purse and wounded my feelings.

Hulton told his miners that unions 'disunited masters and men' and that he would never again employ a member of the Collier's Union. This was a threat he did not successfully carry out.

In April 1831, William Hulton was frustrated at allegations being made against him by union officials, one that he operated a company shop, wages being paid in food and other goods rather than cash, known as the Truck system (later to be banned). He told his miners that unions 'disunited masters and men' and that he would never again employ a member of the Collier's Union. This was a threat he did not successfully carry out.

TO THE

HULTON Colliers

WHO HAVE

"COME IN."

MY FRIENDS,

"FACTS ARE STUBBORN THINGS."

I once more, and for the last time, address you. On the 21st of March, I wrote to the Hulton Colliers who had "turned out,"—and that was to *all*. I now have to state the truth to those, who on terms of mutual satisfaction have "come in—and that is to *almost all*, who are worth having.

I know, from long experience, that however you may be misguided for a moment yet that plain truth will always in the end convince your minds; and I know further that if left to yourselves, the conviction of your minds will always produce corresponding propriety of conduct.

A letter has been published, purporting to be from the Hulton Colliers who were "turned off." You have admitted by words, and proved by deeds, that you "turned out." The signature, therefore, is *false*.

That letter (at least the principal part of it) is from two persons whose names are JOHN TURNER and JOHN LYON; the former in the service of Mr. AINSWORTH, of Halliwell—the latter, employed (I believe) by Mr SCOWCROFT. The original letter was written, signed, and brought to me, by themselves a week ago. You are welcome to see this child of theirs, which they wish to father upon you. Resist the endeavour, as openly as I expose the *falsehood*.

I never discharged one of you because he was in the Union : I re-state this *fact*. The best proof I can give of my determination on this head is, that all my Colliers at Halshaw Moor are at this moment in the Union ; I have "not turned one of them off," not one of them has "turned out." You know that any assertion to the contrary is a *falsehood*.

I shall only notice one observation of the *false* letter. The Authors talk of a "Milk Shop at Chequerbent being shut up." By those who do not know me well, it might be supposed that I had either directly or indirectly paid my Colliers in an article of food instead of the current coin of the realm ; and to those who are aware of my determined and unceasing hostility to the iniquitous Truck System, and who think my professed horror of it amounts to an unwarrantable prejudice, I might appear a hypocrite. From these considerations alone do I condescend to deny all knowledge of such a Shop ; and thus I extract from the Letter I have alluded to another *falsehood*.

One word in conclusion. We have all suffered so severely from the Society, improperly called the "Union"—but which, in fact, has *disunited* the masters and men—that, to my former declaration, that "I never turned a Collier off because he was a member of that Society," I now add, *that I will never again engage one who is*.

Yours faithfully,

W. HULTON.

Hulton Park, April 4th, 1831.

GARDNER, PRINTER, BOLTON

THE ARRIVAL OF ORGANISED MINING AND RAILWAYS

William Hulton became the owner of Hulton Park in 1800. He would invest in coal and also early railways, being one of the main supporters of the proposed Bolton to Leigh line. The first section of the line opened on 1 August 1828, Mr and Mrs Hulton travelling in a coach wagon from Pendlebury Fold, near Hunger Hill, to Daubhill.

The main reason for Hulton's involvement was to expand his lucrative coal markets. The breakage of coal on transfer from railway wagon to horse cart led to experiments with an early form of containerisation in the first year of operation. By 1840, mining operations were mainly taking place north of the A6 with over twenty shafts in use. Chequerbent Pit, White Gate Brow Pit and School Pit (adjacent to and behind the schoolhouse still present today on the A6) were named sites; many other shafts were also dotted about, probably ladder pits. Tramroads linked the pits with the new line at Pendlebury Fold and Hermon Bank. A brickworks was also established at Pendlebury Fold by 1840, which was to be a long-lived concern, featuring as an additional item in the auction catalogue for the sale of Pretoria Pit in 1934.

A slump in the coal industry between 1837 and 1842 led to William Hulton writing to his friend Sir Robert Peel, at that time Home Secretary. He mentioned he had left Hulton Park, that he had resolved for the sake of his younger sons to abandon the comforts he had so long enjoyed to live in London and was wondering if Peel had any work for him, which he didn't! His son William Ford Hulton continued to live at Hulton Park. He was loyal to Hulton, more 'down to earth' and not concerned with public position and social prominence amongst the wealthy.

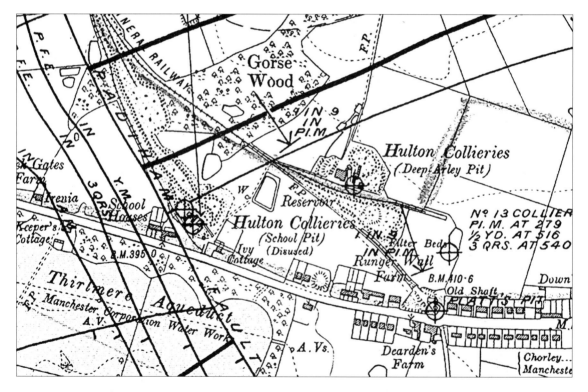

School Pit (abandoned 30 August 1911), so named being alongside the old school house of 1835, which still stands today. An additional school house was present to the east of the one on site today. The by-now-disused Deep Arley Pit (abandoned 3 September 1905) is to the east and also Platt's Pit.

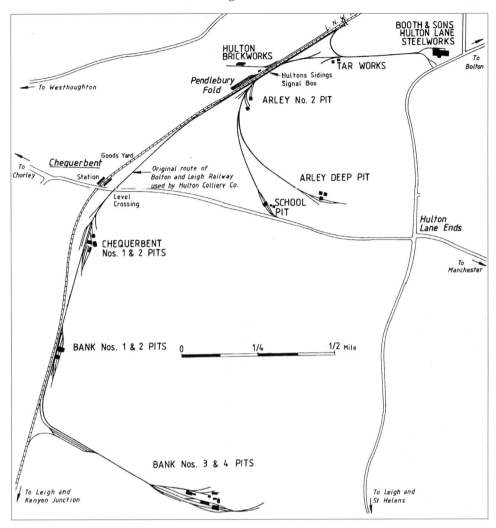

The Hulton collieries *c.* 1910. Chequerbent Pit had been sunk from 1892 onwards, Bank Nos 1 and 2 in 1897. Bank No. 1 was to close in 1927 along with Chequerbent Pit. No. 2 closed in 1921–22. Arley No. 2 Pit was to close temporarily from 1901 to 1905 and finally in 1913. Arley Deep Pit closed in 1914. Bank Nos 3 and 4 pits (Pretoria Pit) feature to the south, sunk from 1900 onwards. (Plan by Mike Pain)

HULTON COLLIERY COMPANY

This was established by William Hulton in around 1858, in partnership with Harwood Walcot Banner. By 1863, the mines at Halshaw Moor near Farnworth had closed, leaving the Middle Hulton and Over Hulton pits. William Hulton died on 31 March 1864, to be succeeded by yet another William, William Ford Hulton. The Banner part of the ownership of the company ended in late 1868. From now on, the collieries came under W. F. Hulton's sole control. Investment in shaft sinking and new colliery developments took place from now on. Park Pit was sunk within the park, north of the coach road entered at today's Newbrook Road gatehouse. Arley Deep Pit was sunk north of the A6, north-east of School Pit.

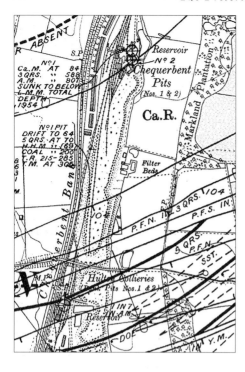

Chequerbent Pit, and lower down, Bank Nos 1 and 2 pits on the geological survey of 1929 (both closed by the time this plan was published). Chequerbent Pit was sunk below even the Arley seam (normally the lowest seam worked) to the Lower Mountain seam at 1,954 feet. Bank No. 1 was relatively shallow, reaching the Trencherbone seam at 305 feet. Note the Five Quarters seam outcropping at the site of No. 1 Pit.

THE HULTON COLLIERY COMPANY LTD AND THE SINKING OF PRETORIA PIT

W. F. Hulton died on 18 May 1879, succeeded by the obligatory William, this time William Wilbraham Brethryn Hulton. This William turned out not to be one for being personally involved in mining activities, preferring to allow R. Brancker, G. H. Daglish and others to operate as The Hulton Colliery Co. Ltd. The new company was registered on 29 March 1886.

By 1892, it was decided to access the reserves of coal beneath the park itself close to the southern boundary with Atherton. The sinking of Atherton 1 & 2 pits (locally to be known as Klondyke Pit after the discovery of gold in the Yukon in 1896) took place south of Chequerbent and east of the Bolton to Leigh railway line in 1897.

By 1900–1901, Atherton Nos 3 & 4 pits were being sunk (to become renamed as Bank Nos 3 & 4 to avoid confusion with the Atherton Collieries). In the Boer War, the British invaded the Transvaal. The Republic's capital, Pretoria, was captured in June 1900; the pit was thus renamed Pretoria Colliery by the jingoistic members of the colliery company board.

The Hulton Colliery records held at the Lancashire Record Office show for 1 July 1900 the huge sum of £35,000 being transferred into a New Sinking Fund. One of many types of historical monetary conversion states that today (2010) this equates to around £2,000,000.

Pretoria Pit was sunk in the farthest south-eastern section of the Hulton estate adjacent to the Atherton township boundary. This area held the last substantial reserves of coal within a block of faulted strata. By siting the pit as close as possible to the Hulton–Atherton boundary advantage could be made of the natural dip of the seams, from the north-west to the south-east, the dip ranging from 1 in 5 to 1 in 7, for haulage and pumping purposes.

'Jigs' or inclined gravity-powered haulage roads (brows) were laid out at the ideal inclination to the angle of dip of the seam. This worked out at around 25 degrees below a line drawn at right angles to the full dip of the seam. Others, such as the North Plodder jig, used the full dip of the seam at 1 in 6. Interestingly, at Pretoria, the seams dipped steeper with depth in

the shaft section. The Trencherbone dipped at 1 in 7.3, the Yard dipped at 1 in 6.2, the Arley seam dipped at 1 in 5.5. The main haulage 'jigs' utilised double-tub-track and endless-wire-rope systems and were as much as 1,200 yards in length. The upper rope passed over pulleys mounted in the roof, the sparking of worn examples being mentioned in the inquiry. Full tubs of coal were 'lashed' with double-hooked steel chains to the rope on the outbye side of the road, thus aiding the raising of empties lashed onto the return-side rope.

This table lists the collieries and seams being worked by Hulton Colliery Co. in 1896 at the time the sinking of Pretoria was being planned and Atherton No. 1 (later Klondyke) was being prepared for sinking with only four men on site. Note that Alfred Tonge, the future manager of Pretoria Pit, was only twenty-eight at the time, yet was acting as the manager for three separate mining districts at Chequerbent Colliery.

Colliery	Location	Manager	Men below ground	Workforce above ground
Arley Deep Pit	Over Hulton	Major Crook	325	33
Arley No. 2 Pit	Over Hulton	Major Crook	184	101
Atherton No. 1 Pit	Westhoughton	Joseph Hadfield	2	2
Chequerbent Arley seam	Over Hulton	Alfred J. Tonge	286	32
Chequerbent Three-Quarters seam	Over Hulton	Alfred J. Tonge	238	41
Chequerbent Yard seam	Over Hulton	Alfred J. Tonge	145	21
School Pit	Over Hulton	Major Crook	95	19
			1,275	249

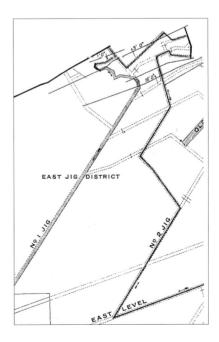

The long haulage roads known as 'Jigs' taking coal from the heavily faulted North East Yard coal faces (top right) down towards the East Level road, heading off to the No. 3 Pit bottom. No. 1 Jig was the return airway, the dust and gas within it feeding and strengthening the coal dust blast. No. 2 Jig was the intake airway.

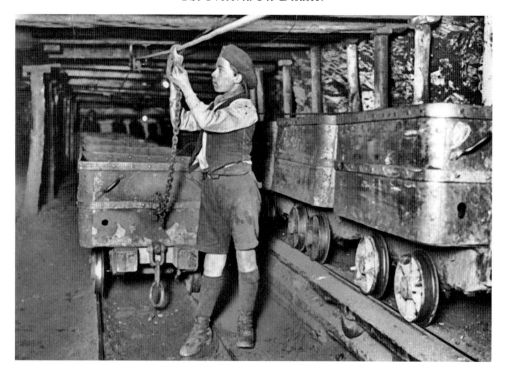

A young boy at work on an endless-wire-rope haulage roadway (colliery unknown) as used in the level haulage roads at Pretoria. He is unlashing the haulage chain from the 'over rope'. These ropes usually ran throughout the shift. The boy is loosening the 'lash' by sliding it back. He had to be quick and careful the tension did not renew itself, taking his fingers off. Note his 'helmet' is a flat cap reversed. Note the roof pulley, the sparking of which due to wear against its hanger was discussed in the official inquiry.

The older abandoned workings of Park Pit, School Pit and Deep Arley Pit to the north posed an enormous potential threat to Pretoria, one of water inrush. As Pretoria was planned and laid out after 1901, a substantial barrier would be left of unworked coal against these old flooded workings.

As the Pretoria disaster was a combined methane and coal-dust explosion, it is worthwhile noting how the industry had long suffered (without realising) from dust ignitions and that sadly the final realisation of the nature of coal-dust explosions and how they could be prevented (after the findings of the Royal Commission of 1906) virtually coincided with the Pretoria disaster.

DANGERS OF COAL DUST RECOGNISED A CENTURY EARLIER

With the increase in size of the industry as a whole and also of individual collieries from the early nineteenth century, coal dust was to be found in ever-increasing quantities below ground. Gradually, through developments in ventilation techniques and equipment, the quality of the air (oxygen percentage) at the working faces improved, a factor that was actually to prove detrimental in terms of coal-dust explosions.

As early as 1803, the great mining engineer John Buddle, active in the North East coalfield, said after the Wallsend disaster, in which thirteen men and boys died,

> The workings were very dry and dusty, and the survivors, who were the most distant from
> the point of the explosion, were burnt by the shower of red hot sparks of the ignited dust

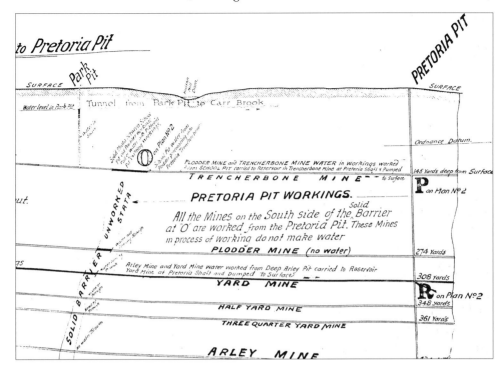

A section of the strata at Pretoria shown on a plan of 1913, drawn up for a court case between the Hulton Colliery Co. and Laburnum Spinning Co. & Others. The case revolved around the pollution of watercourses by Hulton Colliery Co. They pumped mine water into Mill Dam Wood brook, thus affecting the quality of water used as far away as the mills in Leigh adjacent to the Bridgewater Canal. Note the barrier of unworked coal in the seams below Park Pit shaft – the barrier to hold back waterlogged old workings to the north.

which were driven along by the force of the explosion [some men who died at Pretoria were found covered in tiny coked pieces of coal].

This was the colliery's fifth explosion in seventeen years, with more, ever-larger ones ahead. After the Haswell Colliery, Northumberland, explosion in 1844 where ninety-five men and boys died, Professor Faraday, in a discussion at the Royal Institution, said he felt that

the ignition and explosion of the [methane and air] mixture would raise and then kindle the coal dust which is always pervading the passages, and these effects must in a moment have made the part of the mine which was the scene of the calamity glow like a furnace.

STONE DUST TRIALS AT ATHERTON COLLIERIES AND THE ESTABLISHMENT OF A MINES RESCUE SERVICE FOR THE LANCASHIRE COALFIELD

Ever safety conscious, Fletcher Burrows & Co. Ltd, operating the Atherton Collieries, had experimented with stone-dust-spreading machines at Gibfield Colliery back in the late nineteenth century.

Clement Fletcher, of Fletcher Burrows & Co. Ltd, Atherton Collieries, was a very safety-conscious and talented mining engineer who was to be one of the main protagonists for

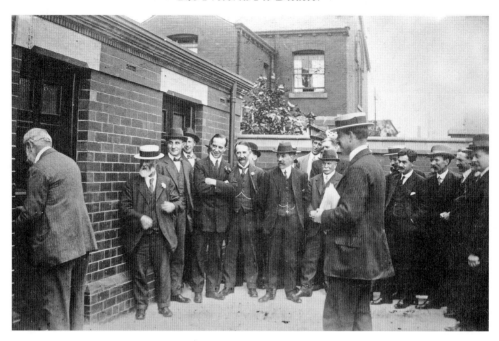

The official opening of Howe Bridge Rescue Station, Atherton, 2 April 1908. The small man second left is John Gerrard, HM Inspector of Mines, who was to attend Pretoria. Also present were William Garforth, President of the Mining Association of Great Britain, Henry Hall, HM Inspector, and Clement Fletcher, all to be involved with either the rescue or inquiry around the disaster.

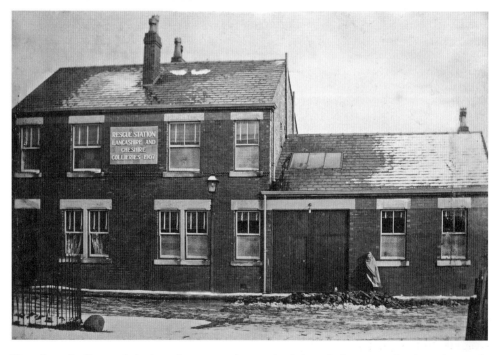

Thursday 2 April 1908, sheltering after a snow shower, this lady with distinctive shawl stands outside the newly opened Howe Bridge Rescue Station. It is seemingly just a couple of terraced houses with a large shed behind, but at the time this was state of the art and of national importance. The building still stands today at the bottom of Lovers Lane.

the establishment of an organised central mines rescue service in the Lancashire coalfield. The First Report of the Royal Commission on Mines 1910 (the Commission actually sat from 1906 to 1911) led to the Mines Accidents (Rescue and Aid) Act 1910, requiring the establishment of rescue brigades. Rescue equipment would be held on site at collieries along with ambulances and first aid-trained men.

In January 1908, Clement anticipated the Act and persuaded the major Lancashire coal owners to set up the first central rescue station in the country serving a wide radius of collieries, at Howe Bridge, Atherton. This was built in late 1907 and opened in 1908. The building still stands today at the bottom of Lovers Lane. Clement Fletcher was to be in one of the first rescue teams down Pretoria after the blast, although preparation work to enable the recovery of bodies was to be the main task.

On 18 August 1908, the Maypole Colliery disaster at Abram near Wigan claimed seventy-five men and boys after a gas explosion. The average large gas explosion might 'only' kill forty or fifty men and boys in the immediate vicinity through the explosive force of the blast. Also, a virtually pure methane explosion does not always produce carbon monoxide. At the larger, more productive collieries of the late nineteenth century, ventilation sheeting, pit props, roof timbers, wooden tubs and large amounts of coal dust were present in the lengthy coal faces and haulage roadways. The initial gas explosion burnt any textiles and timber, creating carbon monoxide. If coal dust itself was also ignited, the amount of carbon monoxide rose substantially, with lethal effects.

ROYAL COMMISSIONS 1891 AND 1906 (PUBLISHED 1909)

A Royal Commission was appointed in 1891 to enquire into the effects of coal dust in originating or extending explosions in mines. In 1893–94, tests on coal dust were carried out in a disused mine shaft at White Moss Colliery, Skelmersdale, the District Inspector of Mines, Henry Hall, recording them. It was found that a 'blown out' shot (one where flame emerged out of the shot hole rather than being confined within the coal) and fired by gunpowder nearly always fired coal dust that was present. It was found that the better-ventilated collieries or well-ventilated specific coal seam districts were, if anything, more prone to coal-dust explosions.

It was also decided (not totally conclusively nor through extensive and detailed scientific method) that certain modern dynamite-type high explosives should be used in future to the exclusion of gunpowder. In general, they did not create a 'long' flame nor ignite coal dust. Gunpowder generated a relatively slow blast wave, travelling at less than the speed of sound, 340 metres per second. High explosives generated supersonic-speed blast waves, ranging from 3,000 to 9,000 metres per second, so it was indeed dangerous to arrive at this conclusion. Nevertheless, the White Moss tests had made some important findings.

In 1906, the Royal Commission on Mines was appointed (its findings were actually published the year before the Pretoria disaster), this time to study, along with other aspects of health and safety, the nature of coal-dust explosions. A surface explosion gallery 1,083 feet long was created in May 1908 at Altofts Colliery, Normanton, in the West Riding of Yorkshire. These were the first organised British coal-dust experiments, funded by subscriptions from colliery companies and conducted by W. E. Garforth, manager of Altofts Colliery and president of the Mining Association of Great Britain.

That these groundbreaking tests were being carried out was noted in other major coal-producing countries. In America, for example, the magazine *Popular Mechanics* featured the results with photographs in March 1909.

The test structure was made up of a wrought-iron tube built up from sections 7 feet in diameter and 78 feet long.

Inside the recreated mine tunnel were tubs on rails, wooden pit props and pit waste. Coal dust could be laid in various quantities and various types of coal dust were ignited.

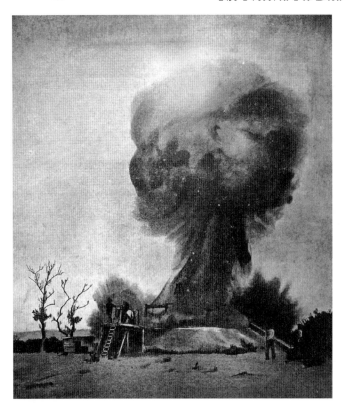

Left: A coal-dust blast expands as it emerges from the disused mine shaft at White Moss Colliery, Skelmersdale, in 1893. The experiments were led by District Inspector of Mines (later Sir) Henry Hall, who was to attend the Pretoria inquiry as an expert witness. Imagine such a blast confined to a small cross-section roadway as at Pretoria; imagine also to be in the way of its progress.

Below: A coal-dust blast emerges with great force from the intake air tunnel (against the air current, as witnessed occurring in certain districts at Pretoria) at Altofts Colliery in the West Riding of Yorkshire. The tests began in May 1908. Note the flame as the blast emerged. These were the first organised British coal-dust experiments, funded by subscriptions from colliery companies. William Garforth, mining engineer, led the tests and was to attend the Pretoria inquiry as an expert witness.

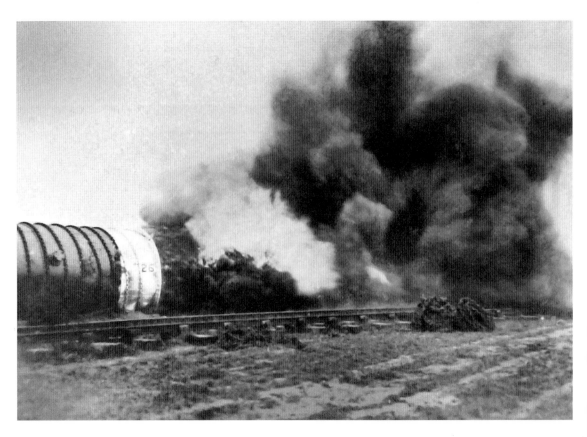

In meticulous scientific fashion, experimental ignitions took place over the period 1908–09. Photographs were taken of the ensuing flame and blast emitting from the tubes; use was also made of cine. Measurements were taken of air pressure at various points within the explosion gallery. Microscopic analysis of material after the explosion was carried out. Gas samples were taken along the gallery at time intervals after ignitions. Coal-dust mixtures with inert stone dusts of varying particle sizes were tried out.

It was found that 96 per cent coal dust mixed with 4 per cent of pit shale dust ignited at 1,025 degrees centigrade. When the percentage of shale was increased to 20 per cent, the ignition temperature had to be increased to 1,095 degrees centigrade, evidence of the damping effect of stone dust. One interesting aspect of coal-dust explosions discovered was that the optimum length of coal-dust-laden 'tunnel' was 18 feet for an explosion to take place. Less than this and only a fire occurred. This could be one (of two) reasons the Pretoria blast did not spread into the No. 4 Pit districts, via less dusty pit bottom area tunnels.

During the investigations, the speed of the coal-dust blast wave was assessed as between 60 and 100 miles per minute, or between 3,600 mph to 6,000 mph. The power of the destruction arising from these explosions of coal dust (in the complete absence of inflammable gas) proved to be startling, with pieces of boiler plate weighing up to 1,500 lb scattered hundreds of yards away over adjacent fields. The explosions were heard seven miles away (similar to Pretoria).

In conclusion, the Royal Commission found that coal dust could extend explosions, could increase the danger of explosions, even when only small quantities of gas were normally found, that coal dust alone with no gas present could cause an explosion. They also concluded that other coal-related dusts could be inflammable in varying degrees.

THE EXPERIENCE AT PRETORIA

We can only imagine what it must have been like in Pretoria for that split second when the temperature rose high enough to fire a brick and the high-speed blast wave of flame shot along the roadways. Imagine also in lesser degrees the experience of those farther away from the coal-dust blast wave, close to the exhaustion points near the pit bottom, who in an instant experienced blast-wave temperatures up to hundreds of centigrade followed by the equally violent reverse air current. Some of the descriptions of the state of the bodies when found after the explosion at Pretoria can be compared to those who died at Hiroshima and Nagasaki.

After the Pretoria disaster, experts puzzled as to why the explosion in the seams in No. 3 Pit did not consume the whole colliery (with the death of a further 545 men and boys). Explosive force was found to have been extinguished after travelling only about 20 yards into the No. 4 Pit Arley districts. It was found that the coal dusts formed in the Arley districts were actually non-ignitable due to their degree of fineness and capability for ignition, yet pure Arley coal itself was the highest-ranking coal, the highest in carbon percentage, and the most flammable of the five seams worked at the colliery. Clearly, there was still a great deal to be learned about the nature of coal-dust explosions.

Company Records and Descriptions of the Colliery Pre-Explosion

LEAD-UP TO THE DISASTER: THE THREE TONGES, 1904, 1905–06, 1908 VISITS

Records of the Hulton Colliery Co. Ltd (NCHu) held at the Lancashire Record Office, Preston, sadly do not give us the background to the geological and mining planning behind the sinking of Pretoria Pit. Colliery companies who survived until nationalisation in January 1947 often only deposited financial and output records with the National Coal Board. Even the NCB did not seem to realise the historical importance of the survival of general documentation of colliery concerns for future generations and much was destroyed.

As mentioned earlier, the Hulton Colliery records held at the Lancashire Record Office only show us the fact that in July 1900 a New Sinking Fund equating to around £1,997,100 in modern terms (2010) was set up.

THE TONGE FAMILY

The Hulton Colliery Co was fortunate to have four members of the academically talented (and local) Tonge family involved in managing operations;

James Tonge senior (born Bolton, 1837) was a Fellow of the Geological Society, Chartered Engineer, and Consultant Geologist. His son Walter Ernest Tonge (born 1866, Over Hulton) was the Hulton Colliery Co. Chief Cashier and later Secretary of the Pretoria Disaster Relief Fund; he was also prominent in local politics as Chairman of Westhoughton UDC in 1902 and 1925. His second son was Alfred Joseph Tonge (born 1868, Over Hulton), Mining Engineer and Colliery Manager. The third son was James Tonge junior (born Westhoughton, 1875), FGS and consultant mining engineer, also a writer on geological subjects.

James Tonge senior had been noticed as intelligent as young as ten by William Hulton, who promised him a job in the future. This came to fruition on 1 January 1853 at Hulton Collieries. He joined the Manchester Geological & Mining Society in 1873, reaching the heights of president in 1891–92, also attaining presidency of the National Association of Colliery Managers. His son James joined Manchester Geological Society in 1898 and was to write *The Principles and Practice of Coal Mining* (Macmillan, London, 1906) and *Coal* (Constable, London, 1907). Alfred J. Tonge joined Manchester Geological Society in 1891.

James and Alfred wrote many articles for mining journals, especially within the *Transactions of Manchester Geological and Mining Society* (*MGS*):

> 1896 [James Tonge] *MGS* vol. 25, pages 267 and 405.
> *A new hydraulic apparatus for breaking down coal in mines*
> 1902 [Alfred Tonge] *MGS* vol. 27, page 382.

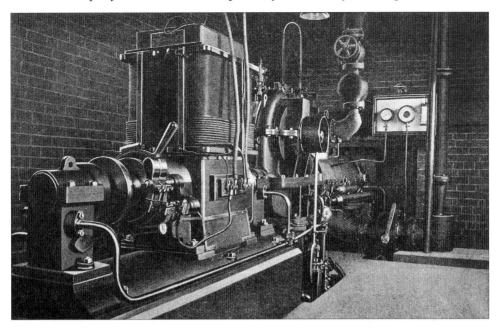

A photograph of early 1902 accompanying a paper by Alfred Tonge to the Institute of Mining Engineers. This showed the latest design of steam turbine-powered electric generator in use at Deep Arley Pit, north of the A6. Alfred Tonge was particularly keen to trial and also make use of the latest designs of electrical equipment.

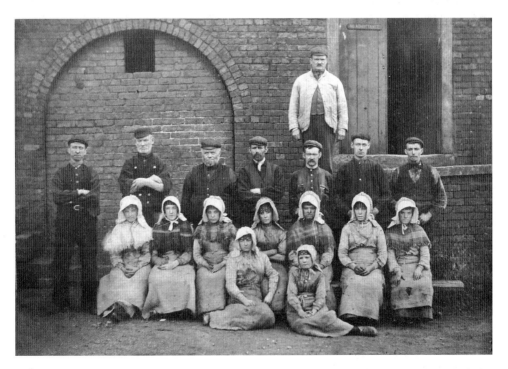

Pit brow women and surface workers at one of the Hulton collieries *c.* 1887. These women picked the dirt from amongst coal passing by on screens and conveyors in the picking sheds, and were usually the wives or daughters of miners. More pit brow women were employed in the Lancashire coalfield than any other. They were happy in their work and welcomed the additional earnings coming into the house.

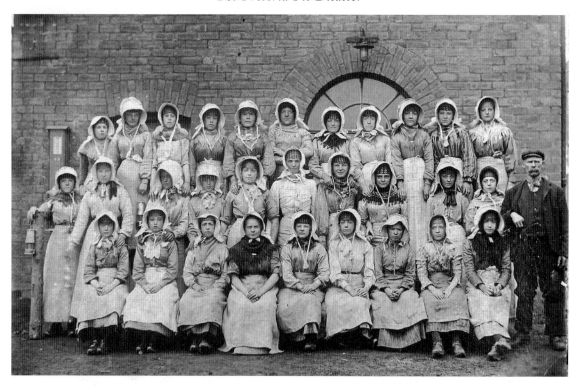

Hulton collieries pit women *c.* 1887. Concern at the unsuitability of the employment of women on the surface at collieries was focused in 1859, 1863, 1866 and 1868 by mining unions and the press. Others not associated with the industry also took on their cause, whether they wanted them to or not. Moves to make their work illegal in 1886 led to a deputation in May 1887 to Parliament by Lancashire pit women, resulting in the proposed legislation being removed. This happened again in 1911, the women once more successful in their appeal.

> *Erection and a few tests of a turbo fan and generator at Hulton Colliery*
> 1904 [Alfred Tonge] *MGS* vol. 28, page 354.
> *Coal cutting by electricity*
> 1906 [Alfred Tonge] *Transactions, Inst of Mining Engineers*, vol. 31, page 207.
> *Underground fans as main ventilators.* Discussion after this particular paper touched on the
> legalities of such installations, potential for damage during an explosion and whether a
> damaged fan could quickly be repaired after an explosion. The inquest and enquiry held
> after the disaster would also discuss the merits of such installations.
> 1907–08 [Alfred Tonge] *Trans, Inst of Mining Engineers*, vol. 32, page 365.
> *A colliery plant: its economy and waste*
> 1909 Feb 9th [Alfred Tonge] *MGS* vol. 31, page 174.
> *Fossil tree in the Arley mine at Chequerbent Colliery*
> 1910 Paper in *Transactions, Inst of Mining Engineers*, page 350.
> *Sinking into the lower coal-measures at Hulton Colliery*

The Tonges were in close and regular contact with some of the finest mining engineers, geologists and mines inspectors in Britain. When it came to the planning and laying out of Pretoria Pit, it was obviously decided to be 'state of the art' in many respects. After the sinking of No. 3 and No. 4 pits at Pretoria, a number of learned mining and scientific professionals and interested societies visited the site, comprising geologists, colliery managers and engineers.

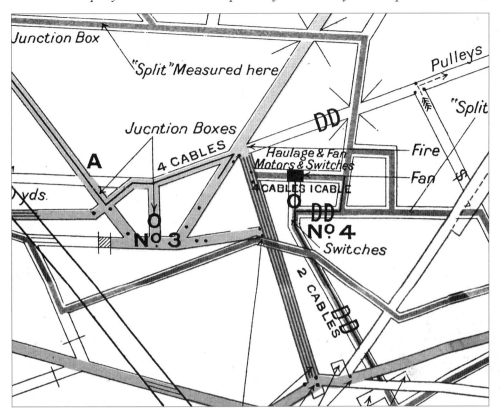

The maze of roadways around No. 3 and No. 4 pits accessed from the Yard seam inset. In May 1904, John Case, engineer, and colliery manager Alfred Tonge travelled No. 3 Pit to see the effect of previously turning off the underground ventilation fan. The result, as they stepped out of the cage, was that they hit a wall of gas and had to crawl inches off the floor until they reached the fan house to switch it on again to clear the gas. For a colliery manager to suggest this experiment seems incredible to say the least.

PRETORIA PIT IN 1904

The year 1904 is an important year in the history of the colliery, as it gave us an advance insight into the potential problem of gas there as well as a detailed description of the colliery.

John Case worked at Pretoria (apparently as an engineer) before the explosion. The explosion at Cronton Colliery, Halsnead, south of St Helens, on 21 August 1972 (until 1947 a Hulton Colliery Co. pit) reminded him of an incident on Whit Sunday morning in May 1904 at Pretoria. John wrote up his experiences, entitled *An Anxious Time*.

The colliery manager Alfred Tonge had decided he would stop the underground fan in the Yard seam and try to measure the amount of gas given off in a given time (this probably means that he would monitor the gas percentage rise over a period of time in the general body of the air). The manager informed John that he would be stopping the fan for 'two or three days' and that they would go down the pit on the Sunday morning. John was to switch the fan back on again, being normally in charge of them. John recalls,

> We met as arranged on the surface at No. 3 shaft [the upcast ventilation shaft] and went underground together each taking with us a safety lamp. When we arrived at the Yard mine [seam, the shaft inset at a depth of 306 yards] we were astounded, we were met with a wall

of gas, which at the shaft was diluted by the air passing up the shaft from the Arley mine [seam]. The manager had a shock. He never expected to find the mine [this section of the mine] filled with gas right up to the shaft. Leaving the cage, he tested [for gas] by means of his safety lamp and found that there was a layer of air, sufficiently diluted, about three feet thick underlying the layer of gas. The problem was, but we had to risk it, would this gas diluted remain fit to breath all the way to the fan room, about 120 yards distance along a roadway that inclined upwards at about 1 in 40.

The manager decided, without a word, to risk it. Going down on our hands and knees, the manager going first with the light on his safety lamp turned low testing the quantity [percentage] of gas in the air we were breathing. As we left the shaft and turned right into the main road the layer of breathable air thinned and we had to proceed with our mouth nearer to floor accordingly, testing the mixture of gas and air foot by foot to assure our safety.

It was evident that nothing like this amount of gas had been expected, the electric lights had been left on. As I looked up, crawling as I did like a worm with my nose near to the floor I blessed the electrician who had connected the wires to those lamps. Had there been one defective joint the gas could have been ignited. My mind however could not dwell on that. The manager continued crawling on his stomach, testing for gas as he went. I followed him also on my stomach crawling over chains, scotches [tub haulage chains and iron rods used to jam tub wheels to stop them] and other obstacles. It was all so strange, in other surroundings one would have thought us loopy. Here we were crawling on our stomachs with our face getting nearer and nearer to the floor, in an electric lighted road 12 feet wide and 7 feet high. In spite of the situation I saw the funny side of it, but again I couldn't dwell on that. I had to concentrate on the danger in front of me. He was preceding me and would be affected by the gas before I would or might be. I don't think he had told anyone on the surface what we were going to do. He had never, for one moment, expected to find such conditions. I knew if [we] were both overcome with the gas we had had it. We were on our own, hence I kept the manager in conversation and watched his every movement, ready to pull him back if he was overcome.

As we proceeded deeper into the mine the layer of breathable air and gas got down to within eight inches of the floor and so we had to proceed with our face almost touching the obstacles over which we passed. When we reached the Plodder tunnel, off which the fan room had been cut, we could feel the temperature of the atmosphere change. It was much cooler. By that I knew fresh air was leaking from the No. 4 shaft [the downcast shaft] through the fan room. This diluted the gas, which evidently was coming from workings on the east and north sides of the mine.

From that point we could proceed in a stooping position until we reached the fan room. On testing we were very relieved to find the gas, if any, was not sufficient to show on our safety lamps. As a precaution I took all the covers off the switches I had to use and the covers over the electric brush gear on the motors, and by means of my cap, fanned out any gas that may have accumulated in the switches or brush gear. In addition the manager opened the ventilation doors leading to No. 4 shaft thus allowing fresh air from the surface passing down No. 4 shaft to pass through the fan room into the roadway we had just crawled along.

Having started the fan and after assuring him that all was well the manager declared we should quit the mine and without delay. We could not possibly return by the way we had come so we proceeded to the No. 4 shaft and there signalled for the cage to be lowered to us. The experiment was never repeated, nor was the manager able to calculate the amount of gas given off. It had far exceeded expectations.

This account showed that huge volumes of gas could very soon accumulate at the colliery, especially in the Yard district and that constant ventilation was crucial in the removal of it. The need to ventilate adequately all active workings would form part of the discussions and

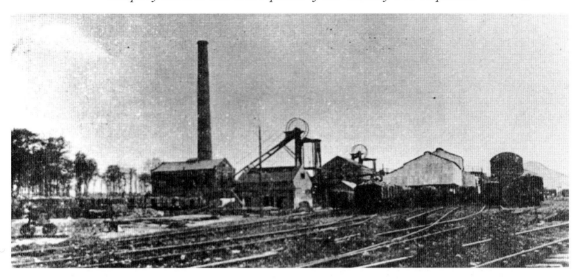

A poor shot from the west of Pretoria in 1904, taken during the National Association of Colliery Managers visit. It is important as it shows No. 3 Pit headgear (nearest) with an open structure. Upcast shafts are normally fully enclosed to stop a short circuit in the ventilation. At Pretoria, the main fans were below ground exhausting air out of the workings. The fan on the surface was a secondary or emergency one, a major colliery design flaw.

recommendations at the explosion inquiry. It also shows an incredible, almost unbelievable, lack of mining precautionary 'common sense' in Alfred Tonge, to just try out such a trial without advance planning, consultation and additional staff or safety back-up.

In October 1904, the National Association of Colliery Managers visited Pretoria Pit, at that time known as Atherton, Bank Nos 3 & 4 pits, to be met by manager Alfred Tonge (who no doubt did not mention his recent lucky escape), and commented on the following equipment and processes in use:

Six high pressure boilers were in use, four running at 100lbs psi, two at 150 psi. No. 3 Pit (to be involved in the explosion) winding engine had cylinders 32 inches in diameter with a 15 feet diameter winding drum. The engine was by R. Daglish & Co. of St Helens. No. 4 Pit winding engine had cylinders 36 inches in diameter with an 18 feet diameter drum, maker Pearson & Knowles Coal & Iron Co. Ltd, Warrington. No. 4 was winding coal from 150 yards and 440 yards insets.

For winding, locked-coil steel ropes of 4 inch circumference [1¼-inch diameter] were in use. Ormerod [of Gibfield, Atherton] safety detaching hooks of 10 ton capacity were in place. The cages were double decked, three x 12 hundredweight tubs per deck (20 hundredweight = 1 ton). [The 1934 auction states that 5 cwt tubs were in use so this may be a mistake.] The pit headgears were of timber with 16 feet diameter iron pulley wheels.

The power house contained two three phase Parsons high pressure steam turbo-alternators working with 150 lbs psi steam, running singly and alternately at 3,000 rpm.

All mechanical work carried out on site at the colliery and below ground was powered by electricity, apart from the winding engines and a single boiler feed pump.

The pit bank was supported on cast iron columns, tubs gravitating from pit bank to creepers then to the mechanical run-through tipplers. The screens were capable of grading coal into 18 different sizes or qualities. Coal finally passed over the picking belts where women were employed separating out dirt. 50 tons of coal briquettes were being produced per day from compressed [coal] dust. All surface lines were graded to allow wagons to gravitate in the correct direction, locos only being required when wagons finally left to the main line.

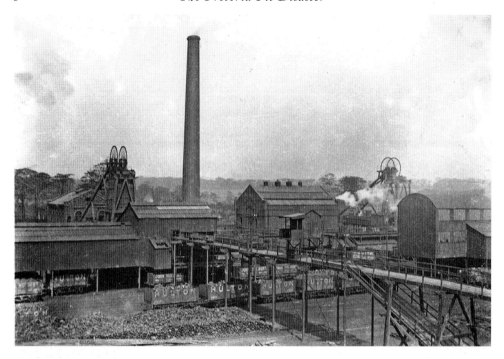

A view of 1934 from the south-west. No. 3 Pit headgear is now fully encased to ensure the surface fan worked efficiently. Centre is the large power house which contained steam turbine generators. No. 4 Pit is to the right. Elevated tubways are in the foreground taking dirt to the tips. Apart from the Hulton wagons there are a few John Hulbert of Middleton wagons in view.

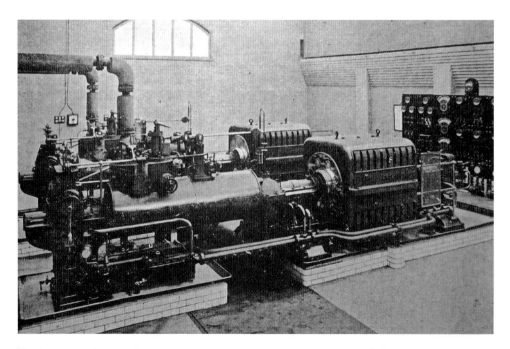

The large power house at Pretoria, seen here in 1904, was sited between the two shafts. It contained two three-phase Parsons high-pressure steam turbo-alternators working at 150 lb psi, running singly and alternately at 3,000 rpm. In 1906, an additional generator by Fraser & Chalmers of Erith, Kent, had been installed. Excess electrical capacity headed off to Chequerbent Colliery by 1¼-mile power lines.

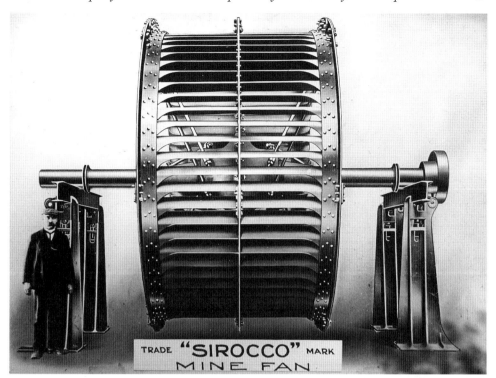

Four electrically driven Sirocco fans were sited underground at Pretoria; three were exhausting (drawing air out of the workings) and one was a forcing fan (boosting the intake ventilation air-current pressure). Fans were placed in the Arley, Three-Quarters, Yard Mine and Trencherbone districts. Sirocco fans were the most efficient available at the time, designed in 1898 by James Howden and made by Davidsons of Belfast. Relying on fans below ground rather one large-capacity one sited on the surface was not advised by many mining engineers due to the potential for explosion damage.

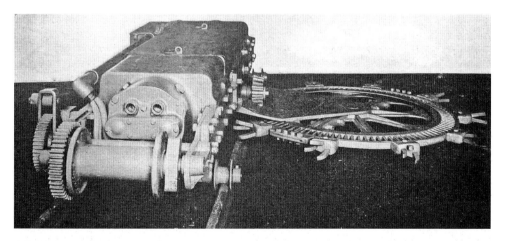

A Diamond coal cutter photographed in 1902. Made by the Diamond Coal Cutter Co., Wakefield. The electric version was used at Pretoria in the Arley seam. The round cutting disc with its triple cluster picks undercut the seam to a depth of 4 feet 6 inches. Looking at the open gearing to the disc, it must have been constantly clogged up with coal dust and dirt. Hulton Colliery Co. used them from 1907–13.

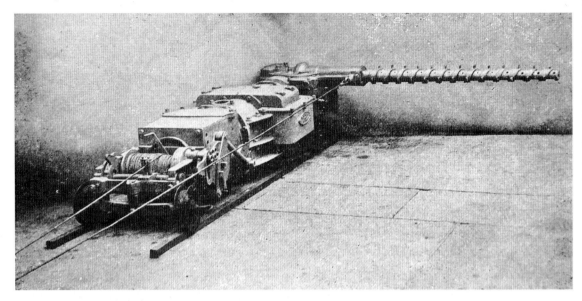

The 'Hurd' electric bar coal cutter was used in the Trencherbone seam at Pretoria. This undercut the seam to the same depth as the Diamond cutters in the Arley seam, 4 feet 6 inches. Invented in 1894, the rotary drill, once fully into the cut, was then drawn along the faceline undercutting the seam.

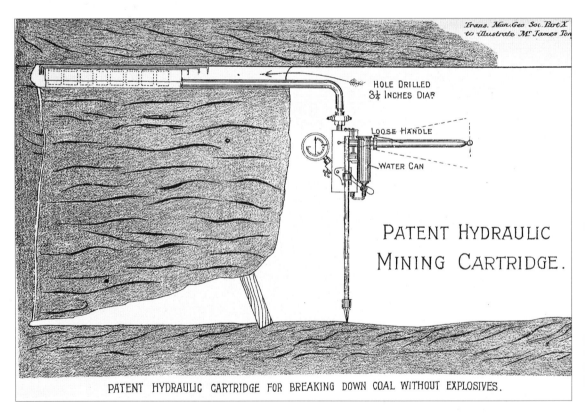

James Tonge senior's Patent Hydraulic Cartridge as used at the Hulton collieries. After the seam had been undercut (here by hand pick), the metal tube cartridge was pushed into a large-diameter hole drilled above the seam. The collier pushed the cartridge tube in the hole then pressurised the eight pistons by pumping the handle, prising the coal down in large lumps.

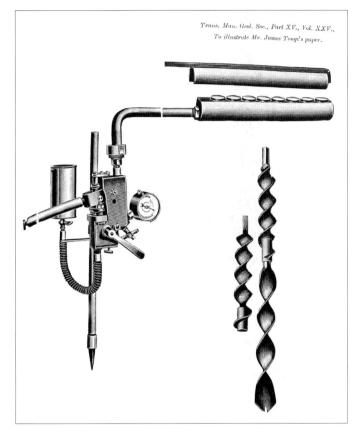

The components of James Tonge's Patent Hydraulic Cartridge. Payments in the accounts of Hulton Colliery Co. went to the Patent Hydraulic Cartridge Company (Bolton) between 1907 and 1915. The company had been advised to use the equipment by the designer's father, colliery manager Alfred Tonge. Similar equipment was in use from the 1940s through to the 1960s as the Wigan made Gullick coal burster, possibly an adaptation of this design.

At the time of the visit [7 October 1904] new workshops were being built, to include blacksmiths, fitting shop, carpenters shop, shed for four locomotives, wagon shop and saw mill. Other buildings planned were lamp room, water purifying and softening plant, sharpening smithy and offices.

Coal was being raised from three seams; the Trencherbone at 150 yards, Yard at 300 yards and Arley at 440 yards. Endless steel wire rope haulages for each seam brought tubs to the shaft insets. The pump in the Trencherbone seam could raise 10,000 gallons of water per hour to the surface. The latest design of Sirocco fans ventilated the workings.

Coal cutting was carried out using 'Diamond' disc cutters in the Arley seam. These undercut the seam to a depth of 4'6". The 'Hurd' bar coal cutter in the Trencherbone seam undercut to the same depth. The cutters ran on metal skids.

By using these cutters along with the Tonge [James senior] hydraulic cartridge a good percentage of high value large coal could be produced from these two seams which were the best quality available in the Lancashire coalfield.

THE COLLIERY IN 1906

A further visit to the colliery was made by Manchester Geological Society and the North Staffordshire Institute of Mining and Mechanical Engineers in July 1906. By this time, an additional turbo generator by Fraser & Chalmers of Erith, Kent, had been installed. Excess electrical capacity headed off to Chequerbent Colliery by 1¼-mile-long power lines. The rest of the description of the colliery is unchanged apart from mentioning that the Three-Quarters seam was being worked using a compressed-air percussive-heading machine.

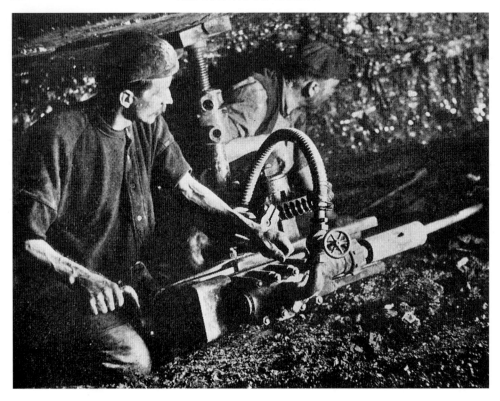

Pretoria was visited in 1906 by Manchester Geological Society and the North Staffordshire Institute of Mining & Mechanical Engineers. They noted that coal in the small Three-Quarters district (accessed via a tunnel from the Arley workings) near to No. 3 shaft was worked by an electrically driven compressed-air-powered percussive bar cutter of the type seen here on a rise face. Relatively lightweight, it was anchored by a screw jack between roof and floor.

INTERNATIONAL ATTENTION AND A BRIGHT FUTURE

The use of electricity above and below ground, well-designed colliery layout both on the surface and below ground, the use of mechanical coal cutters and most importantly the placing of a number of high-capacity ventilation fans underground rather than relying on one large fan on the surface brought Pretoria Pit international attention in mining circles. It also brought criticism, in that an explosion below ground could damage all the ventilation equipment, whereas a surface fan with explosion doors would probably remain intact and could reverse the air current to extinguish fires.

The academic establishment surrounding the British coal-mining industry was highly regarded worldwide. A colliery manager with a Wigan Mining College qualification was in the upper echelon as regards status. International mining societies closely followed developments within the British mining industry and quoted papers regularly. It was quite normal then for the influential American magazine *Mines and Minerals* to be mentioning the ventilation activities of the Tonges at Pretoria Pit in 1907. In 1909, the International Institute of Technical Bibliography stated that the Hulton Colliery (Pretoria Pit) 'secures coal without explosives and is the only mine in England ventilated electrically by underground fans'.

James Tonge senior's patented hydraulic cartridge was in use at the Hulton Collieries on certain coal faces (probably those more prone to becoming gassy) rather than explosives. Shots were still fired in the rock below and above certain coal seams to create work space, more powerful charges being used in larger 'cross measure' rock tunnel drivages.

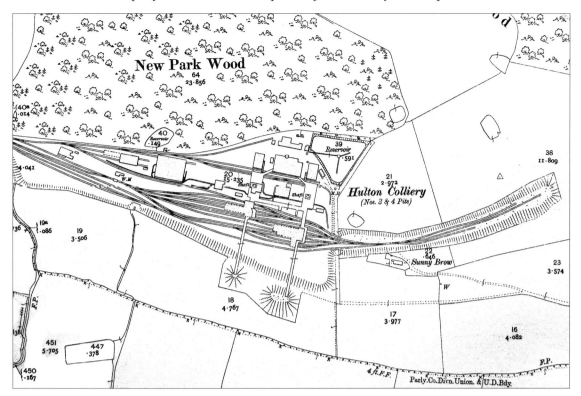

Pretoria Pit on sheet 94.12, the 25-inch edition of 1907. No. 3 Pit was to the left of No. 4, the large power house between them. At the top, to the left of the reservoir, are the colliery offices and lamp room. Note the two screen sheds above the sidings and the tub ways feeding the growing waste tips very close to the Atherton township boundary. A compact and efficiently designed layout.

1910, ANOTHER PRODUCTIVE YEAR AHEAD

By 1910, the colliery had everything in its favour: high-quality (in the academic sense, at least) colliery management, investment in electricity and the latest mining and surface plant, working the highest-quality seams. Safety considerations would normally come along with such a large investment. Accidents would still be expected to occur as in any mining situation, but there would be no reason to be concerned that a major event might take place.

It might be suggested that the colliery management at Pretoria gave too much priority to the academic and technical aspects of this exciting and successful new development. This gave less time or even less inclination to be overly concerned with the vital and important basics of day-to-day mining operations and the safety of those involved. Certainly, the officials below ground, the undermanager and his deputies, would not be blind to the dangers around them on a daily basis. Communication with management of their concerns was poor or at the very worst not taken seriously. Hints of this surface in the official inquiry.

The colliery continued to produce coal like any other until 21 December 1910 when events overshadowed all the achievements that had brought it international attention previously.

The Explosion

THE PHASES OF A MINE EXPLOSION

For obvious reasons, we can never know what it was like to be close to the actual methane explosion in Pretoria Pit. Over the centuries, miners became accustomed to regular ignitions of gas at their candles, even lighting it on purpose at the beginning of the shift to improve the air quality. Poor ventilation and low oxygen levels usually meant the ignition was fairly docile, shooting along the roof until exhausted. At other times, varying degrees of burns might result.

An explosion taking place in such a confined space as a coal face, with perhaps a six-foot cross section by four feet in height, hundreds of feet in length, followed by a coal-dust blast can only be compared to a person being inside the barrel of a very large cannon. Very few men have ever survived methane or coal-dust explosions; those who have often died a few days later due either to the high degree of burns or damage to their lung tissue. Men who have survived were usually working hundreds of yards away from the initial methane blast site and far enough away from the ensuing coal-dust blast wave and afterdamp (the post-explosion gas mixture including carbon monoxide).

When methane explodes on a coal face, the air and gas mixture expands as much as five times. In this very confined space, the mixture has little room for expansion other than to blast along the coal face. The initial flame front of an explosion wave travels relatively slowly, but the pressure waves created as the mixture expands and contracts stir up the coal dust. The secondary coal-dust explosion then takes place, much more violent than the gas blast and usually stronger, surprisingly travelling against the ventilation current. It is thought the turbulence created by the explosion wave hitting incoming air stirs the dust up more violently than in the return airways.

After a methane and coal-dust explosion, the following can be found in various quantities in the atmosphere: water, heat, red-hot coal dust, stone dust, methyl alcohol, formaldehyde, formic acid, carbon monoxide and carbon, a daunting atmosphere for a rescue man to enter.

A SURVIVOR FROM THE NO. 4 PIT ARLEY DISTRICT RECALLS

The explosion at Pretoria occurred at 7.50 a.m. on Wednesday morning of 21 December. This time was verified by a number of pocket watches that stopped at the time of the blast.

In the case of the Pretoria disaster, we have the following gripping account which was recorded by the North West Sound Archive, Clitheroe Castle, in 1980 (Ref 1980.0075) from a man who was actually below ground in the lower Arley seam workings accessed from No. 4 Pit when the explosion took place. The man's name is not recorded. He was born on 7 November 1889.

When the explosion happened I was with my brother, drawing for him [filling his tub and pushing it away to the main haulage roads] … and I was just coming out with this box [tub] of coal when there was such a rumble. A fellow comes down a road, somebody shouts 'It's a rock weight' a fellow says. 'No rock weight, there's summat serious here,' he said. 'Come on lets get cloas [clothes] on let's get pit' he meant to the bottom of the shaft.

Well mi lamp [miner's oil safety lamp] had gone out, I'd no light. So anyway we got to the bottom of the shaft all the machinery were stopped [the haulage engines and fans] were all finished, nothing going and we could feel the air getting worse and worse [the low oxygen afterdamp gas mixture resulting from the explosion]. He says, 'There's no air coming,' one fellow says, 'Come on let's get moving.'

Anyway we got to the pit bottom [at the Arley seam inset level]. Well when we go to the pit bottom I've never seen such a shambles in my life. There were no cages, they were stuck in the shaft and the boss were there and somebody says, 'What's do Jack?' [undermanager John Bullough, he left Pretoria after the disaster. By the time he was called to the inquiry on 20 February 1911 he was working as an undermanager for Wigan Coal & Iron Co. Ltd.] That were to Jack Bullough. 'Eeh I don't know what's do, I can't find anything out.' He says, 'There's no telephones, there's nothing, all lights is gone, no lights in't pit-een [at the pit eye or pit bottom] or nothing. Phones had gone … Well you see all [the] front of where the cage comes down, it's all caged in you see, like doors you know, wooden doors [multiple air doors separating intake from return air in the area around the upcast shaft]. Well all them were blowed away and down at the bottom [of the shaft] were wire rope and all sorts. I fancy they were the guide rods as takes the cage up and down you see. [These were steel wire ropes hung in the shaft, as thick as winding rope with broad and smooth outer strands, the cage had tubular runners at the top and bottom which the ropes passed through. Guide ropes kept the cage steady and in a fixed position in the shaft.]

Anyway we were about nearest to that pit bottom on our coalface … than any of the others and I think we were the first lot to get to the pit bottom you see. Then a while after somebody shouted for help, I heard that, shouting help, help, Bullough shouted up to them [to the Three-Quarters seam mouthing in the shaft 73 yards above] 'Yes and some help wanted down here too'.

Well anyway the air were going worse and worse you know and I were feeling groggy. Well men started a coming in from other districts you know into the pit heading [before the explosion 344 men were in No. 3 Pit and 545 in No. 4 Pit where the Arley, Trencherbone and Three-Quarters seams were worked].

Then Bullough said, 'Now you as is all right' he said, 'help them as can't help theirself'. He says, 'There's men here want to go to sleep, don't let 'em go to sleep, do anything at them, don't let them go to sleep, hit them, punch them, do anything at them, don't let them go to sleep.' [Here the effects of explosion afterdamp gases were taking their toll on the men who had had to walk hundreds of yards to the pit bottom in dense fumes low in oxygen and containing carbon monoxide.]

Well there was a pal of mine, he come out of another district and I see him and I said, 'Now George, don't go to sleep.' 'Ohhh let me go,' he says. I says, 'No than mun wecken up [no you must wake up], keep up.'

Anyway we seemed to be down there hours and hours and we couldn't find nothing out and at last we heard a cage coming down very slow you know. The cage landed at pit bottom and I'll never forget this, everybody seemed to be rushing for it you see and then I think his name were Dixon [H. O. Dixon]. I think he were General Manager of Westhoughton Coal and Cannel Company [correct] … he said, 'Now let's all be British,' he says, 'don't rush we've just come down from the Yard Mine [seam] where there's 344 dead.'

He said, 'You are alive let's try and get you out as easy as we can.' He says, 'Don't panic.'

Do you know everybody went so quiet. He says, 'Let's try and get all these as can't help themselves in this cage first.' [These would be men suffering from afterdamp and carbon monoxide poisoning along with heat exhaustion.]

No.	Name	Address	Age
1 - 852	Richard Clayton	232 Church St. Wingates	47
2 - 853	John Livsey	356 Park Rd Westhoughton	
3 - 854	William Turton	683 Manchester Road, Westhoughton	58
4 - 855	William Green	6 Bowden St Deane Bolton	13
5 - 856	Samson Gibson	13 Marsh Lane Westhoughton	16
6 - 857	Richard Yonge	3 George Street Westhoughton	14
7 -	William Partington	10 Gladstone Terrace Westhoughton	
8 - 58	___ Rushton	687 Manchester Rd Westhoughton	37
9 - 61	unknown		
10 -	Mark Critchley	9 Park Road Westhoughton	22
11 -	Frederick Hanley Houghton	16 Manchester Road Chequerbent	13
12 -	unknown		
13 -	Dennis Dorey	14 Charles Street Westhoughton	14
14 -	Peter Moss	14 Westley Street Atherton	15
15 -	Cyril Cattell	41 Bella Street Daubhill Bolton	12

Police Sergeant Brown took charge of the identification of bodies raised to the surface, listing consecutive number, name, address, age, who had identified the body, property found with them and their occupation. Also, occasionally a comment 'warned' is added, probably as the body was terribly disfigured or burned. Nos 9 and 12 are listed as unknown.

List

Whom Identified	Property	Occupation
Robt Clayton Room 22nd	(Arley 3/4 Mine.) Knife, key, nut + Railway ticket	Fireman
Walter Alped Hindley - 22nd	Nil. (Father took belt & clog)	Haulage hand
— James Turton)	Knife — (Son James took watch from body.)	Fireman
— Eleanor Green)	Nil (Father took jacket) thought it but not his property	Haulage hand
— Thos Gibson	Nil	
— ich Lane of W. Clark?	W. Jones deceased lives with his Aunt	— Jasher On
Richard Longe Father	Nil	Haulage boy
— nutty Partington	Nil Warned	Hooker on
— the Barn of Westhoughton. Brother.	Tape measure — watch with string) took knife & ticket — Propty. handed to P.S. 720	
(cause of death explosion)	Nil. Body gone to Waggon shop)	
John Helm Park Road Westhoughton	(Warned) Tally no. 58.	Hooker on labourer
— J. Houghton	Nil. Warned	
	Nil	
— onard Lyon Step father	Nil	Lasher
— a Moss Father	Nil	Not Known
— ane Catterall Mother	Watch case + an old watch Warned	Hooper on

He says, 'We've only one cage,' he says, 'let's try to get them in and get them up out of the way. Which they did and they all fell back and they helped for to get these lot up and they started getting younger lads out first you know, because they were crying some of them you know and the air was going worse and worse and at finish they got … they had a surface fan you know … they got that going [a surface exhausting ventilation fan drawing air up the upcast shaft].

Well it come better then. The air started a coming better. And you know how they got them up, don't you? There was no signals you know to the winder [the electric bell signals to the winding engineman on the surface]. They had a big iron plate and this man at the bottom where we were, he were hitting [signalling using] that to the Trencherbone Mine [seam shaft inset] higher up. Trencherbone Mine were hitting it [signalling using the same method] to the surface, a man on the top [of the shaft] leaning over listening and then he knocked [signalled] to the engine winding man. And they were only going up in one shaft you know. You know if it had gone again God knows what would have happened, there would have been some lives lost.

Anyway they got us out nice and safe and everybody were saying getting out 'Thank God' when they saw the daylight you know. I never seed more ambulances and people Good Lord I don't know where they all come from! And they were all asking you, you know as you were walking away and a funny thing happened as I were walking down that line through the sidings, there were two women coming.

Do you know who them women were? It were Jack Bullough's wife and Ned Rushton's wife [the two undermanagers down No. 4 and No. 3 pits]. Ned were manager [undermanager] of this that went off [No. 3 Pit], he were dead. But they didn't ask me about their husbands. Mrs Bullough says to me, 'Have you seen our Teddy?' called Edward, well Edward were learning management you see. He were going through it as boy working in the pit [working his way to management by gaining practical experience of all the jobs in the pit; the men respected this route].

Well we had come across that Edward, he were leaning over a body as were badly hurt. Some dirt [stone and shale] had come down with the bang you know [in the Arley district].

Anyroad I said, 'I've seen Edward, Edward's all right.' Her says, 'Oh that's right then.' They never bothered about their husbands still, they walked on then going towards the colliery.

A SURVIVOR FROM NO. 3 PIT

A young boy, Joseph Staveley (sixteen), an apprentice fitter, was a survivor from the No. 3 Pit itself, although well away from the coal faces. His short account appeared in *The Times* on 23 December 1910:

The Lancashire Pit Accident – Three Hundred and Twenty Lives Lost

There is no reasonable doubt that more than 300 lives have been lost in the disaster at Pretoria Pit.

'There is not a single shadow of hope that there is a man in the pit alive,' said John Gerrard, the Inspector of Mines. Rescue parties were in the pit all night, and they have been working ceaselessly throughout the day, but they have seen no sign of life or anything that could lead them to suppose that life could possibly be supported beyond the area of their investigations.

When the exploring party returned to the pithead at 3 o'clock this afternoon Mr Gerrard announced that they had almost arrived at the coal face, and had found an accumulation of afterdamp and gas which stopped further progress and proved that nobody could be alive in that district.

Right: Joseph Staveley (photographed back at work after the disaster) was a survivor from No. 3 Pit with William Davenport and Fountain Byers (who died later), although working well away from the coal faces. Joseph recovered quickly, but, it is said, his life was never to be the same again. He served in the Royal Engineers in the First World War, returning home to Westhoughton to settle down into married life. He died in 1954.

Below: Postcard produced by Bolton fundraiser extraordinaire C. W. Lloyd. He overprinted the latest balance lower right. Left is John Sharples from No. 4 Pit. William Davenport (No. 3 Pit) and Sharples were discharged from hospital on the following Wednesday. Sharples had been gassed and was to die of pneumonia. Davenport was severely burned. Davenport was born in 1891; after working at Pretoria, he was employed at Chanters Colliery, Atherton, until he died on 24 September 1951. Note the card forgets that 545 other men were below ground at the time of the disaster!

J. SHARPLES. GOOD LUCK W. DAVENPORT.

J. STAVELEY.

The Only Survivors
of the PRETORIA PIT DISASTER, at Atherton, December 21st., 1910, in which 344 Lives were lost.
Amount Collected for the BOLTON MAYOR'S RELIEF FUND :-- £87,731-2-9.

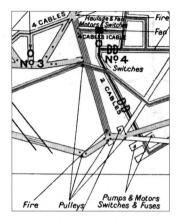

The area near the shafts where No. 3 Pit survivor Joseph Staveley was working was the pump house, lower right (arrowed). He made his way from here to No. 4 shaft 100 yards away, after a period of unconsciousness, suffering from the effects of gas. He recalled not seeing anyone else alive.

It was thought yesterday that none of the men who descended into the Yard Mine in the morning had been brought out alive. It has, however, been discovered today that one of the 440 men who were brought out by the Arley shaft was in the Yard Mine when the explosion occurred. He is a lad of 16 years, named Joseph Staveley, and it seems only too clear that he is the sole [actually one of three from No. 3 Pit, plus 545 others below ground in No. 4 Pit] survivor of the actual catastrophe.

The boy told me the story of his escape at this home at Chequerbent this afternoon. It was in the following words:

'The fitter to whom I was apprenticed, James Berry [James Berry junior, twenty-one] and the under-manager, Mr. Rushton [William, thirty-two years, both were to be killed in the explosion], and I went down to the mine at 7:30am. The fitter and I went down to the pump house about 200 yards away from the bottom of the Yard shaft [No. 3 Pit] and 100 yards from the Arley Mine shaft [No. 4 Pit]. We had just got into the pump house when the explosion took place. It sounded like a cannon going off. It knocked me to the ground, but the fitter kept his feet. We made our way along to the Arley Pit [No. 4 shaft] when the fitter fell, and I fell over him. We had smelt the gas very strongly. I lay there, I think, for about an hour. When I woke up I found that the fitter was dead. I made my way up to the Arley Pit and shouted for about an hour. About 10 o'clock a party came down. I saw nobody else alive in the Yard Mine, and I did not think that I should be saved.'

There was very little change in the aspect of the pithead today. There was again a large and silent crowd on the colliery embankment, but there was little for them to see.

Now and again a rescue party of six with its goggles and breathing equipment would step into or out of the cage. It was noticed that the leader of each party carried a cage with a bird [a canary] in it. The first few birds which were brought back to the surface were alive. At length one was seen to be dead, and that little incident exercised a singularly powerful impression on the minds of the onlookers. It brought vividly home to them the difficult nature of the rescuers amid the foul and heavy air of the mine and showed how illusory was the hope of finding any of the imprisoned men alive.

The real picture of the disaster is to be seen not at the colliery but in the neighbouring townships. Every other house at Chequerbent and Wingates had its blinds drawn today, and few families have escaped losing one or more members.

A Wingates family has lost the father and five sons, and a Chequerbent family has lost the father and three sons. The last case has a peculiar pathos, as the youngest son was making his first descent into the mine.

An idea of how the explosion blast found its way into every nook and cranny of the pit and maintained its power even hundreds of yards away from its origins can be seen in this account from *The Manchester Guardian* on 22 December 1910:

THE MOST TERRIBLE COLLIERY DISASTER IN ENGLAND SINCE THAT OF 1866:

THE TERRIFIC EXPLOSION AT THE PRETORIA PIT AT ATHERTON, NEAR BOLTON.

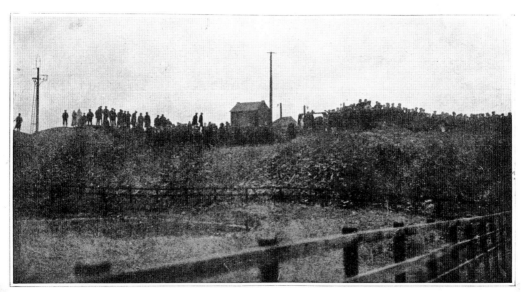

THE HOPELESS DAWN: ALL-NIGHT WATCHERS AT THE COLLIERY ON THE EARLY MORNING OF THE DAY AFTER THE DISASTER.

The Illustrated London News ran a lengthy feature on the disaster with photographs of surface damage at No. 3 shaft. Here on 22 December relatives wait for news. By 23 December, the Inspector of Mines, John Gerrard, had stated that 'there is not a single shadow of hope that there is a man in the pit alive'. Relatives did not want to believe this and continued to come to the pit for days after the explosion.

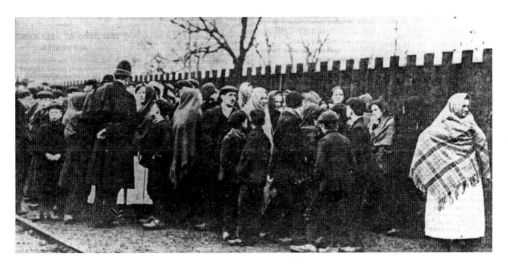

A *Bolton Evening News* photo of relatives waiting for news. Large numbers of police were present stopping the crowds from getting too close to the shafts, also answering a constant stream of questions from relatives and the press.

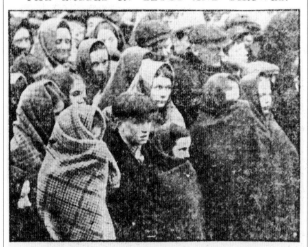

"THE LASSES IN CLOGS AND SHAWLS."

GROUPS OF BEREAVED WOMEN STILL WAITING THIS AFTERNOON AT THE PIT HEAD.

The *Manchester Evening Chronicle* depicted the waiting crowds, focusing on the women and girls in their shawls. The press noted when interviewing families in the streets of Westhoughton how many of the younger girls confidently took on responsibility for their younger brothers and sisters while their mothers were distraught with grief.

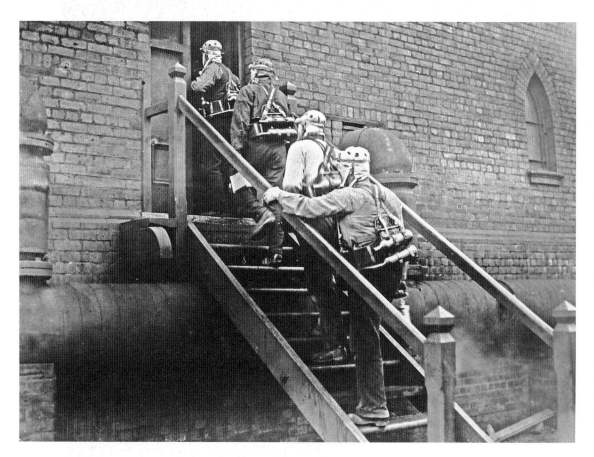

A team of rescue men climb the steps of No. 4 shaft winding engine house. On their backs are oxygen cylinders. Re-breather rescue sets utilised the unused oxygen present in exhaled air (only about 15 per cent or less of the oxygen inhaled is consumed), adding fresh oxygen to it. Any carbon monoxide entering the set was absorbed by caustic soda crystals.

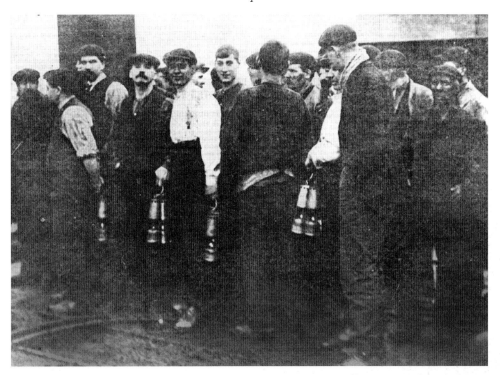

Above: Recovery workmen preparing to travel No. 4 shaft, 22 December. No rescue sets are visible; the men are taking Wolf safety oil lamps with them. Ventilation had by the time of this photograph been re-established. These men had a great deal of hard work to do clearing a way through extensive roof falls and damaged equipment.

Right: Manchester Evening News feature, 22 December. Top left: Rescue men climb No. 4 engine house steps on their way below ground. Top right: Men leaving the rescue station. Bottom: Coffins being delivered to the mortuary at the pit in a horse-drawn Royal Mail van. The colliery offices are on the right.

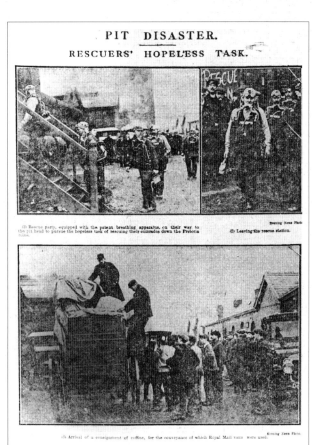

PIT DISASTER.

RESCUERS' HOPELESS TASK.

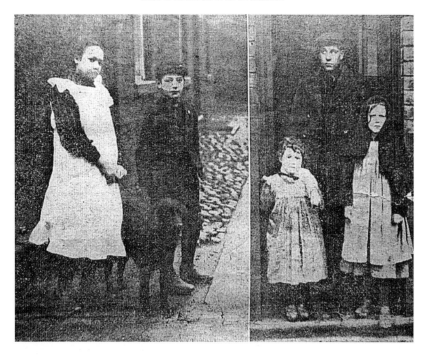

The *Daily Sketch*, 24 December 1910. In an article entitled 'The Great Mine Catastrophe' were these photographs of the children bereaved by the disaster. On the left are John and Ellen Bennett of Bolton Road, Westhoughton. They lost four brothers. On the right are the two little sisters and brother of the two Liveseys of Park Road, Chequerbent. Their expressions speak volumes.

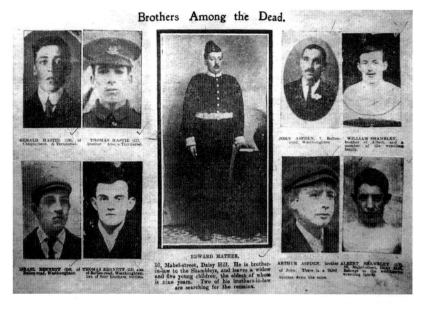

The *Daily Sketch*, 24 December 1910. Groups of brothers killed in the disaster. Top left: Gerald and Thomas Hastie of Chequerbent. Lower left: Israel Bennett and Thomas Bennett of Bolton Road, Westhoughton. Top right (left) is John Aspden, below him, Arthur Aspden. Top right is William Shambley, below his brother Albert Shambley, well-known wrestlers.

Mr. William Rushton, the under manager, was found in the underground office. He had been blown out of his chair, and there were injuries to his head.

Report books found in his office were singed, showing that flame itself had entered into his office. Colliery Manager Alfred Tonge was in his house a few hundred yards away at the time of the blast and would have easily heard the blast. He handed a written account of his narrative to the official inquiry as evidence.

I was in my house and heard the report about ten minutes to eight and was informed shortly after that there had been an explosion. When I got to the pit, I found smoke coming from the upcast [No. 3] shaft. I saw that a portion of the [wooden] casing of the upcast shaft had been wrecked. I went forward to the downcast shaft [No. 4] and was informed by the mechanical engineer that one of the cages was fast in the shaft as a result of the explosion.

There was no damage to the [winding] engine and as the No. 3 shaft was out of [use] the purpose for travelling purposes, we set to work to liberate the cage in the downcast. Fortunately one of the cages appeared to be free, but it could not be brought up because the other cage was fast. We had to disconnect the rope from the cage that was fast from the drum and after that the free cage was brought to the surface. I got to the pit about ten minutes past eight and the cage was free about nine o'clock.

When we got the cage working we took five men in the signal cage [the cage would communicate with the surface by hand hammered signals] and went quietly down calling at the Trencherbone mine [shaft seam inset]. Llewellyn Williams, the undermanager of the Trencherbone mine [seam] was at the mouthing and I asked if all the men were all right there. He said, 'Yes'. They had suffered from fumes but everything was clear. I took him with me in the cage and we went further down. On our way down we encountered obstacles in the shaft, broken signal wires and bearers [large section timbers supporting pump ranges, cable clamps and compressed air ranges], and we were in considerable alarm as to whether

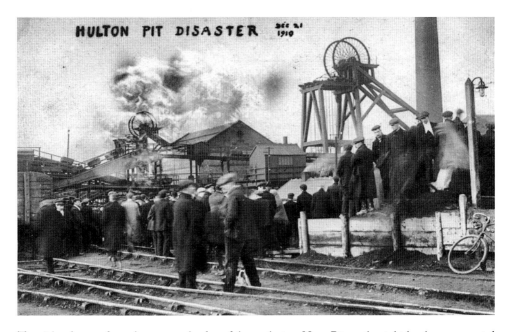

The pithead scene from the east on the day of the explosion. No. 4 Pit on the right has been converted to single-rope winding, No. 3 in the background appears to have fumes emerging, but this may have been added in the photographic darkroom; certainly fires raged for days after the explosion. The large building between the shafts is the power house.

Illustrated London News, 31 December 1910. Blast damage at the surface of No. 3 Pit upcast shaft headgear.

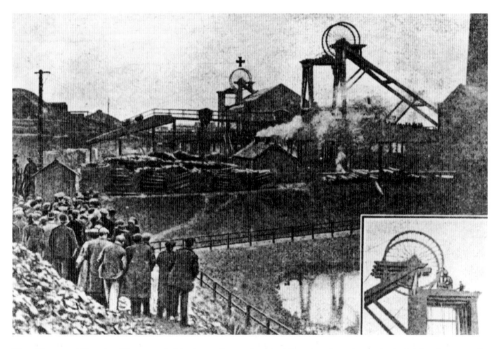

The *Illustrated London News*, probably in an issue shortly after the disaster, included this photograph. The headgear with a cross above is No. 3 Pit. The small inset photograph shows the top of No. 4 Pit headgear where men are repairing the wire-rope guide 'rods' to establish single-rope winding, one of the cages being trapped in the shaft.

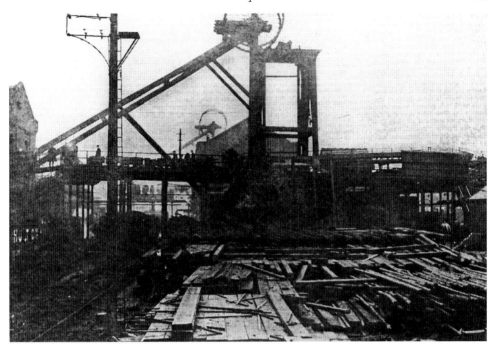

No. 3 Pit headgear shortly after the explosion. A poor image but one of very few taken at the time. It had been thought that the foreground showed evidence of explosion damage, but this is actually the colliery timber storage area, the large baulks used in main roadway junctions and air crossings.

the cage was going to stick or not. But it kept freeing itself and broke through all the obstacles. We got to the Yard mouthing [shaft inset] and, on going in, saw the underground fan blown inwards towards the downcast pit [shaft]. Going forward through the electric haulage house, which was the main route to the upcast shaft bottom, we found great wreckage and got through into the No. 3 pit bottom shunts where we found a boy.

There was afterdamp [gases produced after fires and explosions] and it was hot but we went forward. We picked up the boy and sent him back up the pit. Going forward we found [Fountain] Byres [*sic* Fountain Byers, later to die in hospital] struggling, and we carried him to the cage. I looked about and found more dead bodies lying about, and then we decided to go down and see how the men in the Arley [district] were. We first took the injured men up to the top and then set out immediately to go to the Arley mine [seam].

Having passed the Yard mine [seam], I heard a shout, 'Send the cage to the Yard mouthing' which was repeated mechanically over and over again. We had been at the Yard mouthing and I could not understand it, but I remembered that it would be the other Yard mouthing [on the opposite side of the shaft] and we found the source of the noise. It was a lad from the workshops, Staveley [Joseph Staveley]. We got him out and lifted him up and asked him what he had been doing and were there any more. He said that here was a lad close to him, dead. We took him to the top [surface] and then went down into the Arley mine again having difficulty as the cage kept sticking and freeing itself [against the distorted guide ropes].

We called to the Three-Quarters [seam] mouthing in the shaft, which was not used, instead of going down the tunnel and getting to the Arley mouthing. We asked if they were all right and they replied that they were and wanted to go up. I said there were others in a worse position than they, and they must be patient.

When we got to the Arley, we found regular pandemonium. Men were crying to come up, they were ill with the fumes. Men were waving their comrades arms about. Some were worse affected than others and the undermanager, John Bullough was amongst them calling

upon them to be men and doing what he could. Do as we could we could not get quietness. I shouted to those round about, 'Put those men who are ill in the cage, and the strong keep back!' I was afraid of a panic and that the men would rush the cage and seize ropes or anything, but fortunately they did not.

The men who were ill were put in the cage and taken to the top. I went with them then came back to the Yard [mouthing] taking others with me and sent [signalled] the cage to the Arley [seam shaft inset] to fetch another load. The Arley and the Trencherbone men were all got out safely and we soon had a fair number of the men down in the Arley rescuing. Six of the Trencherbone men who had been in the cage at the Trencherbone [seam] mouthing when the explosion occurred were raised to the surface after the suffering Arley men and the other Trencherbone men were all got out last. It was all done with one cage, signalling by knocking [metal on metal] on the cage, as the proper signalling apparatus [electric bells linking pit bottom with the surface banksman] had broken down. There was no mishap whatsoever in getting the whole of the 545 men out [of No. 4 Pit] and we had them all out in three and a half hours.

After getting down into the Arley mine again, I took a few men and went on the East level, where we found a fire at an air crossing. I left instructions for the fire to be put out and went forward with two men to the down brow.

I also instructed Turton and Scott, two reliable men, to proceed a short distance to the Plodder tunnel to see if there were any fires, and if so, to report. I then went forward down the down brow and at the bend of the brow, after calling out, heard a man respond. The man was able to give his name as Devonport [*sic* William Davenport, Athertonian haulage hand, aged twenty, found near the top of the Downbrow roadway]. I gave him a drink and sent a man back for the doctor and a stretcher. Doctors Lee and Russell had come down with us in the cage. Devonport was carried out on the stretcher and taken to the surface.

As the falls were so bad further on in the down brow, I decided to return to the pit, and it was there reported to me by Messrs. Turton and Stott that they had found a fire but had not been able to put it out. I asked them to return to it to do so, but to be very careful of the fumes. I returned to the air crossing on the East level where the men were engaged in putting out a fire [the air crossings at Pretoria had timber baulks in the roof of the lower road, these had been dislodged and set on fire, disrupting the ventilation].

By this time Mr. [John] Gerrard, H.M. Inspector of Mines and several mining engineers had arrived at the spot. It was decided to restore the air crossing [where the intake air road crosses the return air road]. At about this time news was brought to me that Turton, the fireman who had been sent to put out the fire, had been overcome by fumes. We did what was possible for him and he was sent to the surface [he was dead].

The next operation was the restoration of the air crossing over the No. 1 East North Plodder, Top Yard, and Three-Quarters districts. After restoring this, the air crossing over the North Plodder Jig was restored.

The only ventilation that was being effected in the mines was the natural ventilation combined with a little assisted ventilation, due to the continuous running of the Trencherbone fan, all the rest of the fans had been put out of action by the force of the explosion. The stand-by surface fan was intact, but the casing at the pit top [the wooden casing around the lower part of No. 3 Pit headgear] was damaged and had to be put right.

This was completed early and the surface fan was ready to run in nine and a half hours after the accident. After restoring the air-crossing in the North Plodder Jig which gave the ventilation a chance to get into three important districts, I went along with the Inspectors and other engineers to consult with a Consultative Committee on the surface. It was decided not to put the fan into operation as there was still some doubt as to whether there was any fire in the mine. Returning down the mine, we again went into the Down Brow and fixed a tight cloth stopping [virtually airtight ventilation 'brattice' sheeting] in the brow with a view to forcing the air into the down brow workings.

The finishing touches to this operation were affected by the men with 'rescue' apparatus. Shortly after this, Mr. Gerrard himself, and a few others decided to make an inspection of

After the explosion, manager Alfred Tonge's top priority was to re-establish ventilation. The air crossings on the North Plodder Jig, where intake air passed above the return air, had timber baulk roofs. These had been damaged by the blast. Once reinstated, a natural flow of air initially would be created. The air crossings are indicated on the plan by large 'x' crosses.

The damaged air crossing in No. 2 Jig. This linked with the East level. One roadway is at right angles to the other, the floor of the upper road being of timber baulks set across brick side walls. Repairing these and re-establishing the ventilation system was the first priority after the explosion.

the Three-Quarters mine [seam workings] thinking it possible that a few of these men, being near the shaft, might be still living, and that it was possible to bring them relief. We went in at the intake end and were able to get into the workings and out by the haulage road to the pit, having found a dozen bodies and having been convinced that there was no one left alive in the mine. Shortly after this we returned to the surface and it was decided to start the surface fan. The fan was actually started at five minutes past six and after allowing it to have about half an hour's run we descended the mine again.

The reinstatement of the ventilation around the workings included repairing the burnt brattice sheeting. This was coarse hemp-type cloth, nailed up to roof timbers to course the air, into single road headings for example. The company accounts for the end of January 1911

show £75 4s 7d (equivalent to nearly £4,300 in 2010) was paid for brattice cloth compared to normally approximately £26 per month.

Sergeant-Major Hill, who was in charge of the Howe Bridge Rescue Station, heard of the disaster by telephone at 8.05 a.m., and he at once sent for a car to the motor garage at Leigh. This arrived at 8.17 a.m. and arrived at the colliery with the rescue apparatus at 8.25 a.m., reporting to Mr Tonge at 8.45 a.m. Pretoria Pit had a Howe Bridge trained rescue team that could use rescue apparatus, but of these five, one was killed in the explosion, one was off sick and two were in the Arley Mine leaving John Hunt as the only available trained man at the colliery. He was at home at the time of the disaster but went to the colliery and arrived at 8.55 a.m.

At about 9 a.m., Mr Clement Fletcher, of Fletcher Burrows & Company, Atherton Collieries, who was a qualified rescue man and mining engineer, arrived with two others from the collieries. They at once put on the apparatus and went down at 9.20 a.m. These men were used to put out the fires, first the fire in the haulage engine house near the No. 4 downcast shaft and the one near the main air crossing, east of the No. 4 shaft. (The first rescue team to actually reach the North Plodder explosion site was to be the Ackers Whitley & Co., Bickershaw Colliery, Leigh, team.)

While they were doing this, two members of the party were called away to fetch William Turton out from where he and Stott were fighting the fire at the top of the South Plodder tunnel. Turton was found to be dead.

By this time, there were forty men with breathing apparatus at the pit and 148 rescue-trained men in the mine. There was later criticism that there were no rescue men sent to the fire in which Turton lost his life. A room was provided for Sergeant-Major Hill and J. G. Huskinson, his deputy, and Dr Arnold Green gave medical help. Mr Arthur (Ratcliffe) Ellis, the Secretary of the (Lancashire & Cheshire Coal Owners) Rescue Committee, and Mr Charles Pilkington, the Chairman, were constantly at the colliery. It was arranged that squads of rescue men should not be underground for more than two hours at a time, but this was difficult due to the problems winding the cage.

The surface foreman was James Polley, thirty-one, at the time and the Surface Manager of the colliery. He lived near Chequerbent Station. His edited account via his son is as follows:

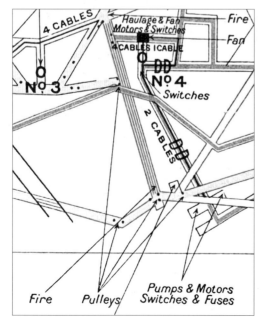

Amongst the first rescue parties to descend was William Turton, an old collier who had two sons below. He got some distance in front of his comrades and paid with his life. When the others overtook him, they found the old man had been asphyxiated while fire-fighting. The location of the fire is shown on this plan section, at the bottom of a rise rock tunnel heading towards No. 3 shaft.

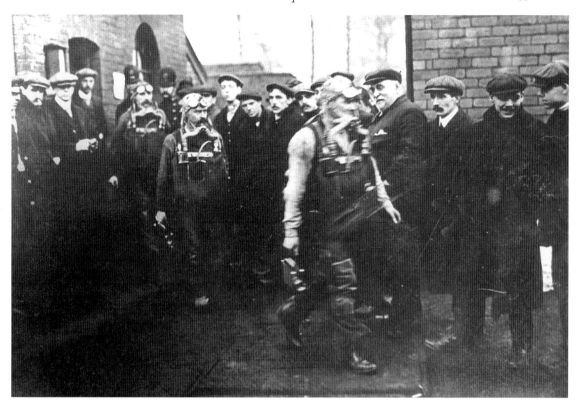

Above: A team of rescue men leave the rescue station near the colliery offices, heading off to No. 4 shaft where a single-rope winding arrangement had been set up. They are wearing the Fleuss re-breathing apparatus and carrying the recently designed electric inspection hand lamps. As all hope of finding anyone alive was realised by the day after the explosion, their main job was extinguishing fires, repairing air crossings and removing bodies.

Right: The Fleuss re-breathing apparatus as used by mines rescue men at Pretoria. Illustrated for the Hulton Colliery surgeon Dr W. A. Hatton's article for the *British Medical Journal* of 20 May 1911. The apparatus lasted for a minimum period of two hours' hard work, the wearer breathed the same air repeatedly. At each exhalation, the air was purified, and immediately before inhaling, a little oxygen was added to the purified exhaled air, to take the place of the oxygen absorbed into the body at the previous breath.

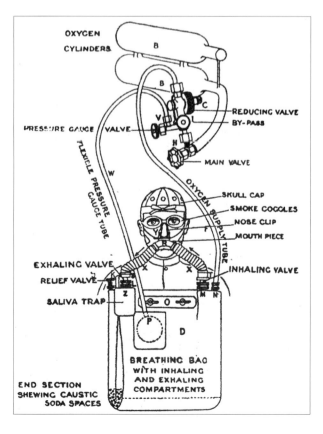

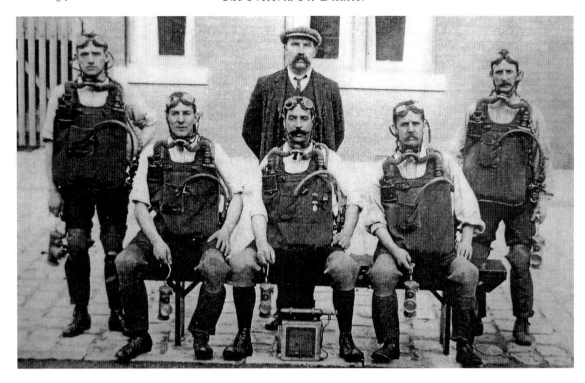

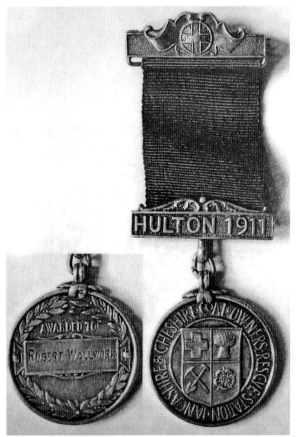

Above: Some rescue men were awarded medals by the Lancashire & Cheshire Coal Owners Rescue Station at Howe Bridge. Robert Wallwork was an example (seated front centre), his medal visible on his breathing set. He was born in 1880 at Little Hulton and was a member of the Bridgewater Collieries No. 3 team. He went down Pretoria with Bridgewater No. 1 team on 21 December 1910.

Left: The Howe Bridge Rescue Station medal awarded to Robert Wallwork for conspicuous gallantry. The ribbon is dark green. He was also awarded the Bolton Humane Society Medal.

He used to walk to work along a footpath which ran alongside the railway line branch serving the colliery. This took him 15 to 20mins and he was scheduled to start work at 8am. On the day he was only 5 minutes walk away from the pit when a loud bang was heard. He recalled seeing 'bits of the pit head machinery going skywards'. A locomotive heading for the pit gave him a lift. He soon realised that the pit head [No. 4 shaft] required attention before a suitable cage could be lowered. He arranged for himself to be lowered slowly, prior to any rescue attempt, to inspect the shaft. He said this did not take long. He reported that the shaft was clear and that he did not note any survivors. Another level [in No. 4 Pit] of the mine was still alright with miners ready to start any rescue [be rescued] once a cage could be ready. For his work James Polley received the Edward medal along with Alfred Tonge from King George the 5th.

At the North West Sound Archive, Clitheroe, a miner (name not recorded) involved in clear-up operations (as was my grandfather) to allow access for the bodies to be removed recalls the experience:

Well, the rescuemen were down before we went down. I was in the rescue team eleven years but not just at that time; the rescue team just belonged to the collieries. Each colliery practically had a working team of their own, do you see? I used to go down to Howe Bridge [rescue station] training at that time.

When I went down I went right to the coal face and there were a few men as I knowed [in] particular. Well, they were just asleep. Gas just come along and put them out, just fell asleep. Fresh, no cuts nor nothing on them.

The purpose as [we] went down for was to clear the way for the ambulance men to go in and bring the bodies out. So that was how I came to be in Pretoria. I had worked there

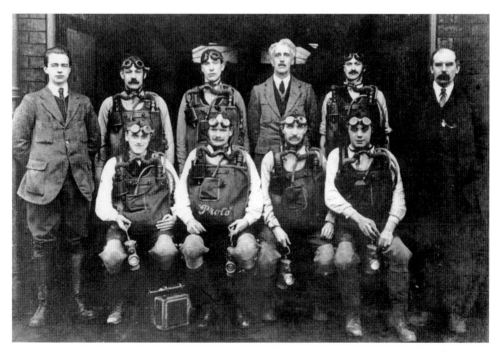

James Polley (left), here seen at Howe Bridge Rescue Station *c.* 1909 with probably a Hulton Colliery Co. rescue team, was the Surface Manager at Pretoria. For his work in travelling No. 4 shaft before any rescue attempts and then organising single-rope winding to be set up, he was awarded the Edward Medal (Mines).

before then and then I went back again and finished. When Chequerbent finished [1927] I were transferred back to Pretoria again so I had the last seven years there before Pretoria finished [1934].

Now my brother … uncovered a fellow, he knew him. He uncovered him and he said as he uncovered him, oh he said he tried to pull his clogs off because they had to pull something off to identify him you see. In the mortuary. As he pulled his clogs off his skin all come with it and he were covered with maggots, vermin were awful he said. Well they had to start working with eucalyptus rags round them you see [over their mouths]. And I think the wages were about six bob a day [30p] for that job. They wouldn't do it today for that [1970s].

This short account in the American magazine *Popular Mechanics* of March 1911 mentions the use of canaries in mines rescue operations at Pretoria, one of the earliest examples in British mining history:

CANARIES ACT AS MINE GAS DETECTORS

Caged canaries played a prominent part in the attempts made to reach the men suffocated by the explosion which occurred in a coal mine a few miles from Manchester, England, recently. Picked men from all the pits in Lancashire were rushed to the Pretoria pit, and gang after gang attempted to penetrate the passages and galleries. At the head of each gang or relief team were six men equipped with breathing helmets whose duty was to repair the broken ventilation doors so as to restore the thorough ventilation of the pit, and to report the first indications of gas. Their lamps, of course, gave them an idea as to the condition of the air, but in addition they carried canaries in cages, as these birds show signs of distress at the first presence of gas. The Pretoria pit disaster was the worst in England in many years, some 360 miners, among whom were many boys, being killed. The mine was one of the best equipped in Great Britain, the coal being mined by electric cutters instead of by blasting or shotfiring.

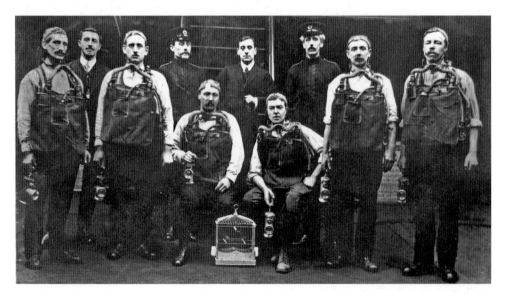

One of the many teams of rescue men who attended Pretoria, photographed at Howe Bridge Rescue Station. William Ewins stands far right, Station Superintendent Sgt-Major Hill stands third right at the back, his Deputy J. G. Huskinson is fourth left. Note the 'three decker' canary cage. The men are carrying Oldham & Sons of Denton electric hand lamps.

IDENTIFICATION REALITIES

Bodies began to arrive at the homes of those killed. The following account gives an insight into how people were very focused and strong facing up to the harsh realities of how their men and boys had died, along with identification difficulties.

> We got word that there was no hope of anyone being alive, and my dad was found on the fifth day and he was only about a hundred yards from the pit bottom. He was on his way in round the return airway, he was going that way. One side of his face was as if he'd been in the sun and he had one clog missing which we assumed after that, he had a foot blown off. And he was home on the fifth day but as far as I can remember he was not brought into the house, he was brought to the front door in the hearse and my brother and me went with him to see him buried in Westhoughton.
>
> Three weeks went, there were no signs of my other brother and it got that there was three hundred and forty two had been accounted for. Then Doctor Hatton, who was the officiating doctor for the colliery then, he came and he just said to my mother, 'Lizzie, I'm afraid we'll have to accept that Lewis your son is in the unidentified grave in the churchyard at Westhoughton.'
>
> He had hardly said these words when one of my dad's brothers came running in the back way. He said, 'Do you recognise these mum?' and he had two pads of cotton wool and inside it was a piece of green mingled stocking and it was a funny colour really.
>
> He said, 'Do you recognise this mum?' Mother was in bed.
>
> She said, 'Yes it's our Lewis's stocking.'

A St John's Ambulance man stands on guard outside the joiner's shop, now a temporary mortuary at Pretoria, stretchers stacked up behind him. After identification, coffins were transferred to the wagon repair shed under police guard due to others anxiously trying to identify their men and boys. The bodies were laid out in a long line along one side of the building; any clothing was wrapped in white calico alongside.

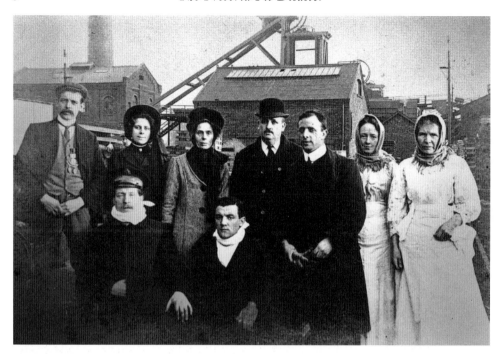

The colliery surface *c.* 23 December 1910. From the left, a rescue man, possibly John Hunt, with medal, Mary Caroline Bates, her mother Mrs Florence Bates, Mr Enoch Bates, a Salvation Army family. The body of their son Enoch Bates, twenty-three, was recovered on 24 December 1910. Next, the Belgian RC minister for Westhoughton, Father Adolphus Leopold Coelenbier. Far right, two mortuary women; in the foreground, two mortuary men.

> He said, 'Well, they've found him.'
> She turned to Doctor Hatton, she said, 'Now doctor if you'll go and see our Lewis – you know him, he has a tooth missing, he had it out the night before the explosion.'
> So Doctor Hatton went there and looked in our Lewis's mouth and there was the cavity. That was the only identification of him and he had been found in the sump [the lowest section of the pit shaft beneath the landing boards for the cage, where water collected] that's right in the bottom of the shaft, there were two floating in the water there. They brought him out and all the coffins were soaked in eucalyptus oil because the stench off some of them was terrible.

The joiner's shop at the colliery was made into an improvised mortuary to allow identification. Coffins were then transferred to the wagon repair shed under police guard due to relatives anxious to try and identify their men and boys. The bodies were laid out in a long line along one side of the building; any clothing was wrapped in white calico alongside. The *Bolton Evening News* noted the process of identification was slow, with a number of people showing deep mental anguish. They commented on the pathetic scenes outside the shed where Salvation Army men did much good trying to comfort grief-stricken women.

Hulton Colliery Co. hired a London & North Western Railway goods van, the colliery locomotive bringing it to the level crossing at Chequerbent where it was unloaded into awaiting hearses, twenty-five to thirty in a line.

A Westhoughton child remembered the impact on the town:

> … the man next door to our house was killed and when I looked across the road there were another there killed and in the row further up there were two killed. It was the same all over

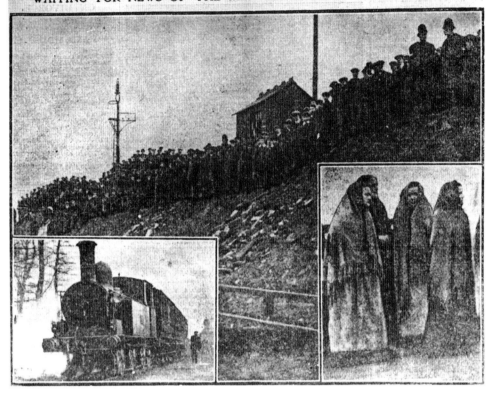

WAITING FOR NEWS OF THE MEN ENTOMBED IN PRETORIA PIT.

The *Bolton Evening News* shows the long line of relatives waiting for news at the eastern edge of the colliery site. Hulton Colliery Co. hired a London & North Western Railway goods van to carry the coffins to the level crossing at Chequerbent. There it was unloaded into waiting hearses, twenty-five to thirty in a line. The loco is a 0-6-2 'Coal Tank' of the type designed by F. W. Webb and built *c.* 1882.

> Westhoughton, part of Wingates Band, some of them killed ... It was really a depressed state there were coffins everywhere. There was an old painter down here as did paintings, he were doing oil paintings after the explosion, after the funerals he did portraits of those men that had gone.

THE IMMEDIATE AND ONGOING FINANCIAL COST TO THE COMPANY OF THE EXPLOSION

Some may be under the impression that when a colliery disaster occurred, free and voluntary assistance came from all directions. The official inquiry and inquest accounts of the Pretoria disaster praised the work of the mortuary women, rescue men, recovery workmen and the valued evidence and knowledge given by various mining experts and professionals who arrived on site. If we look at the Hulton Colliery Co. records held at the Lancashire Record Office, we find the company transferred large amounts into the newly created *Explosion Acct (No. 3 Pit)* to pay for all these services, all the rescue teams later charging for their work. As ever in these situations, the solicitors received disproportionately large amounts for their attendance.

1910

Dec 24	£400	[Paid into the account by chief cashier] Walter Tonge
Dec 31	£770.19.10	[Paid] wages expended [associated with] rescue work

1911

Jan 31	£620	[Paid into the account by chief cashier] Walter Tonge
	£1,987.11.11	[Paid] wages expended [associated with] rescue work
Feb 28	£3.0.0	J. Byrom [for a] coffin
	£22.10.0	Mortuary women
Mar 31	£10.0.0	Salvation Army
	£17.0.0	Jurymen's fees
	£110.14.1	Professional cost of shorthand notes by Peace & Ellis
	£63.1.3	Ditto for [the] inquiry
	£62.8.3	Sir Henry Hall [expert witness, equivalent to £3,500 today]
Apr 30	£99.10.11	Peace & Ellis [solicitors Wigan]. Services in connection with Home Office Enquiry
May 31	£7.0.0	Paid to mortuary women
	£629.3.7	Lanc & Chesh Coal Owners Rescue Station [Howe Bridge]
	£1.0.4	Eyre & Spottiswood [publishers] reports on [the] explosion
	£5.3.0	Mortuary women

EXPLOSION AT PRETORIA PIT.

List of Men from Bridgewater Collieries who attended

for Rescue or Ambulance Work.

December

21st – J. W. Dyson	10.40 a.m. to 3.15 p.m.– 5½hrs. underground.	
J. Potter	" " " "	
Adam Mull	" " " "	
H. Rowson	10.0 a.m. ")	
	& 7 p.m. to 4 a.m.)	
T. Barnes –)	Went to Pit at 10 a.m. and	
J. Grundy –)	stayed till 3 p.m.– did	
J. Evans –)	not go down. Went again	
	at 8 p.m., and were down	
	till 2.30 a.m.	
22nd – J. W. Dyson	6 p.m. to 2.15 a.m.	
J. Potter	8 p.m. but was not wanted.	
Adam Mull	" " " " "	
H. Rowson	6 p.m. to 9 p.m. (did not go down).	
T. Barnes	8 " " "	
J. Grundy	" " " "	
J. Evans	" " " "	

From the day of the disaster onwards, rescue-trained men arrived at the colliery from all directions. Here the Bridgewater Collieries (Farnworth, Walkden, Swinton, Worsley) team document their attendance. Note on the 22nd, some of the men were not needed, probably due to so many rescue men being at the pit, around 150 being available.

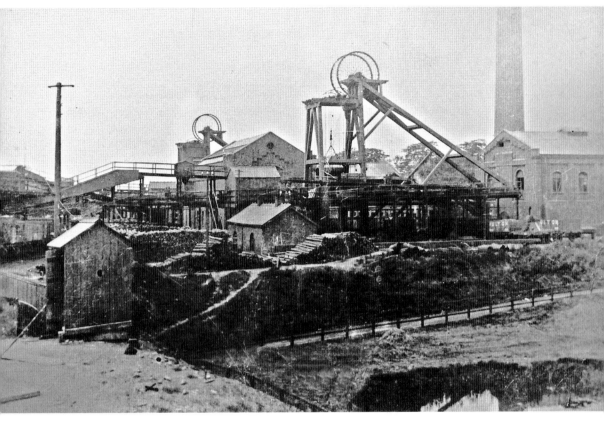

A view after the disaster from the east, probably a few months after coal production had resumed. No. 3 upcast pit headgear is now encased with timber cladding. The cage has arrived at the surface of No. 4 Pit, its Ormerod detaching hook visible within the headgear timbers. Note the large stock of pit props, close to the shaft ready for sending down the shaft.

Press Accounts

As soon as the news broke that an explosion had taken place at Pretoria Pit, the press flocked to the site, including, tantalisingly, 'cinematographers'. The thought that footage of pithead scenes may exist somewhere today in a vault is intriguing, but no amount of searching on the internet has revealed the whereabouts of the films produced. Press reports add a great deal to an account of the scenes after the disaster; they give the human angle totally missing from the dry accounts by the professionals involved. Care has always to be taken when relying on press accounts, as today.

The *Manchester Evening News* (*MEN*) in their edition of the day of the disaster stated that the explosion had been heard as far away as Bolton, three miles away. Six men had been found by noon, all near the shaft inset in No. 3 Pit. The rescue teams had arrived very quickly and rescue-trained men from neighbouring collieries were soon on the scene (so much so that some found themselves turned away, to return the following day). After repairing damage to the shaft fittings, such as guide ropes and structural timbers at landings, No. 4 Pit shaft was set up for single-rope winding. After a number of trial winds, a canary was wound down in a cage and left there for twenty minutes, being alive on winding back up again. Rescue teams then travelled the shaft.

The reporter for the *Farnworth Journal* (a weekly newspaper) of Friday 23 December recalls speaking to a survivor from No. 4 Pit:

'I was lifted clean off my feet ... and thrown some distance away where I lay unconscious and helpless for some time, until I was taken to the pit bottom and carried to the top.'

'How do you feel now?' asked the reporter.

'Oh, I feel better now, but I've got an awful headache.' [The effect of the afterdamp, post explosion gases made up of around 3 per cent carbon monoxide, 80–90 per cent nitrogen and 5–20 per cent oxygen.]

Grouped around the pit mouth are doctors from all parts, eagerly willing to aid in the work of rescue ... two of them are brave enough to go down with the rescue men, and as they come up it is difficult to recognise them, so coal begrimed and black featured are they. Clergymen of all denominations are watching and waiting in the hope of being able to give spiritual consolation to the dying; and to the living the Bishop of Manchester, after a prayer, addresses words of such comfort as are possible under the circumstances. On the platform are two representatives of an insurance company who have come with money to help the urgently necessitous cases.

One poor boy is brought, but he, alas, is dead and almost unrecognizable, so coal-black is he and so scorched and charred. Later John [No. 4 Pit undermanager] Bullough is brought in dazed and stupefied, and laid on some rugs. To him comes Lady Hulton, and asks him if there is any hope. 'Well my lady,' he replies, 'if you put things down at their worst I don't think you'll be far wrong.'

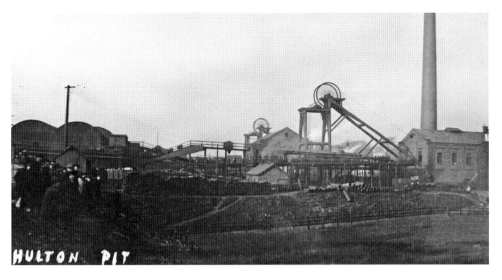

HULTON PIT

A view of the pit from the east soon after the explosion, crowds waiting on the pit waste to the left. The closest shaft is No. 4 Pit, the keen-eyed will note only one winding rope is in use due to damage.

TAKING HOME TWO RESCUED MINERS.

BN-235

A snapshot at the pit-head, showing two of the miners being conveyed home after their escape from the mine.

"Evening Chronicle"

The image is very poor but the content fascinating. The *Manchester Evening Chronicle* is showing one of two miners, still in their pit dirt, from No. 4 Pit being given a lift home in a car. The vehicle was a Bolton-registered Beeston Humber Lightyear two-seater. The other miner must have been sat in the boot.

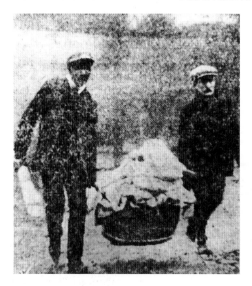

Bandages being delivered to the colliery. Before all hope was lost, the medical team had expected to be very busy. A few of the survivors close to No. 4 Pit shaft suffered blast-wave injuries.

'Have they getten onny moore eawt yet Mestur?' [for those in need of a translation this is 'Have they got any more out yet mister?'] asks one old woman of seeming three score years and ten. 'No' is the reply.

'Have you got someone there?' 'Aye I've getten two sons, and they're a' I have. I durn't know what I'm to do beawt 'em' and the tears start again from her eyes.

The *MEN* (Wednesday 21 December) stated that upwards of twenty doctors were present but

… haunted by grave fears that their services may not be required. On the main road from Bolton business seems to have been entirely suspended. Everywhere groups of people stand discussing the awful event and many women are in tears. Round the shaft officials and employees are working with feverish intensity, but the moments pass with painful slowness. Orders have just been dispatched for enormous quantities of food to be ready if the gravest fears are not realised. Shortly before noon we learned from the firm owning the mine that the men working in adjacent pits [the 545 men in No. 4 Pit] had been withdrawn.

Practically all the mining engineers of the district are on the spot and it is the most experienced of these who give the least hope. There were unusual scenes at Great Moor Street Station, Bolton this morning about eleven o'clock, when a large crowd gathered in anticipation of the injured men being brought to the town. The first arrivals from the pit who were not hurt came out, and carefully bore from one of the carriages two of the men who had apparently been badly hurt by the explosion. There were many of the collier's friends in the vicinity, and especially pathetic was the spectacle of two women who with pallid faces anxiously scanned the faces of the men, and failing to find those they sought eagerly asked for information about the missing ones.

The tunnel linking No. 3 and No. 4 shafts was found to be blocked due to roof falls, the rescue men clearing this amidst fires.

The *MEN* (Thursday 22 December) covered the inspector John Gerrard's announcement that all hope of finding anyone alive had been abandoned. Speaking at eleven o'clock that morning he said,

'There is no hope, absolutely none. Not the slightest shadow of hope at all of anybody being alive. It would be cruel to say anything else.'

Mr Gerrard briefly described the work which had been done since midnight. At two

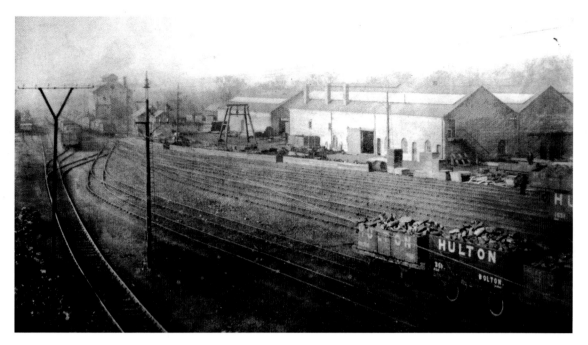

1. An early view to the north-west of the screens, lines and workshops at Pretoria Pit, *c.* 1904. Hulton Collieries had their own wagon works south of Hunger Hill near Pendlebury Fold. It has been suggested the large coal (possibly Trencherbone) loaded in the wagons may be for locomotive use. (Harry Forshaw)

2. It's only a brick, but the name Hulton across it for many will always remind them of the Pretoria Pit disaster. Made around 1900 at the Hulton Brickworks, Pendlebury Fold, near Hunger Hill. (Alan Davies)

3. Westhoughton Library and the Carnegie Hall above it were built with the aid of a grant from the Scottish philanthropist Andrew Carnegie, being opened on 24 March 1906. Winston Churchill appointed Richard Redmayne, Chief Inspector of Mines, to chair the Home Office Inquiry, which would take place as soon as possible after the inquest. Churchill reassured Parliament that witnesses would be safe to speak as they wished and any cases of intimidation would be dealt with. The Coroner's Inquest was adjourned on the day of the explosion until 336 bodies had been gradually found and identified, by 13 January 1911. Proceedings began on 24 January 1911 and concluded on 13 February 1911. The Home Office Inquiry proceedings began on 20 February 1911, concluding on 9 March 1911. (Alan Davies)

6. A magnificent signed record of inquest barrister Samuel Pope, Inspector of Mines John Gerrard and Robert Nelson, the first Electrical Inspector of Mines. Robert was to focus his attentions on switches for conveyors, which may have been subject to sparking. A personal hero for me has to be John Gerrard. He may have been a diminutive man but was certainly a giant in terms of being a totally devoted and professional mines inspector who had attended many disasters. His most recent was at the Maypole Colliery, Abram, near Wigan, on 18 August 1908, where seventy-five men and boys died. Note his heavyweight jacket with numerous pockets for notebooks and equipment, also the camera in his hand. His wearing of a leather skull cap harks back to a previous mining era. The weekly *Farnworth Journal* reported on 31 December 1910 that he had on one day previously worked for fifteen hours with only a one-hour break. (Bolton Museum collections)

Far left: 4. A fossil from the Yard seam workings at Pretoria Pit. The fern is *Sphenopteris* and is around 260–300 million years old. This fern grew in tropical forests located near the equator at that time. Approximately five inches across. (Alan Davies)

Left: 5. A detail of the Yard seam *Sphenopteris* specimen. (Alan Davies)

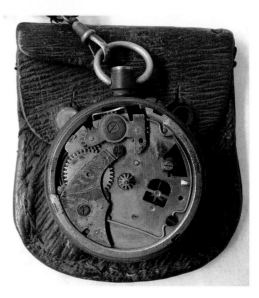

Above left: **7.** John, Richard and Thomas Wild were working very close to No. 2 North Plodder coal face, advancing an air road at the face end and building stone packs. Chief Inspector of Mines Redmayne concluded that the explosion occurred at this point where the intake (fresh air) roadway for No. 2 North Plodder met the face. This watch belonged to one of the Wilds; it has stopped six minutes after the explosion, distorted due to the great heat. (Bolton Museum collections. Photo Alan Davies)

Above right: **8.** Another of the watches found with the terribly disfigured Wild bodies. A cheap, pin-set unjewelled movement. The glass and face have been blasted away; parts of the movement structure have been blued with the intense heat. (Bolton Museum collections. Photo Alan Davies)

9. Memorial tissue listing the dead and the latest amount raised for the dependants. Designed by the energetic and possibly eccentric fundraiser for the Mayor of Bolton's Fund, C. W. Lloyd of Derby Street, Bolton. He was a taxidermist by trade. (Photo Alan Davies)

10. Another version of the memorial tissue, this one published by Palatine Printing of Wigan. This mentions William Turton dying during the rescue operations. (Bolton Museum collections. Photo Alan Davies)

11. Version three, published by S. Burgess of London, including the King's message and listing the dead by their home location. (Bolton Museum collections. Photo Alan Davies)

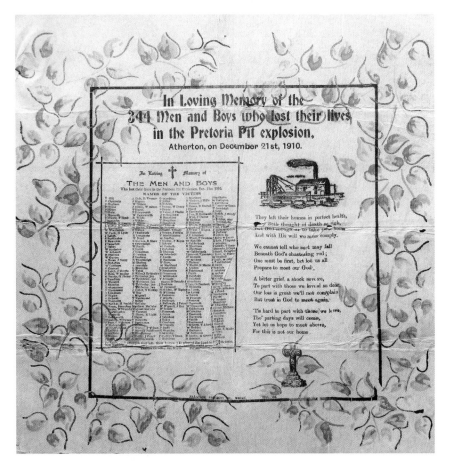

12. Another Palatine Printing, Wigan version. (Photo Alan Davies)

13. John Herring was thirty-one at the time of the disaster and one of the first men below ground when a further explosion may have occurred. As a result he was awarded the Edward Medal for gallantry in mines, the St John of Jerusalem Life Saving Medal, the Royal Humane Society Medal and the Bolton & District Humane Society Medal. He died in 1943. (Medals purchased by Bolton Museum & Art Gallery in 1984.)

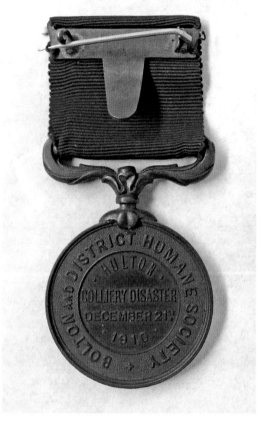

Above left: 14. The Edward Medal for Gallantry in Mines awarded to John Herring. The King said that it was one of the first he had awarded. (Alan Davies)

Above right: 15. John Herring's Bolton & District Humane Society medal stamped with the disaster details. (Alan Davies)

Left: 16. John Herring's Royal Humane Society medal. (Alan Davies)

Above left: 17. John Herring's St John of Jerusalem Life Saving Medal. (Alan Davies)

Above right: 18. The disaster memorial in Westhoughton Cemetery, unveiled on 25 November 1911. (Alan Davies)

Left: 19. Detail from the Westhoughton Cemetery memorial. (Alan Davies)

Sacred
to the memory of
344 MEN AND BOYS WHO LOST
THEIR LIVES BY AN EXPLOSION
AT THE PRETORIA PIT OF THE
HULTON COLLIERY C° ON
THE 21ST DECEMBER 1910, 24
OF WHOM SLEEP UNDER THIS
MONUMENT, BEING UNIDENTIFIED
AT THE TIME OF BURIAL.
THIS MONUMENT IS ERECTED
BY PUBLIC SUBSCRIPTION, AS A
TOKEN OF SYMPATHY WITH
THE WIDOWS AND RELATIVES
OF THE VICTIMS, 171 OF WHOM
ARE BURIED IN THIS CEMETERY,
45 IN WINGATES, 20 IN DAISY
HILL, 3 IN THE CONGREGATIONAL
CHURCHYARDS, AND THE
REMAINDER IN VARIOUS
BURIAL GROUNDS.

"BE YE THEREFORE READY ALSO,
FOR THE SON OF MAN COMETH
AT AN HOUR WHEN YE THINK NOT."
ST LUKE XII. 40.

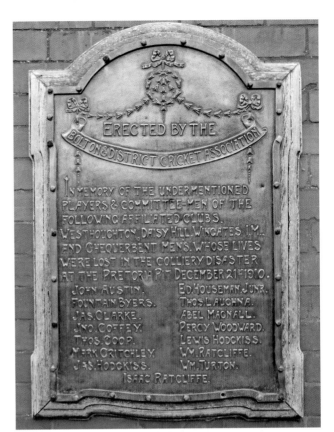

20. Bolton & District Cricket Association memorial on Westhoughton Town Hall. The men listed played for Westhoughton, Daisy Hill, Wingates and Chequerbent cricket clubs. (Alan Davies)

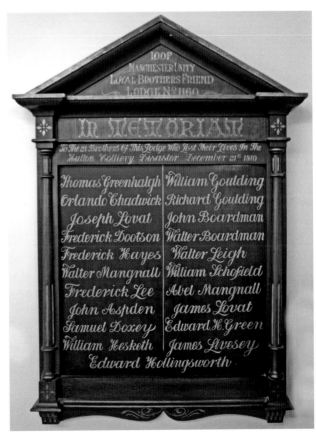

21. Memorial for the members of the Independent Order of Oddfellows, Manchester Unity Loyal Brothers Friend Lodge No. 1,160, Wheatsheaf pub, Westhoughton. Now on display at Westhoughton Library. (Alan Davies)

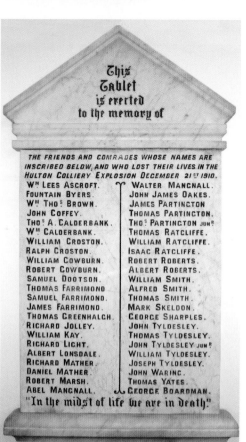

THE FRIENDS AND COMRADES WHOSE NAMES ARE
INSCRIBED BELOW, AND WHO LOST THEIR LIVES IN THE
HULTON COLLIERY EXPLOSION DECEMBER 21ST 1910.

Wᴹ LEES ASCROFT.　WALTER MANCNALL.
FOUNTAIN BYERS.　JOHN JAMES OAKES.
Wᴹ THOˢ BROWN.　JAMES PARTINGTON
JOHN COFFEY.　THOMAS PARTINGTON.
THOˢ A. CALDERBANK.　THOˢ PARTINGTON JUNᴿ
Wᴹ CALDERBANK.　THOMAS RATCLIFFE.
WILLIAM CROSTON.　WILLIAM RATCLIFFE.
RALPH CROSTON.　ISAAC RATCLIFFE.
WILLIAM COWBURN.　ROBERT ROBERTS.
ROBERT COWBURN.　ALBERT ROBERTS.
SAMUEL DOOTSON.　WILLIAM SMITH.
THOMAS FARRIMOND　ALFRED SMITH.
SAMUEL FARRIMOND.　THOMAS SMITH.
JAMES FARRIMOND.　MARK SKELDON.
THOMAS GREENHALCH.　GEORGE SHARPLES.
RICHARD JOLLEY.　JOHN TYLDESLEY.
WILLIAM KAY.　THOMAS TYLDESLEY.
RICHARD LICHT.　JOHN TYLDESLEY JUNᴿ
ALBERT LONSDALE.　WILLIAM TYLDESLEY.
RICHARD MATHER.　JOSEPH TYLDESLEY.
DANIEL MATHER.　JOHN WARING.
ROBERT MARSH.　THOMAS YATES.
ABEL MANGNALL.　GEORGE BOARDMAN.

"In the midst of life we are in Death."

22. Wingates Independent Methodist Chapel
memorial. Ten were members of the chapel when they
died, the other thirty-six had been members in the
past or removed to another circuit or been connected
through their families. The memorial was saved when
the church closed on 6 May 2001. (Alan Davies)

23. The Lancashire & Cheshire Coal Owners Rescue
Station (Howe Bridge) medal. The station was opened
on 2 April 1908, situated at the bottom of Lovers Lane.
A special award of the medal was made after the Pretoria
disaster to certain rescue men (see the Robert Wallwork
medal with the Hulton 1911 bar). (Alan Davies)

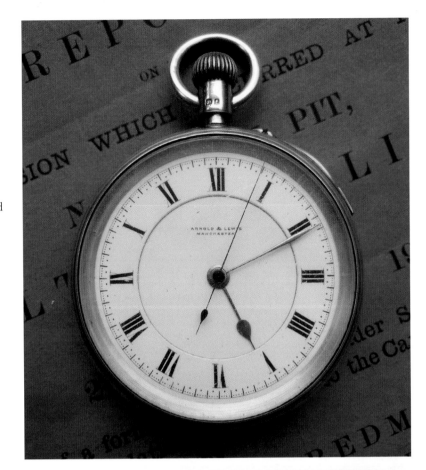

24. A silver pin set pocket watch with seconds hand. Presented to Police Sergeant William Brown from Coroner Samuel F. Butcher. The Coroner praised the work of Sergeant Brown, who had kept a detailed list of bodies and their possessions arriving at the surface. This was to be crucial when identification of the badly burned or disfigured was not possible. (Courtesy Harry Forshaw. Photo Alan Davies)

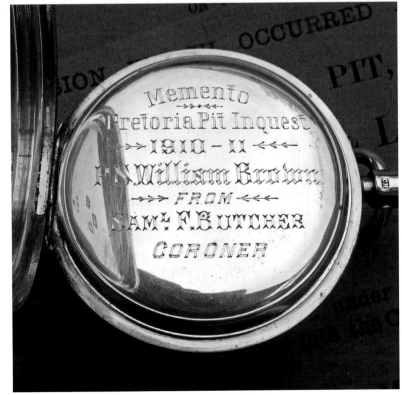

25. The inscription on the dust cover that transforms this medium-quality watch into something very special. (Courtesy Harry Forshaw. Photo Alan Davies)

26. A 'pigtail scotch' found on the Pretoria Pit site in the late 1980s. This was jammed into the side of tub wheels to stop them. The loop hanging down protected the man's hand from contacting the tub wheel. Looking at the very detailed colliery auction catalogue of 1934, there is every chance this was below ground at the time of the disaster. (Alan Davies)

27. In 1909, Bamforths of Holmfirth produced a series of four postcards around the 'Don't Go Down The Mine Dad' poem/song. This is card number one in a later series and includes an image of Pretoria No. 4 Pit headgear with added flames. The series was reissued a few more times afterwards.

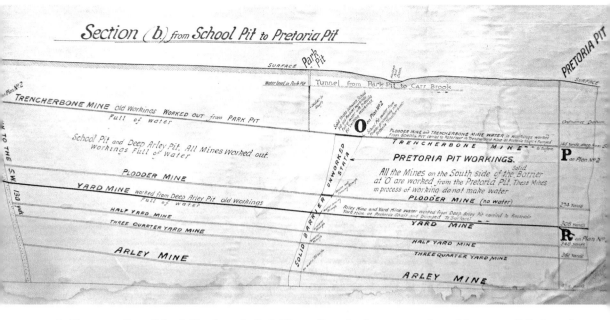

28. The strata from School Pit, through Park Pit, to Pretoria shown on a plan of June 1913. Pollution of watercourses by Hulton Colliery Co.'s pits was cited by the Laburnum Spinning Co., Atherton, and four mills at Bedford, Leigh. Note the section of waterlogged strata left unworked to the rise of Pretoria's workings.

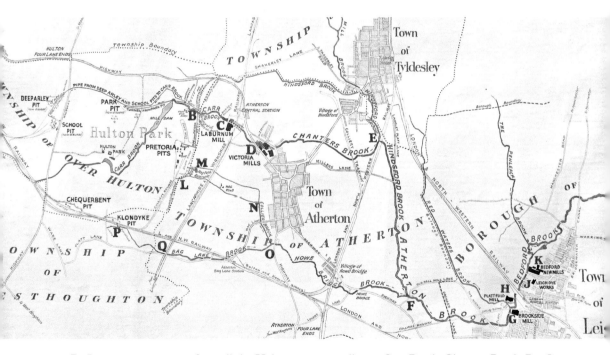

29. By June 1913, mine water from all the Hulton pits was polluting Carr Brook, Chanters Brook, Bag Lane Brook, Howe Bridge Brook, Hindsford Brook and Atherton Brook, resulting in legal action and remedial treatment of the mine water by the company.

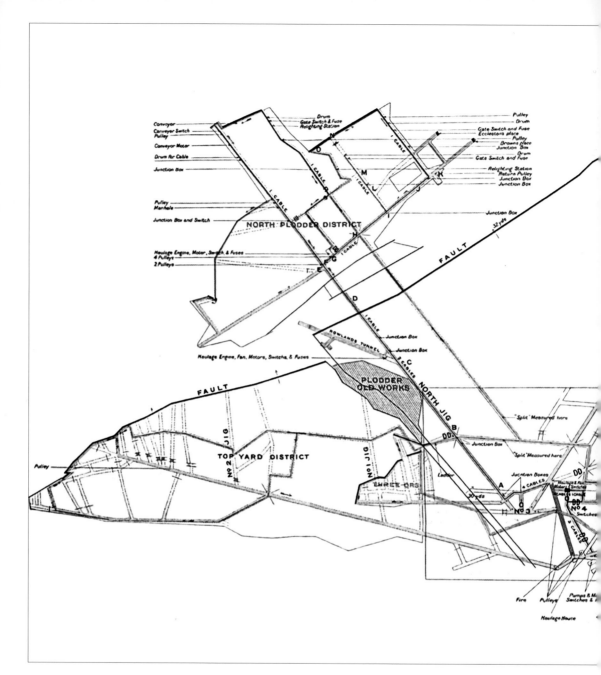

30. The plan of the workings at Pretoria Pit included in the official inquiry. A very large-scale version of this was used at the inquiry in the Carnegie Hall to be visible to the large attendance. From the left: the Top Yard workings, top left the North Plodder explosion district, on the right the South Plodder workings, and close to No. 3 shaft the Three-Quarters workings. Note the long 'Jigs' or haulage roads feeding the shafts making use of the strata inclination. Blue-tinted roads are intake air, yellow are return airways.

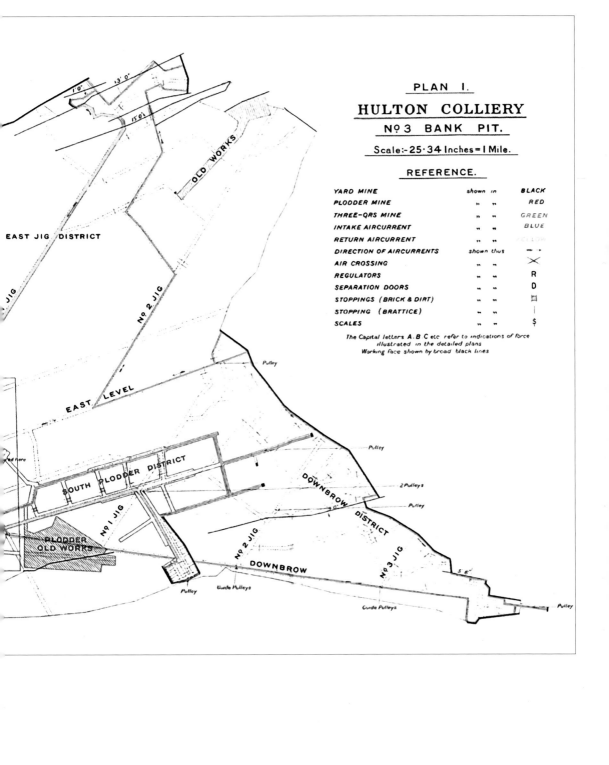

PLAN I.

HULTON COLLIERY

№3 BANK PIT.

Scale:- 25·34 Inches = 1 Mile.

REFERENCE.

YARD MINE	shown in	BLACK
PLODDER MINE	,, ,,	RED
THREE-QRS MINE	,, ,,	GREEN
INTAKE AIRCURRENT	,, ,,	BLUE
RETURN AIRCURRENT	,, ,,	YELLOW
DIRECTION OF AIRCURRENTS	shown thus	
AIR CROSSING	,, ,,	✕
REGULATORS	,, ,,	R
SEPARATION DOORS	,, ,,	D
STOPPINGS (BRICK & DIRT)	,, ,,	
STOPPING (BRATTICE)	,, ,,	
SCALES	,, ,,	$

The Capital letters A. B C etc refer to indications of force
illustrated in the detailed plans
Working face shown by broad black lines

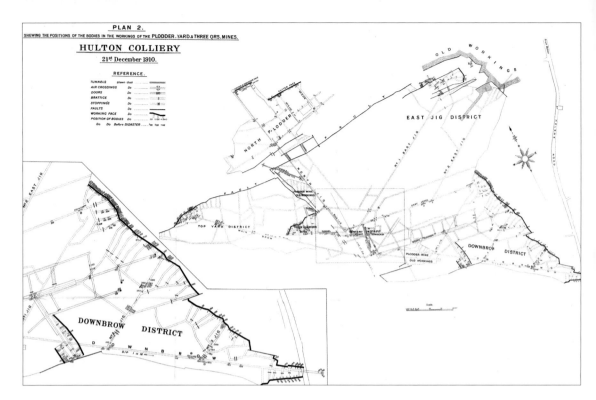

31. A plan drawn up through the work of the mines inspector John Gerrard showing the workplaces of men before the explosion (numbered in black) and the location of bodies after the explosion in red. The injuries sustained by men along with the distances some walked after the explosion was vital in working out the origin of the ignition. One can only wonder how many survived for a few minutes after the explosion only to be overcome by carbon monoxide. St Helens Road (on the surface) can be seen far right.

32. Massive winding house engine beds at Pretoria No. 4 Pit, photographed in October 2010. Two cast-iron engine beds 38 feet long were mounted on top of these brick foundations. A horizontal twin-cylinder steam winding engine by Pearson & Knowles Coal & Iron Co. Ltd, with cylinders 36 inches diameter by 6 feet stroke, was mounted on top of the beds. The winding drum was 18 feet diameter x 8 feet 9 inches wide. (Alan Davies)

o'clock this morning, he said, parties of explorers, led by Mr Robinson, manager of the Haydock Colliery [Collieries], and numbering altogether twenty men, went down to examine the Down Brow of the Yard district, the largest of the five sections into which the pit is naturally divided. Here 150 bodies are probably lying.

Rescue teams were drawn from the following colliery companies:

Abram [Colliery Co], Maypole [Colliery]
West Leigh [Colliery Co]
Bridgewater [Collieries and Wharves Ltd, Worsley]
Ackers Whitley [Bickershaw Collieries, Leigh]
Moss Hall [Colliery Co, Wigan]
Pearson and Knowles Collieries [Ince, Wigan]

Ventilation was improving, reinstatement being hampered by having to deal with the many extensive falls of roof. Mr Arthur Rushton, manager of Maypole Colliery, Abram stated that fresh air was now nearly reaching the coal faces.

The article mentioned that colliers were back at work in the other Hulton collieries. One can only wonder what the reasoning for allowing that might have been: financial on behalf of the workforce who could not afford to be unemployed without any form of benefits, financial as regards the company in general, or more controversially sheer contempt for human life.

Charles Fazackerley, a West Leigh boy working in the Three-Quarters seam, recalled the events surrounding the death of Richard Clayton, head fireman in the No. 4 Arley district. The dramatic and sudden variation in air quality between the explosion districts and those districts accessed via No. 4 shaft where the survivors worked is seen vividly in this account:

> I was working about 300 yards from the Arley shaft [No. 4] and away from the Yard mine when the explosion happened. The noise was like the fall of a heavy load of coals. After the noise came clouds of black dust, which covered our safety lamps and made the light dimmer but did not put it out. Mr Jobson, our fireman said; 'It is only a fall of roof', I said; 'It is a pretty big sound for a fall of roof'.
>
> John Rigby, a young man was with me. We picked up our lamps and headed for the mouthing [the shaft inset with access to the cages]. We met Richard Clayton, the head fireman, now dead, and he said; 'Run towards the fan, you will be safer there, I will knock for the cage when I get back to the pit eye.' We turned back from the tunnel and made towards the fan, and about 18 or 20 others came with us. The air kept going worse. We stopped for about an hour and a half near the fan, and then the word was passed that Richard Clayton was dead. We went towards the mouthing and where the ventilation doors were blown down we found him with his arms spread out near a tub, dead. Some of the drawers [men who pushed pit tubs around] said they heard him say; 'Oh my I am done' and then he fell down. He had gone nearer towards the Yard [district] than we did and he was going in that direction when he turned us back over an hour before. He was nowhere near the Yard mine when we found his body. I got out nearly two hours after the explosion.

A miner wrote into the *MEN* (Thursday 22 December) and asked the following questions:

1. How much longer are miners going to risk their lives in working under conditions that are not conducive to their safety by working in places where there is known to be an accumulation of gas?
2. How much longer are we to be told that the accident was caused by a defective safety lamp?
3. And how much longer are the provisions of the Coal Mines Regulation Acts [1887] to be carried out by firemen and others, who are not in the employ of the owners of the mines,

and who are handicapped to a very large extent, by having to sign records daily which they know are not a correct and true account?

The editorial of this issue commented on the lot of the miner in his daily work and the bravery of the rescue teams:

> These occasions always bring out the most magnificent qualities of the miner. Their unflinching courage is in a sense grander and more impressive than that of the soldier who risks death under other and more exciting surroundings. In the dark passages through which the miners have to work their way they face death by explosion, by gas, by suffocation, and by falls without caring for risk or thinking about exhaustion. Their heroism and chivalry are always such as makes the world wonder. They are beyond praise. The general public do not from practical experience know exactly what a colliery accident like this is. They never go down coal mines, and they are ignorant of the depressing conditions under which work is carried out.

The *MEN* (Friday 23 December) included an illustration headed in bold type HELP! with a female vision of Charity to the left and a bereaved woman, wearing a shawl, in need of support. The issue mentions the colliery locomotive giving distressed and tired women lifts from Chequerbent to the pit and back. One woman who was so affected by identifying a body in the mortuary shed was seen to fall back into the arms of a Salvation Army officer, and was carried away to recover. Some 120 police officers were on duty at the pit, working in three shifts of eight hours each. Chief Inspector of Mines Professor Redmayne arrived at the colliery at noon, the delay due to illness.

PET COLLIERY?

In a very curious use of words, a short piece in this issue stated that the colliery was regarded by Mr Brancker, the managing director of the Hulton Colliery Company, as 'a pet'. They had, the piece stated, 'got everything of the latest pattern in the mine, and they had done everything they possibly could to avoid an explosion. They thought they had a colliery which would be the very last mine in the country to have such a terrible affliction.'

The *MEN* (Saturday 24 December) described the decision to reverse the air current at the colliery. This technique had been used as a temporary measure at collieries in emergencies, after explosions or fires, to extinguish the flames. The mines inspector John Gerrard explained the need for this at Pretoria, to enable rescue men to work in the gassy and hot return airways where bodies awaited recovery.

Rescuers recalled as they came to the pit bank that

> almost in one heap were 17 bodies, with 60 others pinned down close by. One man was [found] in the act of striking his pick into the coal, which showed that death had been very sudden. Another had his false teeth in his hand, and one or two were sitting with their tins in their hands as though they were about to drink.

The rescuers said the bodies (some of them) were fearfully mangled, and the sight of them was enough to make anyone cry. The rescue party came across two men holding hands as though aware of their fate and 'saying their last farewell'. The arduous nature of the rescue work was noted where, due to roof falls, a distance of 300 yards near the coal face took nine to ten hours to traverse. The newspaper stated that more than a thousand women and children had been bereaved.

The half dozen doctors on duty were trying to piece together and make more presentable the 'wrecked and mangled bodies'. 'Theirs was a dreadful work indeed, but they went through it unflinchingly, placing shattered limbs in position.'

Sergeant Brown's work carried on into Christmas Eve, all these men being identified. Property was not listed by now; most of these men were gassed and identification was easier than those suffering from severe burns or explosion violence.

Christmas Day and the bodies continue to arrive at the surface.

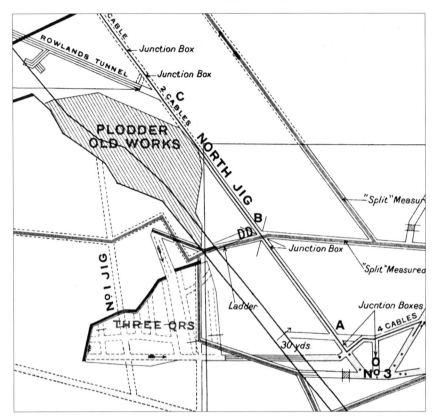

The small Three-Quarters seam district (lower left) intake and return roadways along with Rowlands Tunnel (top left).

A coffin is carried through the streets of Westhoughton. Although a very poor image, this is one of only two surviving showing funerals.

It was noted that coffins were in short supply and temporarily the resources of all the local undertakers were not sufficient. Men who could not be identified were often named by their metal tallies found close by. Funerals at Westhoughton church contained throughout the day, eighteen services for twenty-one bodies taking place, the church bells ringing constantly. About forty gravediggers were in attendance.

The *Daily Sketch* had been established in 1909 by Edward Hulton. The tabloid ran extensive multiple-page coverage of the human angle of the disaster, with many photographs of those bereaved and also the men and boys killed. The edition of 24 December reported the King and Queen sending £60 to the relief fund, and the opening of the inquest in the colliery engine room.

'He was always singing, but he'll sing no more,' said a bereaved relative yesterday of a little pit boy. William Naylor, who lies with the men who were entombed in the Atherton pit. Little Naylor was a happy lad with a clear treble voice, which made him very popular among the workers in the Pretoria pit. When the colliers were resting they used to call this little pit boy of fourteen to sing for them down in the dark workings. Many a day he came home, his pockets lined with coppers which had been given him for singing to the miners in this way.

The *MEN* (Tuesday 27 December) headed its feature on the disaster 'A Black Christmas' and described the sad scenes in Westhoughton as funerals continued. They commented on the fact that many families could not afford, even if they wanted to, to have a Christmas dinner. The paper commented on the generosity of neighbours who had not lost members of their family and how they helped out those in mourning.

In the main people kept to their houses, but now and again one would see a kindly disposed woman hurrying across the road with a jug of steaming tea and a basket of food for some poor stricken and half-demented woman.

The Mayor of Bolton's Fund had reached £12,214 10s 3d, including the latest amount sent from the Mayor of London's Fund.

The *MEN* (Wednesday 28 December) listed recent donations to their fund. This included many collections taken at Christmas parties as well as the following:

Spontaneous collection from Mount Pleasant Church, Glossop, after song 'Don't Go Down in the Mine, Dad' sung by Miss Alice Pickford	£1 0s 3d
Moss Side Wesleyan Sunday School	£0 11s 0d
Mrs B's Christmas party	£0 5s 0d
Found in plum pudding, Clarendon Road	£0 4s 0d
No name	£0 1s 0d

The *Farnworth Journal* (a weekly) of Friday 30 December 1910 stated that the previous day the rescue teams from Astley and Tyldesley Collieries Ltd had spent seven hours in the North Plodder district where the explosion was suspected of originating. Starting duty at 1 a.m., the men set to work resetting props and extending air pipes to clear out large pockets of gas. The men came across six bodies during their shift.

Two French journalists visited the pit. They had recently reported on the Courrières mine disaster, Europe's worst mining accident with 1,099 miners killed on 10 March 1906. They spoke good English and managed to discuss the situation with 'officials of a more polished utterance', but when they tried to speak to colliers, they had broad Lancashire dialect to deal with. 'Dramatic gestures with the hands and frantic attempts to throw light on a remark like "deawn yon theer brow" [down that there inclined roadway] were unavailing. The puzzled Frenchmen had to give it up.'

Bolton taxidermist C. W. Lloyd was an energetic fundraiser for the Mayor of Bolton's Fund, here allowing children to climb onto his stuffed zebra, dog, lion and tiger on the steps of Bolton Town Hall. He also published the postcard of the three 'survivors' of the explosion (only two were actually from the explosion district) with the latest fundraising amount overprinted.

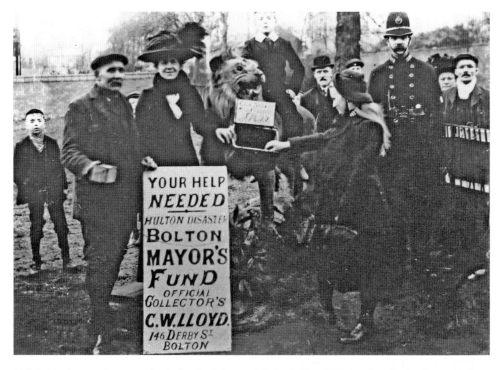

C. W. Lloyd at work raising funds for the Mayor of Bolton's Fund. He lived in Derby Street, Bolton, where two of the men killed lived and possibly knew them. Behind, a young boy has a ride on the lion for a penny or two.

The latest donations to the Mayor of Bolton's Relief Fund were described, the Fund now standing at over £20,000 (equating to about £1.5 million in 2010). Donations came from the whole of Britain virtually and not just mining districts; they ranged from a few pennies given to local collecting boxes to £500 and included:

His Majesty The King	£500
N. M. Rothschild & Sons London	£500
The Lord Mayor of Bradford	£305
David Davies MP	£305
The Lord Provost of Glasgow	£105
Sir William Hulton	£105
The Central Mining Association of France	£100
Her Majesty the Queen	£100
Queen Alexandra	£100
Lord Derby	£100
Halifax Town Council	£100
Thomas Cook & Sons	£100
Glass Houghton and Castleford Collieries	£75
Bolton Operatic Society	£52
Countess of Derby	£50
Bolton Co-op Society (1st donation)	£50
Westhoughton Gas Co.	£50
The Mayor of Gloucester	£50
Christmas Day collection at St Matthews Church Torquay	£30.14.9

Miners working for Westhoughton Coal & Cannel Co. (including my grandfather) were members of the Lancashire & Cheshire Miner's Federation. Their branch voted to grant £20 to those men who found themselves unemployed through the disaster.

The resumed inquest was reported on and included William Mawson of Walker Street, Westhoughton, stating that his son Richard Seddon (twenty-four) had complained many times of gas:

The Coroner; 'What has he said?'
Reply; 'He said they would all be blown up and it would be a worse 'do' than the Maypole. [Abram, 18 August 1908, seventy-five men and boys killed]. He said it many times in the house.'

A ten year old boy identified his father, James Schofield of 7 Georgina Street, Daubhill. The deceased's brother, who lived at 30 The Valley, Atherton, was taking care of him. The Coroner agreed to reimburse the brother for funeral expenses from any money due to the children but advised him not to be too lavish on mourning apparel!

It was reported that the events were attracting undesirables in the hope of earning money or obtaining free food. A member of the exploration parties found his silver watch had been stolen and pockets rifled when he returned to the surface.

In the Salvation Army newspaper *The War Cry* (31 December 1910), a special correspondent recalled the events:

Among the first to arrive on the scene were members of the Atherton Corps. Every entrance to the colliery was guarded by police. Beyond this line the public were not allowed to pass. The wearers of the Salvation Army uniform were, however, instantly recognised and admitted. As we passed in and out among the workers and heard continually the rumble of the undertaker's van; as we saw the long row of coffins in one shed and the forms of

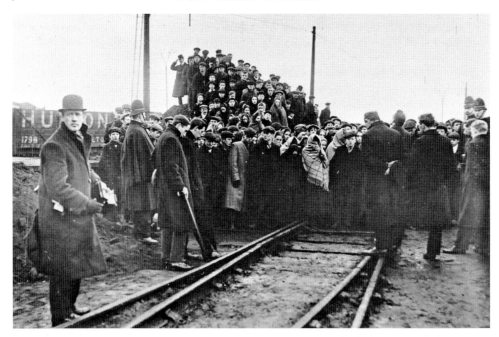

A Salvation Army service at the pit, possibly on the day of the explosion. The Atherton Corps were first to attend the site. The army carried out a vital task, comforting those waiting for news, and also those newly bereaved after identification of bodies.

the six identified bodies in another; the arrival at the pit-head of many other broken and blackened bodies, all of which were laid tenderly in their appointed places, our minds turned to the sorrowing relatives. It will be a black Christmas for them. One local Salvationist was amongst the dead, Arthur Bates of Bolton.

Some of the bereaved were still turning up at the colliery six days after the explosion. 'Oh my poor mother! If I could only take some hope and help back to her!' moaned a poor girl, whom Captain Williams endeavoured to comfort. This girl had lost at one stroke father, four brothers, two uncles and two cousins. Another young woman, who was married but twelve months, and who hugged a baby to her breast, was only persuaded by an officer to leave the pit mouth and go home after waiting a whole day and night for the husband she is never more to see alive.

The *Farnworth Journal* (31 December 1910) recalled aspects of the events of the disaster including the fact that, after the explosion, colliery manager Alfred Tonge had spent nearly twenty-four hours involved with rescue work below ground, being partly gassed in the process, and that John Gerrard, Inspector of Mines, had worked for fifteen hours with only a one-hour break.

One man tried to cheer the waiting crowd up with a song. A man whose brother was dead in the pit came across, spoke to the man and punched him; the man sloped off. Amongst one of the first rescue parties to descend was William Turton, a fine old collier who had two sons below. So eager was he in his efforts that he got some distance in front of his comrades and paid for his anxiety with his life. When the others overtook him they found the old man asphyxiated, a victim to the deadly black damp (actually he had been fire fighting and had succumbed to post-explosion afterdamp while his colleague had not), the aftermath of the explosion.

Few of the professionals involved in one way or another with the disaster openly expressed true empathy with the experiences of the mining communities involved, the exceptions being

Dr Hatton, Chief Inspector Redmayne and the Rev. A. L. Coelenbier, the Belgian rector of Sacred Heart RC Church, Westhoughton. On 1 January 1911, he recalled to a journalist;

Two men of my parish, after the early Mass, called upon me to say that according to reports a serious explosion had taken place at one of the Hulton Colliery pits, known as 'the Pretoria Yard Mine', and that 350 lives were lost. I appealed to a well known gentleman who took me in his trap, and set off quickly to the exploded mine. However when about half way the motor carriage of Dr Hatton of Westhoughton came up under the charge of the chauffeur … and I was soon conveyed to the scene of disaster.

All along the road I saw hundreds of people, men, women and children running as fast as they could. When approaching the pit I beheld crowds of poor creatures, some had their hands lifted heavenwards, others had their heads bowed, some again were crying bitterly, especially women with babies in their arms, while others exclaimed 'the Catholic Priest is here'.

On arriving at the top of the pit brow about nine o'clock I was then the only priest present, and I at once discharged my priestly duties to three men who had been hauled up in a dying state, unconscious, their faces being badly burned, no one could tell me their name or religion. Between Christmas Day 1910 and New Years Day 1911 the different cemeteries presented appalling sights which no one will forget: the hearses, the mourning coaches, the long funeral processions, the throngs of bereaved widows and orphans, relatives and friends, the hundreds of visitors, all of them making their way to the last cold resting places. To see the people in tears, to hear the sobbing and sighing of the wives and children, brothers and sisters, was something beyond human endurance.

Boys reading notices pinned up outside the lamp room at Pretoria after the disaster. This might be a list of those recovered or details of any work available for the No. 4 Pit men while recovery of the colliery took place. The numbered holes in the wall are for returning safety oil lamps after the shift.

The *Farnworth Journal* (6 January 1911) in a sub-section headed 'New Years Day at the Pit' described the difficult work clearing a route into the North Plodder explosion district. The previous Sunday, the coal face had been reached but was mostly fallen up.

A canary belonging to Wigan Coal & Iron Co. which had been down the pit a number of times had a brass plate attached to its cage recording its services. The work of Police Sergeant Brown was mentioned. He had compiled a list of those unaccounted for – fifty-six in total. Through enquiries from the families of the deceased and the descriptions of their clothing, some of the bodies already buried were identified. (Sergeant Brown was to receive an engraved silver watch for his work from the Coroner Samuel Butcher.)

Joseph Staveley, the sole survivor from the Yard district at the time of the explosion, was now back at work, 'looking no worse for his experience'. Being a fitter, he was at work in the surface engine shed. On the previous Sunday (New Year's Day) a memorial service had been held at Chequerbent Mission Church. Lessons were read by Sir William Hulton. Also present was Lady Hulton, Roger Hulton, Dr Hatton and Alfred Tonge the colliery manager.

In the *Farnworth Journal* (Friday 13 January), it was recorded that coal getting had resumed in the Arley district (Wednesday 11 January) and both shafts were now back in working order. Twenty bodies now remained to be recovered; a team of fifty men were at work clearing the roof-fall debris.

In *The War Cry* (Saturday 14 January), it was stated,

In some cases the [Salvation Army] Officers in their visitations found two, three and four coffins in one house. Every door was open to them, and even Catholics gladly allowed them to pray with them. Ensign Scale gives some pathetic details in her report: 'In one short street [Westhoughton] there were nine homes that had lost one or two inmates. In another street we visited there were four houses next door to each other that had done so.'

The *Farnworth Journal* (Friday 20 January) included a fascinating account of a visit to the pit by the inquest jury, one which gave an insight into the terrible state the pit was in. A correspondent described this as 'an awful experience'. Within the account are the following sections:

Our first duty was to visit the office, some 15 yards from the pit-eye, where the underground manager, Mr Rushton met his fate. The papers in the office had their edges charred, showing that the fiery wave of the explosion had singed them in passing. The force of the explosion had been terrific. Tons upon tons of debris lay about. Rails were bent and twisted, tubs had been driven into each other and telescoped with enormous force, and stout beams forming the roof were bent out of the perpendicular. We had to clamber over and down enormous falls that had once formed part of the roof and in many places to get under beams that seemed bending dangerously beneath their weight of dirt, and sundry bumps on the head taught us to be exceedingly careful.

The sweat poured out of us, for the temperature increased, and travelling, bent nearly double, with a short stick as a support was very exhausting. We passed the great 'Rowlands' fault which has a 'throw' of about 40 yards, and presently the [visible] direction of the explosion suddenly changed. For the space of about 20 yards where it was possible to walk upright there were no signs of wreckage and some of the jury thought it possible that this is where the explosion may have started. A little further on we entered upon a new region, where instead of the explosion having travelled downwards towards the shaft, as had so far been the case, all the indications now pointed to the theory that it had travelled upwards towards the [coal] face. At intervals were chalk marks denoting where bodies had been found. We had to stride repeatedly over ropes and litters of 18in steel tubes that had been used to improve the ventilation.

At last after clambering over numerous obstructions we reached a point 900 yards from the pit eye and within 14 yards of the extreme end of the mine. From this point a narrow

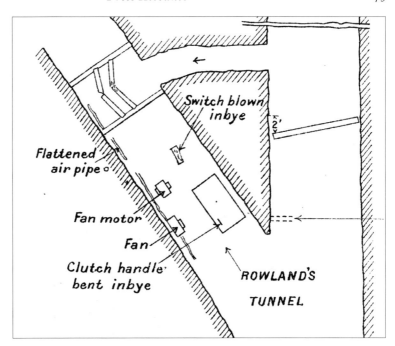

Indications of blast damage and direction at the bottom of Rowland's Tunnel shown in the official inquiry. The ferocity and power in such a confined space of a coal-dust explosion is enormous; any men or boys in its path never stood a chance.

tunnel, 80 yards long and only about two feet high opened out behind a brattice cloth door at right angles to the jig brow. We were informed that at the end of this tunnel was the No. 1 coal cutter or 'Iron Man', which has excited so much comment. It looked a terrible place to go down and most of the party refused to go any further. Only five out of the fifteen ventured to the end to see the 'Iron Man' and they had to crawl on their hands and knees holding their lamps in front of them. We could imagine the horrible task of the explorers in dragging decomposed bodies through these low tunnels. On a ledge near a chalk mark showing where a body had been found was an orange, a can containing drink, and a tin of food that had all gone mouldy.

We heard thrilling stories as to the great difficulties the explorers had had in recovering the bodies from the sump of [the] dib-hole [bottom of the shaft]. They were at work 20 hours and had to remove 80 tubs [5 cwt] full of dirt, huge baulks of timber 14ft long and 14in square, and part of the fan, and then stand waist deep in dirty water to haul out the bodies. After being nearly three hours in the pit, [we] were drawn to the surface, where the landscape, lit up by the almost full moon and the lights of Atherton in the distance looked more beautiful than ever by contrast with the gloomy depths of the mine.

The journal mentions that men were now waiting at the pit in the hope of securing work when coal getting resumed and were travelling from various mining districts, including one man from Northumberland.

The *Farnworth Journal* (Friday 27 January) stated that only three bodies now remained in the mine. The previous Sunday, the body of James Tyrer of Leigh Road, Westhoughton, was recovered, being identified by his clothing. Survivors William Davenport (No. 3 Pit) and John Sharples (No. 4 Pit) were discharged from hospital on Wednesday. Sharples had been gassed and was later to die of pneumonia, Davenport severely burned. (William Alfred Davenport was born in 1891; after working at Pretoria, he was employed at Chanters Colliery, Atherton, until he died on 24 September 1951.)

Expert mining witness Sir Henry Hall gave evidence to the official Home Office Inquiry, one particular comment about the use of the Wolf lamp being highlighted in the *Farnworth Journal* (Friday 3 February):

Sir Henry was asked by the coroner as to his suggestion that the explosion might have been started by men trying to re-light their lamps. Sir Henry replied: 'One has to be careful what one says about the lamp. I may be prosecuted if I libel this lamp'

The coroner replied: 'No you will not. It is a privileged communication.'

Sir Henry Hall, feeling at ease stated: 'Well, I suppose you know this Wolf lamp is very little used in English mines. It is used very much on the continent and some years ago it was proved that this self igniting apparatus could be so used that little pieces of the phosphorous or whatever it is that makes the spark, break off, and deposit themselves in the bottom of the lamp, and remain there all right, until someone lights the lamp … and the lighting of the lamp causes these pieces to get alight at the same time, and the mechanical effect of the two things together was enough to pass the flames through the gauze, and the lamp was condemned on that account … I gather from the precautions taken about re-lighting these lamps that there must be some danger in the operation.'

Sir Henry's evidence was pretty condemning and one wonders why colliery manager Alfred Tonge decided to change over from Protector oil lamps to Wolf in 1908 when he must have been aware of these concerns through his professional contacts. He needed a lamp which could be relit below ground, possibly because his men's lamps went out so often due to large percentages of gas?

The *Farnworth Journal* (Friday 10 February) reported on the third week of the coroner's inquiry with evidence from Sir Henry Hall on lamps, coal dust and electricity. A barrister acting on behalf of the Wolf Safety Lamp Co. addressed the coroner and asked to appear on account of the 'serious complaints' made by Sir Henry against the company's lamp. He hoped to cross-examine Sir Henry but was not allowed to by the coroner as he had no statutory right and also as the lamp was not the main subject matter of the inquiry, merely a side issue.

The inspector John Gerrard had earlier displayed the Wolf lamp he found near the conveyor coal face. This was the one which he had found with its internal safety gauzes (which surround the open flame) coloured 'foxy red', indicating severe heating recently. Gerrard was convinced this lamp caused the gas ignition.

Alfred Henshaw, manager of the Talk O'th Hill Colliery, NW Staffordshire, (the scene of four explosions since the 1860s) felt it almost certain coal dust had been the major destructive factor in the explosion. His colliery suffered a coal-dust blast on 27 May 1901, luckily only four men being killed. He recalled the actual blast: 'A rumbling noise increasing in force, followed by the ejection of dust and debris from the downcast shaft, and afterwards of smoke, these phenomena occupying probably half a minute.'

This gives us an insight into the accelerative aspect of a coal-dust explosion and the period of duration. Some men at Pretoria had travelled up to 260 yards towards the shafts after the initial gas ignition before the gas wave reached them.

Richard Cremer, managing director of the Wolf Safety Lamp Co., stated in support of the safety of his lamps that 22,000 were in use at forty collieries in Britain and that exhaustive experiments had been carried out with the lamps showing them to be safe.

It was decided to retain the Carnegie Hall rather than Bolton Town Hall for the forthcoming Home Office inquiry. Winston Churchill stated that he had appointed Richard Redmayne, the Chief Inspector of Mines, to chair the Home Office Inquiry, which would take place as soon as possible after the inquest. Churchill reassured Parliament that witnesses would be safe to speak as they wished and any cases of intimidation would be dealt with.

Compensation claims in the County Court, Mawdsley Street, Bolton, were reported by the *Farnworth Journal* (Friday 17 February). The unprecedented number of cases meant that the judge, J. Bradbury, had to be assisted in processing them by seven members of staff. A detailed list of claimants and their awards was published.

Alice Fairhurst of St Helens Road, Daubhill, had lost her husband Richard Fairhurst. She had no less than ten children aged between one year and twenty-two. She was only awarded

THE WOLF SAFETY LAMP COMPANY, LEEDS.

WOLF LAMP.

MODEL 1907.

Fig. 751.

Right: The workmen's Wolf safety oil lamp in use at Pretoria at the time of the explosion. This was the 1907 model.

Below: The 1907 model Wolf lamp as used at Pretoria. The conclusion of a number of expert witnesses was that a roof fall in the North Plodder district damaged one of these lamps, possibly smashing the glass. Gas was ignited followed by coal dust. Exhaustive tests on the lamp showed it to be sturdy, its design not really in question, although Sir Henry Hall doubted the safety of the re-igniter mechanism.

Made in Steel, Brass, German Silver, or Aluminium.
For burning Naphtha or Oil.
Flat or Round Wick.
Improved Magnetic Lock.
Friction Igniter, Model 1907.
Double Gauzes.
Enamel Reflector.
Improved Glass and Gauze Fastening Arrangement.

Shield and Lamp Vessel pressed out, no joints.
Shield not removable.
Candle-power, with Flat Wick, 1·43 Heffner Units.
Candle-power, with Round Wick, 1·02 Heffner Units.
Weight, 3 lbs.; Height, 11 in.

£300 with a £30 lump sum given immediately (£300 in 1911 would have the spending power of approximately £17,118 today). Sarah Ann Brown, who lost her husband William Brown of Francis Street, Daisy Hill, only had one child yet received only £37 less than Alice.

The scene within the courtroom was described, men deciding to sit on the left, women to the right. Many had never been into a courtroom before and appeared anxious. Solicitors representing both Hulton Colliery Company and the miners' union representatives monitored the award decisions. An example of how many agencies contributed to a widow's benefits was highlighted in the case of Fanny Hurst; she would be in receipt weekly of 15s from the Lancashire & Cheshire Miners' Permanent Relief Society, 14s from the Mayor of Bolton's Fund and 5s from the company, total 34s a week. A collier earned 6s 6d a day at Pretoria at the time.

Hulton Colliery Company had in some cases settled out of court with dependants to possibly avoid litigation under the Workmen's Compensation Act (1906). Set up in 1897, this awarded up to three years' wages to workers or their families who were injured or killed through their employer's negligence. Lord Salisbury's Conservative government had passed the Act, which automatically granted damages upon application to a County Court without the need to prove negligence.

Hulton Colliery Co. insisted they were sympathetic in their dealings with the bereaved and as generous as an employer could be (a glance at the company's financial returns for the previous ten years held at the Lancashire Record Office shows they could have been far more generous). Some families were not happy with the compensation offered by the company and pursued litigation through Bolton County Court.

In the *Farnworth Journal* (Friday 24 February), the fourth day of the Home Office Inquiry was reported. Discussion surrounded the role of coal dust and safety lamps. John Gerrard, the mines inspector, said he was convinced that the origin of the explosion was at the North Plodder No. 1 conveyor (coal) face due to the position of the bodies and the indications of the force of the blast. He proposed strongly that stone dust be laid in mines to combat the danger of coal-dust explosions. He had arrived at a figure for the cost to the company of dealing with the aftermath of the Pretoria explosion at £100,000 (£5,706,000 today).

Dr W. A. Hatton's account of his experiences in association with the disaster formed the basis for a paper to the *British Medical Journal* (20 May 1911). As well as describing the course of events as above in the *Colliery Guardian* extract, he compiled the following statistics:

Number of bodies recovered to February 16th	343
Causes of death:	
Carbon monoxide	224
Explosion	5
Explosion and carbon monoxide	63
Asphyxia	2
Unstated (probably explosion and CO)	3
Died in infirmary (shock and burns)	1
Bodies charred and scorched by flame	92
Bodies uninjured	312
Bodies injured by violence (including those under falls)	31
Bodies unidentified	19

Hatton goes into detail as regards specific horrific injuries which I do not feel need to be described here. He mentions one man being blown bodily a distance of 40 yards from his normal workplace, to then fall 135 yards down the shaft into the sump. He recalls the power of the explosion noted through the size of some of the roof falls in the pit, up to 200 yards in length. Hatton found that no men died through burning due to the fires created after the blast.

He commented on the work of Dr Arnold Greene, medical officer to Howe Bridge Rescue Station, who wrote to him after the explosion:

The newly introduced Oldham's of Denton electric re-chargeable hand inspection lamp with bull's-eye lens. This was used by the rescue teams and officials at Pretoria. See the photograph of the inspectors and barrister in the colour section.

Every [rescue] man trained has to pass through my hands as being medically sound. As regards the accident itself, we had some 150 local rescue men at work, and during the whole time I was there I never had an accident of any sort brought to my notice as regards the rescue men. All the men I examined, both at the time of the disaster and subsequently, showed no signs of the hard work they had undergone, not only as regards the oxygen breathing, but as regards their physical condition. It was a severe test for oxygen breathing, but everything came out all right, and only proves that oxygen breathing in the way we use it does no harm to the men.

Hatton was contacted by the mines inspector John Gerrard, who could not recall such a rapid recovery of a mine after an incident. In one day, 123 bodies were recovered, in five days, 270. Gerrard praised the work of colliery officials and rescue men who arrived from Burnley, Accrington, St Helens, Leigh and Atherton (not forgetting Bridgewater Collieries men).

Hatton gives information on the distances men travelled after the explosion (which indicates roughly how long they lived for until the gas reached them). In the Downbrow Yard district, the men were found to have walked the farthest distance. Thirty men and boys had travelled without lights 260 yards to within 300 yards of the shafts. Other districts showed evidence of men walking towards the shafts after the blast. Hatton praised the boy scouts delivering messages all day long.

If these men had had the use of today's portable mine 'self rescuers', which work by converting carbon monoxide into less hazardous carbon dioxide (introduced in 1967), most or all would have survived.

The Coroner's Inquest and Home Office Inquiry

Under Section 45 of the Coal Mines Regulation Act 1887, an enquiry had to be held into the causes of the explosion. Due to the enormity of the event, the Chief Inspector of Mines, Professor R. A. S. Redmayne, carried out the investigation. Redmayne was held in very high regard in the coal-mining industry and was probably one of the most highly regarded inspectors in the history of mines inspection, which had its origins in 1843. He was the first Chief Inspector of Mines, the post created in 1908, along with Robert Nelson, Electrical Inspector of Mines (who was also to attend Pretoria).

Redmayne was a staunch advocate of greater efficiency in mining. He also felt the role of a colliery manager went beyond the statutory role some managers assumed, and was to say,

> The life of a colliery manager is so varied and interesting with wide opportunities for service to one's fellows. Apart from the purely technical work which colliery management involved, there were schools to look after … the miners' cottages to inspect and repair … the farms to manage …

In his reminiscences of a life in mining in *Men, Mines and Memories* (Eyre & Spottiswood, 1942), he recalls the day of the Pretoria disaster:

> I remember well Mr [Winston] Churchill had asked me to telephone to him on my arrival at the scene of the disaster, so about 1 a.m I got through to the Home Office. The Home Secretary had left but Mr Charles Masterman, the Parliamentary Under-Secretary, was there waiting to hear from me. I gave him a brief account of the little I had gleaned on my arrival, and told him I was about to go underground. 'Well good-bye, good night, and God be with you' was his reply.
>
> In connection with this disaster one incident is fresh in my mind, illustrative of the unselfishness and spirit of helpfulness which pervades the mining community on these sad occasions … on coming out of the mine next morning I was shown the place where the dead were being confined, a large shed … In which were row upon row of coffins, and there the official accompanying me introduced me to a handsome rosy-cheeked pit lass of about eighteen years of age, attired in the garb adopted by the women surface workers at Lancashire collieries … short dark skirt, bodice, shawl over the head or cloth covering and wooden clogs … telling me that she, herself alone, had washed over one hundred of the bodies.
>
> 'Why did you do this?' I inquired.
>
> 'Some one had to do it,' she replied in broad Lancashire, 'and I had lost none and t'other womenfolk mostly had.'
>
> She blushed and smiled when I said, 'It was fine of you to do this,' and warmly shook her hand.

The nature of the two inquiries and their timing can be a little confusing, so it is worth noting initially the dates. The Coroner's Inquest was adjourned on the day of the explosion until 336 bodies had been gradually found and identified by 13 January 1911. The inquest proceedings began at the Carnegie Hall, Westhoughton, on 24 January 1911 and concluded on 13 February 1911. Some information submitted in the inquest report published on 20 May came from the inquiry, which had actually taken place later than the inquest. The Home Office Inquiry proceedings began at Westhoughton Carnegie Hall on 20 February 1911, concluding on 9 March 1911. The Home Office Report containing these two inquiries was published on 20 May 1911.

THE INQUEST

Mr Samuel Forster Butcher, County Coroner, the jury, witnesses and members of the press were brought together in the courtroom, the No. 3 Pit winding engine house, initially for the formal identification of 336 bodies. From 23 December 1910 to 16 January 1911, the inquest was to be convened twenty-one times.

Painstaking research by Peter Wood and Pam Clarke has found from reports in a variety of newspapers eighty-two comments about work conditions directly attributed to a victim. The coroner had asked each witness whether conditions at work, particularly the presence of gas, had been a problem the deceased might have mentioned.

The members of the jury were:

From Atherton: John Yearnshaw, Foreman, Richard Harrison, John Norbury, John Lowe, Samuel Mather, James Guy Turner, William Orrell of Atherton, James Speakman, John Edward Barlow, John Bullough. From Westhoughton: Thomas Rigby, William Harrison, Thomas William Gorringe, Philip Westhead, Edward Lyon, William Moss, Thomas Brown. John Henry Taylor of Chequerbent completed the jury.

Evidence of identification was taken as the bodies were received from the pit up until 13 January. The hearing to determine the cause of the explosions was opened at the Carnegie Hall, Westhoughton, on 24 January 1911. All interested parties were represented.

Samuel Pope, barrister, acted on behalf of the Home Department (Office); Hulton Colliery Co. Ltd was represented by Thomas Ratcliffe Ellis and Arthur Ellis of Peace & Ellis, solicitors of Wigan; Thomas Dootson, solicitor of Leigh, represented the relatives of the deceased; Thomas Greenall and Henry Roughley acted for the Lancashire & Cheshire Miners' Federation. The Miners' Federation of Great Britain was represented by Robert Smillie (later president 1912–21), W. Straker and C. Bunfield. The mines inspectorate in attendance consisted of John Gerrard, HM Inspector of Mines for the Manchester and Ireland District; Robert Nelson, HM Electrical Inspector of Mines; G. B. Harrison and J. C. Roscamp, Junior Inspectors of Mines also attended most of the sittings.

THE EVIDENCE

A total of 129 witnesses attended the inquest hearings to give evidence, beginning with Alfred Tonge, the colliery manager. Seventy-five of the witnesses were widows, close relatives and friends to those who had died, many recalling discussions about working conditions at the pit. The remainder ranged from mining teaching academics, mining and electrical engineers, colliers, day-wage men, firemen, the undermanager from No. 2 Chequerbent Pit, contractors, a retired inspector of mines and surface workmen and union representatives, most of whom would also be attending the Home Office inquiry on 20 February 1911.

In the report on the inquest by Samuel Pope, barrister, he occasionally indicates that he is referring to Redmayne's Home Office Inquiry report (which came later) for technical

reference and the description of the colliery, as they did not come within the scope of the inquest. At times the overlap in information or evidence sources is difficult to ascertain.

VENTILATION

Regarding ventilation, the coroner had referred to the Home Office Inquiry for technical information. He decided that the question of the system of underground rather than surface fans being the main means of ventilation should be discussed and also the manner of recording and measuring the air.

The fact that the underground fan was destroyed in the explosion was highlighted by Robert Smillie on behalf of the men. Statute demanded any fan equipment placed below ground be so designed as to be able to survive an explosion (surface fans also by now were designed with relatively weak explosion doors, which diverted the blast away from the fan rotor). Manager Alfred Tonge replied that his system of ventilation, with a traditional surface fan in addition to those below ground was if anything superior to the requirements of the law relating to mines. The coroner felt that the need for ventilation in the case of Pretoria during rescue operations had shown that the main fan ought to be on the surface with underground fans secondary.

MEASURING AND RECORDING AIR

The Inspector John Gerrard said he felt the standard of recording air measurements at the colliery was poor and uninformative (as regards assisting him in his investigations). The coroner noted Tonge struggled to provide accurate information on the ventilation of individual branch roadways and districts, the only information available being ventilation 'totals'.

Tonge said that he certainly thought the splits (ventilation branches) into each mine (seam working district) ought to have been in the book, and once more admitted to managerial shortcomings at the colliery 'that again, I am sorry to say, is not quite up to the full letter of the law I think'.

The coroner was not impressed.

LIGHTING

The coroner referred to the miner's lamp relighting mechanism and the rules at the colliery for its use only by authorised persons. Tonge admitted, very matter of fact, that the rules at the colliery related to the old Protector lamp, which was relit electrically at specified relighting stations and did not offer to say why new rules had not been laid down for the Wolf lamp.

Once more, the coroner was not impressed, saying that, without commenting on Tonge's reply, there was a proper course which he should have taken once the changeover in lamps was planned. Tonge mentioned that he had been sympathetic to the idea of men relighting their own lamps but decided against this.

MANAGEMENT

The coroner questioned Alfred Tonge repeatedly about the system in place where the undermanager was effectively acting as a colliery manager, without any regular communication with the group manager, Tonge. He wondered why Tonge did not need to see on a daily basis

Date.	District.	Time.	Conditions.	Signature.
7.12.10	Nos. 1 & 2 Yard	2.45 p.m.	Good and safe except Morris's Place off No. 1 E. Jig ; giving off gas diluted as made.	J. Hundy.
7.12.10	No. 3 Dis. & ¾	2.45 p.m.	Good and safe except Seddon's and Jolley's Places ; giving off gas diluted as made. Jolley's fenced off.	Lewis Hodgkiss.
7.12.10	Nos. 1 & 2 Plod.	2.45 p.m.	Good and safe except Eccleston's, Yard Tunnel and No. 1 E. Jig ; giving off gas diluted as made.	William Thomas.
7.12.10	No. 3 Yard ...	9.20 p.m.	Good and safe—as described above	William Bullough.
7.12.10	No. 1 Yard ...	9.20 p.m.	Good and safe—as described above	Ben Thompson.
8.12.10	No. 3 & ¾ Yard	5.30 a.m.	Good and safe except Jolley's, Seddon's and Yard Tunnel ; giving off gas diluted as made. Jolley's fenced off for gas.	William Bullough.
8.12.10	Nos. 1 & 2 Yard	5.30 a.m.	Good and safe except Morris's Place off No. 1 E. Jig ; giving off gas diluted as made.	Ben Thompson.
8.12.10	No. 2 Plod. ...	5.30 a.m.	Good and safe except Eccleston's Place and Brown's ; giving off gas diluted as made.	Isaac Ratcliffe.
8.12.10	No. 1 Plod. ...	5.30 a.m.	Good and safe except No. 1 E. Jig ; giving off gas diluted as made. E.R.	Fred Ratcliffe.
8.12.10	Nos. 1 & 2 Yard	2.45 p.m.	Good and safe except Morris's Place off No. 1 E. Jig ; giving off gas diluted as made.	J. Hundy.
8.12.10	No. 3 Dis. & ¾...	2.45 p.m.	Good and safe except Seddon's and Jolley's ; giving off gas diluted as made. Jolley's fenced off.	Lewis Hodgkiss.
8.12.10	Nos. 1 & 2 Plod.	2.45 p.m.	Good and safe except Eccleston's, Brown's, Yard Tunnel, and No. 1 Jig ; giving off gas diluted as made.	William Thomas.

In the appendix to the official inquiry, the records of the various deputies' inspections in the Plodder, Yard and Three-Quarters were transcribed. In this list, for only two days in December 1910, the dubious practice of entering 'gas diluted as found' can be seen, also that areas were being fenced off due to being full of gas. A colliery manager or deputy today would set alarm bells ringing if just one of these entries was made.

the report books (which were left below ground). Tonge said he thought that, as Rushton, the undermanager, was very highly qualified, holding a first class (manager's) certificate of competency, he was happy that he could rely on Rushton to make the correct decisions should any problems occur. The coroner was becoming aware of the sense of security Tonge had with Rushton in place, hinting that this may have lead to a slackening of discipline and supervision.

Surprisingly, the coroner later stated that he felt the managerial system in place was not the root cause of the disaster. He noted that as all the men in the districts had been killed, including the undermanager and firemen, this meant a full investigation of events and practices in place through interrogation was impossible, a fact no doubt that Alfred Tonge was fully aware of.

The coroner suggested the number of mines coming under one man's management should be limited.

The coroner queried how deputies and firemen were appointed, the deputy in charge of the explosion district being the youngest at the colliery, aged only twenty-three. Tonge replied saying that the deputy in question was the son of a deputy, a very intelligent young man who had been to evening classes. Tonge was confident in his abilities.

The practice of deputies reporting gas found during a shift as 'diluted as made' was discussed at length. A deputy who was asked about this practice said that when gas was found it was accepted that the general flow of air would dilute it and all the deputies used this phrase. Tonge stated that he was aware of the practice and thought it was used when no gas was found a few yards outbye of the source.

ELECTRICITY

Some men recalled sparks being seen on 15 December at a conveyor electrical switch at the top of No. 1 Jig in the North Plodder, the undermanager Rushton (killed in the explosion) also being a witness. The switch had been examined by Robert Nelson, the Electrical Inspector. He concluded that the condition the switch had been in at the time of the explosion could not

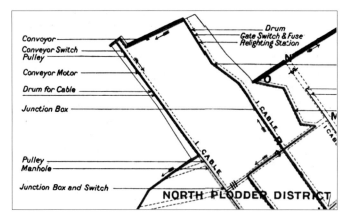

Convoyor
Conveyor Switch
Pulley
Conveyor Motor
Drum for Cable
Junction Box
Pulley
Manhole
Junction Box and Switch
Drum
Gate Switch & Fuse
Relighting Station
NORTH PLODDER DISTRICT

The North Plodder No. 1 and 2 coal faces, the prime candidate for the origin of the explosion. Some experts suspected the electrical switchgear at the top left end of the face may have been a source of sparking and gas ignition; the theory was later to be discounted.

be accurately ascertained as oil may have been lost from it (some electrical switches contained oil which stopped open sparking), although he felt the oil depth seemed adequate. The switch box was noted as having a hole in its casing, possibly allowing oil to escape. The coroner concluded that the utmost care was needed in the maintenance of electrical equipment. The presence of the hole in the casing of the switch box was noted as being surprising.

COAL DUST

The watering of zones stopping 200 yards short of the coal faces in the North Plodder was mentioned as being inadequate to protect that district. Even the areas watered, once subject to the ventilation current and heat, soon dried up again.

All the expert witnesses agreed coal dust had been the major explosive agent in the disaster. Sir Henry Hall discussed the nature of coal dust in Lancashire mines. He stated that no conclusions had yet been arrived at as regards the most effective means to render coal dust harmless, and that experiments were ongoing.

THE CORONER'S CONCLUSIONS

The coroner said that certain breaches of the Coal Mines Regulation Act 1887 had taken place, but the jury felt they did not contribute to the explosion. No specific negligent acts could be ascertained where proceedings might be taken, the only potential example being the level of maintenance of the electrical conveyor switch, the electrician responsible being killed in the explosion.

Mr Samuel Butcher, the coroner, then commented on the subject of coal dust in the mine: could its contribution have been avoided by precautions taken by diligent management? He decided a charge of manslaughter could not, in this case, be pursued.

The report was to be submitted to the Secretary of State for the Home Office, Winston Churchill.

At the conclusion of the evidence and the summing up, the coroner submitted the following fifteen questions to the jury for their consideration:

1. When did the explosion take place?
2. When did the men die?
3. Are you satisfied with the evidence of identity given in the cases of the several persons as to whom such evidence has been given?
4. What other persons were killed by or in consequence of the same explosion?

5. Do you accept as correct the list compiled of the several places where the bodies of the deceased were found?

6. Do you accept as correct the evidence given by Dr Hatton [the surgeon to Hulton Colliery Co] as to the causes of death?

7. What was it gave rise to such causes of death, e.g., an originating explosion of gas, or gas and coal dust with or without a larger consequent explosion of coal dust?

8. In what district of the mine did the explosion originate?

9. At what place in such district did it originate?

10. What was the cause of the ignition, (a) Safety lamp, with any observations as to its character; (b) Electricity, with comments; (c) how otherwise?

11. Was the explosion attributable to the gross neglect of any persons or person, and if so, of whom and in what particulars were they or he grossly negligent, or was it due to accident?

12. Was the explosion in anywise due to the non-observance of any statutory obligation, and if so, on the part of whom?

13. Were due care and reasonable precautions taken in the following districts, viz;--- South Plodder, North Plodder, Top Yard, Down Brow Yard, East Jig, and Three-Quarters in respect to all and each of the following matters:---
(a) The examination for and the removal or adequate dilution of gas.
(b) For preventing workmen from working in places where gas was present.
(c) In keeping all places supplied with a quantity of air adequate to render them safe and proper to work in, and to render harmless any noxious gases.
(d) With regard to the use and supervision of any part of the electrical plant, and
(e) In other respects by the Manager, Under-manager, Firemen and other officials in their respective departments of supervision and control?

14. Does blame rest upon anyone in connection with the explosion? If so, upon whom, and in respect of what acts of omission or commission?

15. Do you desire to make any recommendations upon any of the following or any other points:---
(1) Dealing with coal dust in mines
(2) Safety lamps
(3) The use of electricity and particularly as to the gas tightness of switch boxes
(4) The appointment and instruction of firemen
(5) The nature of the tests and reports to be made, (a) by firemen; (b) as to ventilation, and as to the duplication of such reports
(6) The definition of 'return airways'
(7) As to any other matters

The jury discussed the evidence, retiring for six hours before they returned their verdict. They also asked for the following points to be recorded, including recommendations for inclusion in future mining legislation. They stated that they felt the explosion was not the result of any negligence regarding statutory obligations (i.e., by management). They felt the use of advance headings (roadways) in gassy areas were to be avoided unless adequately ventilated, highlighting the heading in advance of the North Plodder Jig (haulage roadway). Competence of those working on electrical equipment was questioned, the recommendation being that a skilled electrician should be in attendance. The failure of the day shift fireman to make his inspection was highlighted as a sign of poor supervisory standards. The jury asked that an inquiry into both coal dust and safety lamp characteristics be carried out. Amendments to electrical regulations were thought desirable so that equipment casings might be gas tight and that internal contacts be immersed in oil. They felt that firemen's reports should state the exact place gas was found plus the quantity, and that adjacent workplaces should be borne in mind in case potentially affected. Full ventilation reports should be made at least monthly on each and every ventilation roadway in each district.

THE VERDICT

The foreman gave the verdict of the jury:

> On behalf of my colleagues and myself I tender the verdict that on the 21st day of December 1910 at the No. 3 Bank Pit, commonly known as the No. 3 Pretoria Pit, Westhoughton, in the County of Lancaster an accidental ignition of coal dust and gas occurred in the conveyer face of the North Plodder mine in some manner unknown to the jury but probably from a defective or over heated safety lamp, and produced an explosion. That upon such ignition and explosion followed a large ignition and explosion of coal dust affecting the whole of the coal mines working in the said pit. That the said men [a list of the victims was read out], were with others at the time of the said explosions employed in the Yard Mine [seam] of the said pit and in consequence of such explosions and resulting afterdamp died there the same day so that they came by their deaths by accident and not otherwise. That Mr Coroner is the verdict of the jury.

THE HOME OFFICE INQUIRY

At a meeting of the Miners' Federation of Great Britain in Derby on 4 and 5 January, it was resolved that senior officials Robert Smillie and W. Straker would be appointed to attend the inquiry into the explosion. At the same meeting, they passed the following resolution:

> We strongly protest against this terrible slaughter of our comrades at the Maypole [Abram, 1908, seventy-five killed], West Stanley [Durham, 1903, 168 killed], Whitehaven [1910, 136 killed] and Pretoria Pits and this conference moves that the Federation appoints a strong deputation to meet the Home Secretary with a view to urging upon him the absolute necessity of introducing as early as possible such legislation as shall tend to reduce these appalling calamities to a minimum.

The Home Office Inquiry hearings were held at the Carnegie Hall, Westhoughton, starting on Monday 20 February 1911 and continuing on 22, 23 and 24 February and 7, 8 and 9 March.

Hulton Colliery Co. Ltd was represented by Arthur Ellis of Peace & Ellis, solicitors of Wigan; Thomas Dootson, solicitor of Leigh, represented the relatives of the deceased; Thomas Greenall and Henry Roughley acted for the Lancashire & Cheshire Miners' Federation. The Miners' Federation of Great Britain was represented by Robert Smillie (later president 1912–21) and W. Straker. Also represented were the General Federation of Deputies and Firemen of Great Britain and The Wolf Safety Lamp Co. Ltd.

The mines inspectorate in attendance consisted of John Gerrard, HM Inspector of Mines for the Manchester and Ireland District; Robert Nelson, HM Electrical Inspector of Mines; G. Poole, Inspector of Mines; G. B. Harrison and J. C. Roscamp, Junior Inspectors of Mines also attended most of the sittings.

Thirty-seven witnesses were called by Richard Redmayne, the Chief Inspector of Mines, and examined in the following order:

1. Alfred Joseph Tonge, General Manager, Hulton Collieries
2. John Taylor Shaw, fireman [deputy]
3. William Alfred Davenport, haulage hand [aged twenty, survivor of the explosion from the Yard mine workings]
4. William Alfred Hatton, doctor [surgeon to Hulton Colliery Co.]
5. Harold James, manager of New Hayden Collieries, near Cheadle, Staffordshire
6. Arthur Henry Leach, consultant mining engineer, Wigan
7. William Galloway, consultant mining engineer [and pioneer investigator of the role played by coal dust in explosions]

8. James Howard Walker, consultant mining engineer [Wigan]
9. W. H. Pickering, Inspector of Mines [Yorkshire]
10. John Gerrard, Inspector of Mines [Hulton Collieries came under his district]
11. J. C. Roscamp, Junior Inspector of Mines
12. Percy Lee Wood, general manager Clifton & Kersley Coal Company
13. Richard Cremer, Managing Director, Wolf Safety Lamp Co. [Leeds]
14. Robert Cowburn, collier
15. Frank Garswood, dataller [general day-wage labourer below ground]
16. Clarence Boothroyd, dataller
17. John Winrow, dataller
18. Paul Garswood, dataller
19. Nicholas Singleton, assistant to coal cutter man
20. Joseph Miller, dataller
21. Abraham Stott, fireman [deputy]
22. William Mangnall, lampman [surface]
23. Alfred Teasdale, dataller
24. John Bullough, former Pretoria No. 4 Pit undermanager, now working for Wigan Coal & Iron Co.
25. George Ratcliffe, coal cutter man
26. George Houghton, dataller
27. Percy Taylor, Assistant Manager, Tyldesley Coal Co.
28. William Singleton, dataller
29. Joseph Basnet, dataller
30. Peter Gallagher, dataller
31. Thomas Cunliffe, dataller
32. Fred Ratcliffe, fireman [deputy]
33. Henry Roughley, local miner's agent [union official]
34. Thomas Greenall, President of the Lancashire and Cheshire Miners Association
35. Frank Kinsella, conveyor attendant [below ground]
36. Rowland Francis Bull, Electrical Engineer, Hulton Colliery Co.
37. William M. Thornton, Professor of Electrical Engineering and consultant electrical engineer
38. Robert Nelson, HM Electrical Inspector of Mines
39. William Bullough, fireman [deputy]
40. William Brindle, collier
41. Sir Henry Hall [later Sir], consultant mining engineer [District Inspector of Mines at the time of the White Moss Colliery, Skelmersdale, coal dust experiments in 1894]

The Home Office Inquiry is the major source of information on the working of the colliery before and at the time of the explosion along with the course of events immediately afterwards.

The introductory background to the colliery given at the inquiry can be summarised as follows. Additional explanatory comments are provided in square brackets.

The Hulton [Pretoria] colliery was owned by the Hulton Colliery Company, situated close to Atherton about 11 miles to the west of Manchester. The company comprised four different and distinct collieries [all under the management of one person, Alfred Tonge]. There were seven coal-drawing shafts in total and prior to the accident about 2,400 tons of coal a day were raised. The colliery employed approximately 2,400 people above and below ground. The Nos 3 and 4 shafts at Pretoria were sunk in 1900 and 1901, 18 feet in diameter, 75 yards apart. No. 4 was the downcast and No. 3 the upcast shaft. Both shafts were sunk to the Arley seam, found 434 yards from the surface. The output from five seams was wound from both shafts:

Trencherbone at 146 yards, 3 feet 6 inches thick
Plodder at 274 yards, 2 feet thick
Yard at 306 yards, with 18 inches of dirt total 3 feet 11 inches thick
Three-Quarters at 361 yards, 1 foot 5 inches to 1 foot 6 inches thick
Arley at 434 yards, which was 2 feet 11 inches thick

Colliery Layout Below Ground

The general dip [angle of inclination] of the seams was to the south at an average inclination of 1 in 5.5. A west–east geological fault cut through the coal measures worked from the Nos 3 & 4 pits, making it necessary to lay out cross-measure drifts [tunnels driven through at times coal and rock] and coal haulage roads. This allowed the three seams: Plodder, Three-Quarters and Yard to be worked from one level [or horizon] in No. 3 shaft. It was on this level that the explosion occurred.

The workings at this level [see the colour image section] were further divided into five districts; the North Plodder, the Three-Quarters, the Top Yard [or Up Brow] and the Bottom Yard [or Down Brow] finally the South Plodder. These were sub-divided into the North Plodder Nos 1 and 2 coal faces.

The most extensive workings at the time of the explosion were in the Top and Bottom Yard seams. The other coal-producing districts were in the thinner seams below the Yard and connected to it by drifts.

Of these smaller districts, there were two rise workings [working the coal uphill allowing gravity haulage of coal away from the faces], the North and South Plodder. Also in production was the Three-Quarters seam, a small dip district employing a few men. The North Plodder was the district with the highest manpower [in the No. 3 Pit] with seventy men.

The coal in all these districts was worked on the longwall [long wall] system with men spaced out along the faceline. The longwall coal face in the Yard seam Downbrow district heading east had a coal face approximately 700 metres long, two faults creating steps in the faceline. By comparison, coal cutter faces with powered roof supports in the 1970s to 1990s had facelines around 250 metres wide.

The total number of persons working in the No. 3 Pit on the day of the explosion was 344 and 545 in the No. 4 pit. Of those in the No. 3 Pit, 230 were in the Yard mine [seam], 90 in the Plodder mine [seam] and 24 in the Three-Quarter mine [seam]. In the No. 4 District there were 109 in the Trencherbone mine [seam], 306 in the Arley mine [seam] and 130 in the Three-Quarters seam workings. Coal from the larger area of the Three-Quarter seam was brought to the Arley Mine level and drawn to the surface at No. 4 shaft. From a mouthing [inset] in the No. 3 upcast shaft at the Yard mine level, the coal from the Yard, Plodder and the small area of the Three-Quarters seam was raised. The Trencherbone coal was raised from a mouthing in that seam in No. 4 downcast shaft.

Management and Communication

Colliery manager Alfred Tonge lived close to the colliery. He was certified as the colliery manager and agent [or group manager] for the Hulton group of collieries [four pits with 2,400 men employed], but did not go underground every day. He did not have a separate colliery manager at each mine [the reasoning behind this has never been explained; I personally suspect Tonge wanted to be in total control and did not want or feel the need for individual colliery managers to make operating decisions without his input]. Delegating for him was an undermanager at each colliery. Rushton, who was killed in the explosion, was the undermanager for No. 3 Pit at Pretoria. He held a first class [colliery manager's] certificate. He went down the pit every day at 6.45 a.m. and came up for his breakfast at 10.30 a.m. which

he had in the pit office and went down again between 11 and 11.15 a.m. He finally came to the surface about 3.15 p.m. Under Mr Rushton were foremen [in later days known as overmen, usually experienced deputies]. The general manager saw his undermanagers regularly but not every day. Of the eleven firemen or deputies employed in the Yard seam where the explosion occurred, six were in the day shift, four in the night shift and one in the afternoon shift. On the day shift, there were 344 men in the district including six firemen.

As the mine was a 'single shaft pit' as regards coal getting and winding, coal being wound in each shaft [often collieries would wind coal from one shaft, the upcast, using the other for winding, supplies and ventilation], the coal-getting shift descended from 6.45 a.m. and began to be wound up at 2.45 p.m. The repairing and mechanical coal-cutting shift which carried out work in the North Plodder only at the time, was down from 10.30 p.m. to 6.30 a.m., comprising about 150 persons.

Unbelievably, no system of reporting from the undermanagers to the colliery manager existed. Redmayne, understandably surprised to hear of this, was told by Tonge:

I am afraid we relied on verbal reports from the undermanager to myself. Of course he sent me a lot of notes of one sort or another, but they were not systematic … they had no connection with the firemen's daily report book … and we had no systematic daily report from the undermanager to the manager.

Redmayne wryly commented on the gradual tailing off of entries in the 'Sudden Danger' or 'Withdrawal of Workmen' report book. Tonge accepted the incompleteness of the records, that men had probably been withdrawn a number of times due to gas between 1903 and 1910 but as they were not sent home, but re-deployed elsewhere in the pit, the records did not give an accurate account overall.

Ventilation at Pretoria

Gas was known to be emitted from all the seams of coal at Pretoria in varying degrees. The Yard seam was gassy, and more so as workings in it approached the geological fault crossing the colliery 'take' from west to east. The fault acted as a seal for the gas to rise up against and increase in concentration.

The North Plodder seam was also gassy but to a lesser degree. Above it, separated by four foot of shale, was a thin seam which was known to be gassy. If roof falls occurred, the exposure of this upper seam caused gas problems, an important factor borne in mind by Redmayne when assessing the causes of the explosion. Seven months before the explosion, the practice of removing the shale and coal above the Plodder seam to create height [and remove any gas as a result] had been stopped after conveyors were installed and the floor was taken out instead. Now the gas was pent up under pressure.

When colliery manager Alfred Tonge first came to the colliery, it was ventilated in the 'old way' by two underground furnaces. The hot air they created rose up the upcast shaft pulling air from the workings via the return roadways. The very antiquated and inefficient method of steam-jet ventilation was also in place where steam was piped part way down the shaft and jetted upwards; the hot, moist air rose, drawing air from the return roadways.

Shortly after his appointment, he decided to modernise the ventilation arrangements. At the inquiry, Alfred Tonge said in evidence:

Our seams are generally speaking very thin and we required a fairly high water gauge [ventilation air pressure, some mining engineers felt the colliery was actually over-ventilated]. The fan that we put in first was put in to work between four and five inches of water gauge to give us the required amount of air. We found after starting it up that we were only getting one half of the air underground that we were getting through the fan.

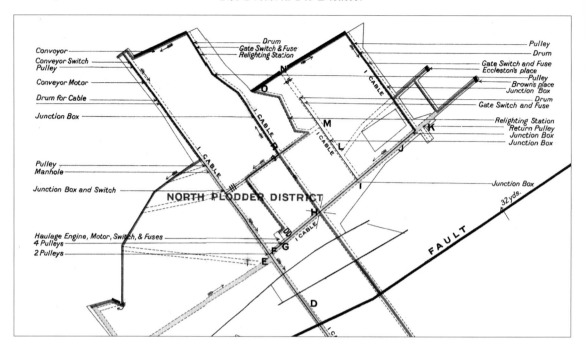

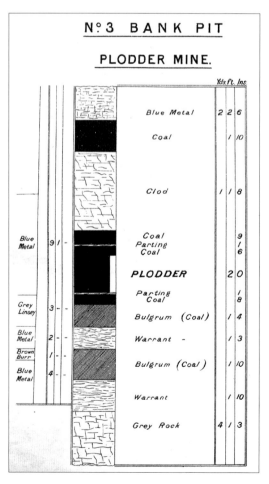

Above: The North Plodder seam workings, No. 2 coal face, top right, is where the ignition is thought to have originated. The seam was known to be gassy but not excessively so. Evidence came out during the enquiry of men being 'gassed' occasionally in the North Plodder district as large volumes of gas replaced the air normally present. Above the seam, separated by four feet of shale, was a thin seam known to be very gassy. Any roof falls exposed that seam and allowed its gas to vent.

Left: The section of strata above and below the Plodder seam. Above the Plodder was nearly five feet of 'clod' or loose shale. When this cratered upwards after a roof fall, the upper seam of 1 foot 10 inches was exposed. This was very gassy and probably the supply of gas ignited in the explosion.

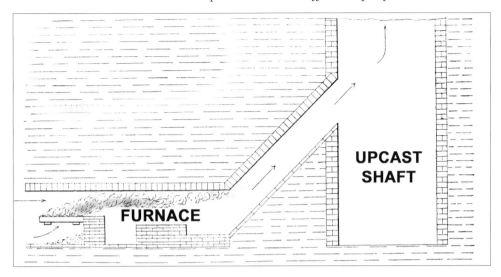

The colliery was initially ventilated in the 'old way' by two underground furnaces. The hot air they created rose up the upcast shaft pulling air from the workings via the return roadways. The air supplied to the furnace came from the downcast shaft rather than the gas-laden return airways. There would be no shortage of coal for the furnace!

This pointed to a great deal of leakage underground [into old workings inadequately sealed off or between intake and return roadways]. Ventilation was problematical at the other Hulton sites. Tonge mentioned that at Deep Arley Pit [north of the A6, close to the M61], the actual amount of air that was coursing through the workings was about half that produced at the fan, and at the Chequerbent Pits the amount was reduced to as much as twenty-five per cent.

Ventilation of the workings in the Pretoria Nos 3 and 4 pits was carried out by four electrically driven Sirocco fans underground, three were exhausting [drawing air out of the workings) and one was a forcing fan (boosting the existing ventilation air current pressure]. Fans were placed in the Arley, Three-Quarters, Yard Mine and Trencherbone districts. The forcing fan was used in No. 3 Pit workings and this means of ventilation was used due to the fact that the coal was brought up the shaft at the Yard seam level and wound up the upcast shaft. If an exhausting fan had been used it would have created an obstruction in the shaft mouthing and hindered coal winding.

The fan was placed close to the downcast shaft and sucked the air from there and forced it round the workings. Air crossings [where intake and return air roads crossed each other] in No. 3 Pit were solidly built of brick with wooden baulk 'roofs' laid on girders, the main road stoppings [semi-permanent seals between intake and return roadways and permanent on disused roadways and districts] were substantially constructed of stone packing and faced with brick. Their regulators [these allowed a regulated amount of fresh air past the air door] were properly constructed with sliding wooden doors.

An additional large Sirocco fan, 8 feet 2 inches in diameter, with a double inlet capable of exhausting 300,000 cubic feet of air per minute at 3-inch water gauge [pressure] was sited at the surface of No. 3 upcast shaft. This fan was electrically driven and was used as a standby being worked at the weekends when the underground fans were being overhauled or when any problems occurred with the underground fans.

Chief Inspector Redmayne commented that regular measurements of the quantity of air passing through the various districts were not taken, the interval being from fourteen to forty-nine days and that the measurements were, he thought, taken too close to the shafts to give a full picture of the ventilation of the workings. He also mentions that the actual sites of ventilation measurement were also not recorded.

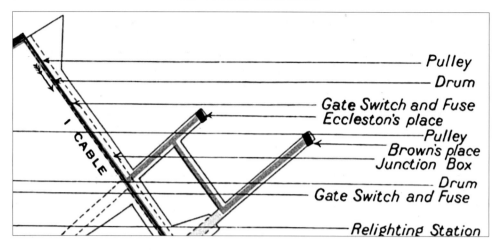

Brown's place (top right) was a single road heading proving the seam, here indicated on the inquiry plan of the workings in the North Plodder seam. Appendix A to the inquiry report contained extracts from the firemen's reports for the Yard and Plodder districts for December 1910. The list shows that many single road headings regularly gave off gas, Seddon's, Jolley's, Eccleston's and Brown's appearing many times. Occasionally, workplaces are recorded as being 'fenced off for gas', Brown's being an example on four occasions.

In general, officials stated that their coal faces were well ventilated and gas was never found in the general body of the air. Gas was found in areas of the mine where it might be expected, in exploratory single-road 'headings' in advance of coal faces proving the continuation of the seam. Where roof falls occurred in these headings, gas [being lighter than air] might accumulate in roof cavities.

Redmayne questioned Tonge about one of these headings in the North Plodder, known by the chargeman's name as Brown's. Tonge displayed a lack of knowledge of active working places and practices in place at Pretoria. He could not remember whether it was ventilated by either air pipes or 'brattice' sheeting [heavy duty textile sheets pinned up to roadway timbers to divert some of the air current]. He said he could not imagine a fireman [deputy] allowing men to drive such a heading without some artificial means of additional ventilation [rather than having in place manager's or even undermanager's rules for working these headings he was happy to leave the decisions to his lowest level of official].

Tonge also showed he did not know how another heading, known as Eccleston's, was ventilated in the South Plodder [see image]. This heading extended 118 yards in advance of the coal face and was not being ventilated with bratticing.

Redmayne stated: 'He [Tonge] said the air circulated naturally as the place dipped slightly [an astonishing assumption to make]. I put it to Mr Tonge that the fact that the place dipping was no reason in favour of its being properly ventilated …'

Redmayne asked Tonge: 'And you instance that as an argument in favour of its being well ventilated?'

Redmayne also asked: 'Mr Tonge, you do not wish to make me believe that is satisfactory do you?'

Tonge answered: 'I do not; but as a matter of fact in that place the air came into it and passed out along the roof. The heat of the gas, if there was any, and the heat of the men formed a sort of natural ventilation.'

This is an astonishing statement to make from someone who was not on a daily basis acquainted with this particular heading, nor the details of work being carried out in the various districts below ground. As all the men and officials in the district were now dead, nobody could contradict him.

Redmayne asked: 'Mr Tonge, you do not wish to make me believe that is satisfactory do you?'

Tonge replied with a statement that as good as stated that the workmen themselves assessed the ventilation requirements. His final matter-of-fact sentence is almost too incredulous to believe coming as it did from a highly qualified [on paper] colliery manager!

> I do not for one moment wish to say I consider that was right but the men down the pit largely judge by whether a place is naturally cool and whether it is ventilating itself or not, and that is what they were doing there. It was ventilating itself *for some reason or other.*

When asked by Redmayne what quantities of air were being diverted into the heading, Tonge said he had some figures, but those figures were from measurements taken *after the explosion.* Tonge 'was of the opinion' that 25 per cent of the air available was being diverted up the heading.

Redmayne added that he inspected the heading two days before the enquiry and found gas present. He commented on the large amounts of gas found as coal faces or headings approached the geological fault in the Plodder workings leading to men being sent home. He also stated that management ought to have increased ventilation to those areas. He cited the night shift fireman [deputy] William Bullough, who had stated that the amounts of gas were so large that no amount of increased ventilation would have fully diluted the gas.

Redmayne felt that additional ventilation should have been provided if only to dilute partially the gas present; Tonge said no amount of ventilation would achieve this. Redmayne stated that even though no contravention of the Coal Mines Regulation Act 1887 had taken place, it was his opinion that 'best mining practice was not followed'. He added that the gas problem in this particular part of the mine was not thought to have had a bearing on the explosion.

By questioning Tonge, Redmayne had exposed poor mining managerial practice and even a basic understanding of ventilation theory. In general, Alfred Tonge very rarely went into detail about operations at the colliery, his answers were matter of fact and curt, often a yes or no, I think so or I'm afraid so, not being prepared to expand or explore points raised by Redmayne and lacking in specific detail. To say he was on the defensive as regards his own position is an understatement. Considering the enormity of what had happened under his 'management', it is understandable that he would be in a defensive frame of mind. His style of answering seems at times to border on contempt of the proceedings. He did not have the detailed knowledge of practices, events, facts and figures that the investigation expected.

It must have been glaringly obvious as the hearing progressed that a colliery manager could only efficiently take charge of one pit to be fully conversant with the minutiae of operations taking place there. One man alone could never manage four collieries at once efficiently and, most importantly, safely.

Coal Dust

Coal dust was naturally to be expected in varying quantities in all coal mines; Redmayne commented on the particular nature of the Plodder seam dust, describing it as an extremely 'quick' dust, one liable more than most others to ignition.

Redmayne questioned Tonge at length regarding coal dust, Tonge initially stating that they were 'not troubled with coal dust as they … waggoned it out systematically from the main shunts … once a week'. Tonge stated the existence of zones near the shaft insets where dust was controlled; Redmayne questioned their location. He felt they should be in areas where explosions were likely to take place where gas was being released by new working. In a very subtle way he managed to get Tonge to agree that their location was ineffective.

Safety Lamps

The Wolf Safety Lamp was the only type of oil lamp in use, with electric lamps at the pit bottom. The oil lamps burned naphtha, a mineral oil with a low flash point and were locked magnetically on the surface. Previously, the 'Protector' double-gauze safety lamp [manufactured at Monton, Eccles] had been used. Tonge explained that the change to Wolf lamps had been made approximately two years before, as the lamps could be relit below ground should the light be extinguished through banging the lamp or various other reasons. The lamps were fitted with an internal strip match, which was operated with a metal key. Initially, Wolf lamps were supplied to officials; later, colliers were supplied with them as well.

During the inquiry, Paul Garswood, a day-wage man who worked in the North Plodder district, recalled making a key for himself, even though not authorised to relight lamps. He mentions a deputy lending him his key so that he could practise relighting his lamp, an illegal practice. That deputy, Isaac Ratcliffe, was to die in the explosion. Another boy, William Singleton, assistant to the coal cutter man, stated that he also had made a key to relight his lamp and had kept the fact a secret.

Redmayne questioned the head lamp man, William Mangnall, about lamp issue and maintenance systems in place. The man was under a great deal of stress, having lost his sons in the disaster; Redmayne also noted his distinct short-sightedness. William stated that a record of the number of broken lamp glasses had been kept, the figure for the last eight months being 1,200. Considering close on 900 miners worked down Pretoria, this was not an alarmingly high figure. The performance of the Wolf lamp would be questioned later in the inquiry as a possible cause of the initial gas ignition

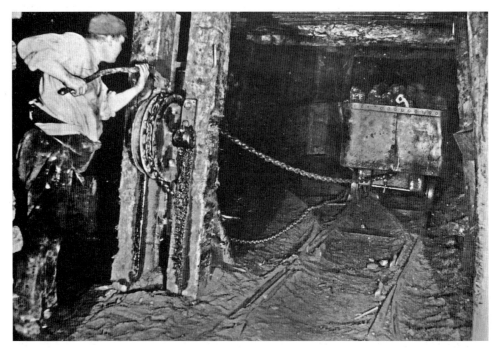

Coal faces at Pretoria worked to the rise, coal was then sent by conveyor to a tub loading point, then jigged (lowered down in tubs using a hand-operated braked winch) down to the cross roads (short roads linking the jigs to the main haulage roads) or main level haulage roads. Here a man is operating the jig brake to control the speed of the tub. Steep rows of terraced houses in Tyldesley were known as 'The Jigs', two men from the town losing their lives in the disaster.

Coal Haulage

Coal mined at the face was hauled away on the main roads by endless rope haulage powered by an electric motor. Where coal faces worked to the rise, it was jigged [lowered down in tubs using a hand-operated braked winch] down from the face to the cross roads [short roads linking the jigs to the main haulage roads] or main haulage roads.

No horses or ponies were employed. All the main haulage roads in No. 3 Pit, with the exception of the Down Brow Yard seam district, were in the return airways. Redmayne regarded the use of return air roads [usually very dusty and containing variable quantities of gas] being used for coal haulage was potentially an important factor to be borne in mind when arriving at a theory for the causes of the explosion.

Coal Cutting

Mechanical coal cutting was in use in Nos 1 and 2 faces of the North Plodder district. The coal cutters were of the bar type and electrically driven. All the cutting was carried out on the night shift, the breaking down and filling of the coal was done during the morning or day shift. The coal face conveyor was also electrically driven. The conveyor at the coal face of No. 2 North Plodder was of a bogey type which was hauled along the face by hand. The Gibb-type conveyor on the No. 1 face was also electrically driven.

Electricity

On the surface was the large electric power-generating plant between Nos 3 and 4 shafts. This served all the collieries in the Hulton group. It generated three-phase current at 2,500 volts, the exhaust steam from the winding engine being reused to drive the turbines linked to the generator. The current at Pretoria Pit was taken down the shaft at a voltage of 465 V. There were two separate cables down the No. 4 downcast shaft and two cables down the No. 3 upcast shaft to the Yard Seam inset. There were also cables in the shaft which supplied the Trencherbone and the Arley seams.

Electricity was used in the Yard seam level at the shaft siding near the downcast shaft and in two of the five main districts. The Bottom Yard district had two electric pumps and the North Plodder district had electric haulage engines and coal cutters as well as conveyors.

An electric motor was in the course of erection in the South Plodder section. It had not worked up to the explosion and the cable to it was not live. After the explosion, it was found that several motors had been running at the time of the blast and the bulk of the coal had been cut during the night, but the conveyor was working when the coal-getting shift was at work. Other electrical fittings below ground included lights and the ventilation fans.

Working Methods and Conditions at the Time of the Explosion and Recovery Operations

On the day of the explosion, the barometric pressure was 29.6 inches [1,012 millibars], slightly high but not favourable to an explosion of gas. The wind direction was southerly, the air being extremely moist at 98 per cent relative humidity. At the coal face in the North Plodder district, the temperature was 68 degrees Fahrenheit.

Evidence came out during the inquiry of men being 'gassed' occasionally in the North Plodder district. This meant that the volumes of gas [probably where roof falls had occurred] were so high that the oxygen percentage was reduced, the men being suffocated temporarily.

Regular working places below ground were usually named after the chargeman or contractors working there. Wild's place was close to the coal face on No. 2 North Plodder district, John, Richard and Thomas working there advancing an air road at the face end. Chief Inspector of Mines Redmayne concluded that the explosion occurred at this point where the intake (fresh air) roadway for No. 2 North Plodder met the face.

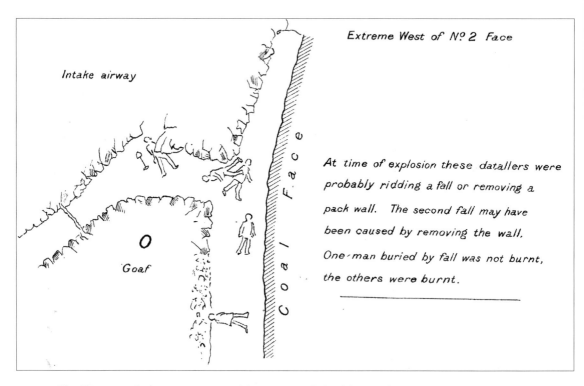

Extreme West of Nº 2 Face

At time of explosion these datallers were probably ridding a fall or removing a pack wall. The second fall may have been caused by removing the wall. One-man buried by fall was not burnt, the others were burnt.

Chief Inspector Redmayne summarised his reasoning behind his conclusion as to the location of the ignition origin as follows: a roof fall had taken place at this point; the body of John Wild had been buried and not burnt, whereas the two bodies next to him had. Finally, evidence had been given by the night shift of 'weighting', or roof movements warning of imminent roof falls. The short extension of the coal face (top) would be a prime candidate for a gas build-up if not ventilated. The pocket watches belonging to the Wilds, who died here, can be seen in the colour section.

Methane explodes when present in percentages between 5 and 15 per cent. A methane percentage of 25 per cent would not be explosive but the subsequent reduction in oxygen percentage would be at a suffocating level, perhaps as low as 4–6 per cent [normal air contains 20.9 per cent oxygen].

Men working in the North Plodder mentioned their lamps going out after roof falls and having to erect brattices [temporary ventilation sheeting] to divert the air up into the cavity to flush out the gas.

On the morning of the explosion and for some days previous to that, Richard Wild and his two sons John and Thomas were working at a fall at the top of the intake to the No. 2 face to make the inlet larger. The cutter had never cut across the face to the end. Alfred Teasdale, a dataller [a day-wage man not directly involved in coal production] who had been working in the place on the afternoon before the explosion said that the fall took place on the Sunday night of the week before the disaster. He had been working under it the night before and saw that the roof was very bad. In all probability, there was gas coming off from this weighting.

He said, 'We didn't venture to go in [beneath the fallen ground]. We had to push our spades as far as we could and then fill it [to remove the fallen dirt, the roof threatening to further collapse].'

Paul Garswood, a day-wage man, recalled working in these roadways [Nos 2 and 3 jigs] the night before the explosion. He had been ordered to timber the fallen area and resupport the roof cavity.

He said, 'I will show you [the gas]. So I pulled my lamp down and held it up about on a line with my chest, and it was plain to be seen there [the enlarged flame on his lamp indicating the presence of methane]. Come on, we will be getting out.'

On the way out from the district, he recalled meeting a number of men whose lamps had gone out due to the high gas percentage, so many that the deputy Isaac Ratcliffe left them his relighting key.

Alfred Tonge, the colliery manager then recalled the course of events he took after the explosion occurred [see earlier].

The Work of the Rescue Teams Praised

Chief Inspector Redmayne commented on the great advantage of the use for the first time after a colliery explosion of squads of trained rescue men, available at short notice. In this case, their use had not saved those affected by the actual explosion but their presence no doubt saved the lives of those involved in exploration and recovery work.

The excellence of the training being given at Howe Bridge rescue station [the first central rescue station in Britain serving a wide radius of collieries, opened in 1908] was commented on as an example 'to the rest of the kingdom'.

Discussion as to the Probable Causes and Point of Origin of the Explosion

Chief Inspector Redmayne stated that he came to a 'very definite' conclusion [backed by other mining engineers involved] after his inspection of the No. 3 Pit workings on the Saturday preceding the inquiry.

He stated that the eminent mining engineers Sir Henry Hall and J. H. Walker could not pin down with total certainty the origin of the explosion but felt overall that the No. 2 North Plodder coal face was the most likely, Redmayne agreeing. The evidence for the direction of the blast on dislodged roadway girders and other features, including debris embedded into pit props on one side only, helped them come to this conclusion.

Manager Alfred Tonge suggested before the enquiry was held that he felt a possibility was sparking of pulleys on rope haulages at No. 1 North Plodder haulage jig, but this also was dismissed due to lack of evidence. It is interesting that he was aware at all of open sparking in a section of the pit; possibly he was told of this occurring after the explosion by men who worked in that area on the other shifts.

A lengthy discussion surrounded the electrical conveyor switch in the heading in the North Plodder and that it may have been made to spark by the force of the initial gas explosion. Some men stated that they had seen sparks there; others who worked alongside them said they had never seen any sparks from the switchgear. Redmayne was dubious as to the truthfulness of some of these witnesses, and the electrical inspector Nelson thought that a sparking switch would continue to spark once in a condition to spark in the first place and dismissed the theory.

The North Plodder conveyor coal face had been left as gas free by the night shift men. Attention turned to the Wolf safety oil lamps used in the North Plodder and the pit in general. The lamps and their gauzes [which the flame burned inside of, normally] were subjected in the laboratory to conditions far worse than could ever have existed down Pretoria with high-velocity currents of gas, sprinkling of coal dust into the gauzes and finally mechanical damage including cracking the lamp glasses.

The tests proved negative and showed the lamps to be reliable in harsh conditions, but Redmayne stated that they could never know the actual conditions the lamps had been subject to at the time of the ignition if indeed they were a contributory factor.

Bodies found alongside the conveyor on the North Plodder coal face showed signs of carbon monoxide poisoning and scorching, other bodies were found heading away from this point in either direction as though they had attempted to walk away and had been overcome by carbon monoxide. Some had abandoned their lamps, suggesting they had been extinguished due to the force of the blast. Wolf lamps were known to be susceptible to extinguishment after sudden physical force was applied, such as by dropping them.

Redmayne felt it very important that the night-shift fireman [deputy] Isaac Ratcliffe had stayed behind at the end of his shift and was still below ground at the time of the explosion. His body was found at the return end of the North Plodder coal face. Redmayne thought that perhaps he had stayed behind to rectify some form of problem or inform the incoming day shift of it.

Attention turned to No. 2 coal face in the North Plodder district. Redmayne, by painstakingly retracing the course of the blast through physical evidence in roadways, noted the types of injury sustained by men at various points and studied the distance men had been able to walk after the blast. He concluded that the explosion occurred at the point where the intake [fresh air] roadway for No. 2 North Plodder ends [see the image earlier of where the Wilds were working].

Redmayne summarised his reasoning behind his conclusion:
(i) A roof fall existed on the morning of the explosion at this point.
(ii) The bodies of day-wage men [roadway repairers] were found at this point.
(iii) One man buried at this point by a roof fall was not burnt, those next to him were.
(iv) Evidence had been given by the night shift of 'weighting' [roof movements, indications of imminent roof falls] in the area.
(v) Roof falls in the North Plodder were normally accompanied by the emission of gas.

Redmayne concluded also that, notwithstanding the tests on the Wolf lamps, which showed it to be reliable, the ignition of gas probably came from damage to a lamp in the presence of gas, probably due to a roof fall.

He stated that but for the presence of coal dust on the coal face [it had been stated to be a dusty face], the explosion may have been limited by the amount of gas discharged.

Regarding management of the colliery, Redmayne questioned colliery manager Alfred Tonge. Initially, he put on record that he felt Tonge was most assiduous in his work and devoted his whole time to it, but besides being the manager of the Hulton group of collieries,

he was also the manager of each individual pit [and thus had a responsibility for being in close personal contact with operations at that pit].

Redmayne pointed out the fact that at each pit there was only one undermanager and that the general manager should confer with his officials each day. Tonge agreed but had to add [in the manner which was becoming typical] that he felt 'after the experience of the last two months I would not think of not seeing the men as often as I possibly could, but I do not think for one moment that it would have made any difference to this explosion'.

Redmayne asked Tonge if he felt his colliery was understaffed, to which he replied calmly, 'I had not thought so sir, before this accident. I have never suspected that it was. I never suspected that such a thing as this could have happened at our colliery, and I think the disaster is quite out of proportion to the cause of it. It has been a small cause whatever it is.'

Redmayne responded [in disbelief, no doubt], 'I quite appreciate the point that a small cause may cause a big disaster. It may have been a small ignition of firedamp. Small as the explosion may have been, tiny it may have been, I quite realise it. But still it is with a view of obviating such an initiation that the inquiry is being carried on?'

Tonge replied as if reluctantly accepting that practices had to change and that his workload would become unbearable as a result! 'I had not thought so before the accident, but I might say that I shall not be satisfied for the future to have so much work on my own shoulders.'

Redmayne asked a very obvious question, as if to drive home his feelings about the situation in place at the Hulton Collieries, that each colliery should have its own manager, with a group manager overseeing the whole: 'I mean the responsibility is enormous of the management of several collieries, is it not?'

Tonge replied, 'Yes.'

Redmayne admitted that within the law Tonge was entitled to delegate his responsibilities to his undermanagers. He added that he felt there should be some limit to the number of mines a manager could personally supervise and that he should at the very least exercise some level of personal control over each colliery through contact with all levels of officials.

Redmayne highlighted the danger of leaving the night-shift inspection of districts to the leaving night-shift fireman [deputy] rather than the arriving day-shift fireman. The night-shift fireman in the Plodder district had stayed behind after his normal shift and was killed in the explosion. He stated as regards the inspection: it is made by a tired man towards the close of his shift, by a man consequently in a less vigorous and alert state of mind and body than the incoming fireman.

Redmayne felt there was a danger of the night-shift fireman's report being accepted without question by the incoming day-shift fireman and also that the leaving fireman might not mention any potentially dangerous situations to the next official. The crucial fifteen to thirty minutes interval between the leaving of the night-shift men and the arrival of the day-shift men might allow a dangerous situation to deteriorate, such as a build-up of gas in an area where roof falls appeared imminent to the night-shift fireman.

Redmayne felt so strongly about this he suggested future legislation should correct this anomaly to ensure constant inspection and reporting. He felt that the use [as at Pretoria] in report books of the standard phrase 'gas diluted as made', in other words gas was known to be present and that the ventilation current removed it, was not adequate. He wanted the location of gas found and the manner of removing it to be documented.

Redmayne through experience knew that most explosions in mines had taken place due to flame and sparking. Safer housings for electrical equipment might be designed, but as 679,131 miner's safety lamps were in use in British mines in 1909, the rapid move to electrical lamps was not immediately practical. He commented on the changeover in 1908 at Pretoria from the Protector safety lamp to the relightable Wolf lamp, commenting that Tonge should have introduced new rules for their use and the restrictions on relighting by unauthorised persons.

Turning to the subject of coal dust, Redmayne reminded everyone that the rapid spread of the explosion through No. 3 Pit was due to the presence of coal dust, that attempts to

lessen the potential for explosion had been made but away from the coal faces, thus being ineffective.

He decided not to make any specific recommendations regarding dealing with coal dust and rendering it harmless, showing that experiments were still taking place with stone dust covering of dusty areas; he also touched on the subject of watering dusty areas, which would have to be fairly constant and may affect the environment to the detriment of the miners.

As regards ventilation, Redmayne pointed to a breach of the Coal Mines Regulation Act 1887 where measurements should have been made of the quantity of air passing through secondary roads, rather than just main roads leaving the downcast shaft. The irregularity of the readings taken was also commented on.

Commenting on the use at Pretoria of the return airways as haulage roads, Redmayne and other mining engineers felt this was a bad idea. With haulage roads being laden with coal dust, the added danger of the gas they contained only compounded the potential for a forceful coal-dust explosion.

Redmayne concluded his report by commenting on the bravery of the rescue team members, particularly those who were first down the pit after the explosion. He named them in his report: Alfred Tonge, manager, James Henry Polley, electrical fireman, James Moss, shaftman, John Hilton, shaftman, William Markland, fireman, John Hardman, fireman, Robert Roberts, fireman, John Herring, fireman, and James Hartley, fireman.

Redmayne's report was submitted to the Home Secretary at the time, Winston Churchill (from 1910–11), who had been busy sending police to quell the Tonypandy (South Wales) miners' riots in November.

Appendix A to the report contained extracts from the firemen's reports for the Yard and Plodder districts for December. The list shows that many workplaces regularly gave off gas, Seddon's, Jolley's, Eccleston's and Brown's appearing many times. Occasionally, workplaces are recorded as being 'fenced off for gas', Brown's being an example on four occasions.

Appendix D lists those killed, their cause of death, remarks on their condition as found and tally number.

THE COAL MINES ACT 1911

In 1911, the Coal Mines Act came into force. The success of the newly trained Howe Bridge Rescue Station men in saving lives during rescue and recovery operations at Pretoria had been noticed. It became the duty of all coal owners to make adequate provision in the manner laid down for the establishment of rescue work in mines, and for the maintenance of rescue apparatus. Rescue stations had to be provided so that all mines were within a 10-mile radius of a station, unless they employed less than 100 men or were specially exempted from the provisions of the regulations.

Between 1911 and 1918, additional rescue stations were opened in Lancashire to cover all mines in the county, at St Helens, Coppull, Skelmersdale, Denton and Burnley. Including sub-stations without full-time brigades, the number of stations in Britain was to reach forty-six.

Even though it was never proven that a damaged oil lamp might have ignited the gas at Pretoria, the law regarding miner's lamps was also tightened up:

1. All lamps must have double gauzes (the internal wire gauze surrounding the flame area which stopped enlarged flames in the presence of gas leaving the body of the lamp).
2. A straight edge put between the outside of adjacent pillars (the brass or steel 'standards' separating the oil container from the bonnet to allow the lamp glass to be in place) must not touch the glass.
3. Lamps must be so constructed that they cannot be assembled without the gauzes.
4. Lamps must have an efficient locking device to prevent removal of oil vessel, glass or bonnet by unauthorised persons.

As regards management and supervision of collieries, the situation where Alfred Tonge could be

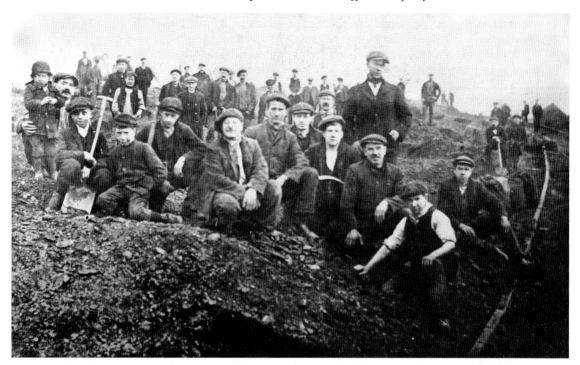

Coal picking during the 1912 strike on Pretoria 'rucks'. These men must all have lost many friends and workmates in the disaster of two years earlier. The dispute, which had started at the beginning of March, was over wage reductions. It began on 1 April and lasted for eighty-nine days.

in charge of three or more collieries at once ended. The Act included the following sections:

> Every mine shall be under one manager who shall be responsible for the control, management, and direction of the mine, and the owner or agent of every mine shall appoint himself or some other person to be the manager of such mine.
>
> A person shall not be qualified to be appointed or to be an under manager of a mine which is not required to be under the control of a manager, unless he is for the time being registered as a holder of a first or second class certificate of competency under this Act.
>
> There shall be two descriptions of certificates of competency under this Act:
> (1) First Class certificates.
> (2) Second Class certificates.
>
> For the purpose of ascertaining the fitness of applicants for certificates of competency under this Act, a Board, to be styled 'The Board of Mining Examinations', shall be constituted by the Secretary of State.

This new style of assessing competency would include oral examination of candidates rather than relying on paper qualifications as a result of taking written examinations. In this way, a candidate could be assessed as regards his practical situational competency rather than theoretical knowledge.

Redmayne and others like him could only hope that the new act might further eradicate the reasons for many of the disasters in the industry from the mid-nineteenth century onwards; he also knew the nature of the industry he worked in and the attitudes of its owners.

The comments made twelve years after Pretoria in *What We Want and Why* (1922) by Noah Ablett, a South Wales mineworker and trade unionist (4 October 1883 – 31 October 1935)

show the reality of the state of the industry and the profit motive which continued to drive it relentlessly forward at the expense of lives:

> I have examined several collieries in South Wales and a few in Yorkshire. I have had hundreds of conversations with miners in all parts of the country and I think I can fairly say that I have never heard of a single instance where the conduct of a colliery is up to the standard of safety asked for by the Mines Act, 1911. It is common ground that even if that Act was rigidly adhered to the mines would not by far be in that condition of safety that they might easily be, by a greater expenditure of money. While, as we might expect, some mines are managed more carefully, and less regard to the cost of safety is had than is the case in others, the tendency unquestionably is that the average safety standard approximates to that of the poorest mine. Why is this the case? The answer is – and it is an answer of sinister significance – *that it is cheaper to take risks than to expend the money necessary to the maximum possible safety*. Colliery owners are not angels, but even if they were better men than they are, this ugly fact would always be a temptation.
>
> In mining the incentive of profits inevitably means a big casualty list. With all the elaborate machinery of Mines Acts, the slight increase in Mines Inspectors, the restraining influence of the powerful Miners' Federation of Great Britain, the casualty list is four men killed every twenty-four hours, Sundays included, and nearly 200,000 wounded, some maimed for life, and the slightest recorded in this total, incapacitated for seven days. This is appalling, and no intelligent miner can ease his conscience by acquiescing in this terrible state of affairs. Surely every decent minded man agrees that human life is more sacred than private gain. If that be so then an impartial study of the history of mining for the last century must carry the sorry conviction that thousands and tens of thousands of lives have been lost because mining is conducted primarily for private gain.

The Relief Fund

From the day of the disaster onwards, fundraising collections began to arrive at the Chequerbent offices of the Hulton Colliery Co. from just about every situation where people came together, from workplaces all over Britain, from parties in homes to the staff of large companies, also thousands of wealthy and not so wealthy individuals. A total 593 widows, children and parents now needed caring for urgently.

The Mayor of Bolton, Alderman J. T. Cooper, energetically went into action, setting up a mayoral fund on 23 December. He was followed by the Mayors of Manchester and Liverpool. The Bolton fund advanced money to pay the men who had been thrown out of work by the disaster. Men were paid 5s per week, widows 4s and 2s a week for each child under fourteen years of age. Until they got their compensation from the colliery company and the Lancashire & Cheshire Miners' Permanent Relief Society, they were paid double. The amount paid to the man included all the men in the family, whether father or son. There were a number of cases where the relatives had to attend the pit every day waiting for the bodies of their loved ones. One man was at the pit every day for two weeks waiting for the body of his son. In these cases 20s a week was paid. In the case of old fathers and mothers, 3s a week was paid.

A court met on 16 and 17 February, when the pit had not worked for more than four days a week, and sixty cases were dealt with, an average compensation of £249 per man being awarded. In April 1912, the committee decided to increase the amount paid to widows to 7s per week, children 2s per week and to a father or mother who had lost a son, 5s per week for the rest of their lives. It was not decided at that meeting what should be done in cases where two or more in the family had been lost.

Under the Workmen's Compensation Act, the Hulton Colliery Co. had to pay a total of £32,481 (£1,853,365 today) in compensation to 196 widows and other dependants. Usually, the money was invested by the Bolton County Court in the Post Office Savings Bank, with payments paid monthly to dependants via the Post Office.

The Lancashire & Cheshire Miners' Permanent Relief Society, based at Bridgeman Terrace, Wigan, paid widows 4s per week with 2s for each child in the house. Only eleven of those killed were not members of the society. Child payments ceased at the age of fourteen.

The winding up of the relief fund was announced in January 1971 after having administered all but £11,881 of the remaining funds. The initial £149,200 raised had been invested, with £300,000 being paid out from 1911 to 1975. The fund's committee still met until October 1975, administering the remaining monies to suitable mining-related charities.

All the records of the fund are now held within Bolton Archives. The records of Lancashire & Cheshire Miners' Permanent Relief Society (Wigan) are held at Wigan Archives. The personal correspondence files in these two series of records really bring home the struggle families were to have many years after the disaster. Being sensitive, not all these files are open to viewing.

Worsley Urban District.

HULTON COLLIERY DISASTER

RELIEF FUND.

A Fund has been opened at the District Council Offices, Park Road, Walkden, in aid of the sufferers from the terrible Colliery Explosion at the Pretoria Pit, Over-Hulton.

Subscriptions are urgently needed, and will be thankfully received at the above Offices.

JOSEPH WALKER,

Chairman of the Worsley Urban District Council.

December 22nd, 1910.

A. ROTHWELL, PRINTER, WARDLEY STREET, WALKDEN.

In Memoriam

As bodies began to be buried, mourning cards were produced. Photographs of the dead appeared in local newspapers such as the *Bolton Evening News* and the *Farnworth Journal*. Later, disaster memorials in various forms were produced to remember the men and boys, from the churches they attended, also their clubs and societies. Memorial and poetry cards were also produced, some to keep cash coming in for the Relief Fund. A substantial memorial was erected in Westhoughton cemetery, being formally unveiled on 25 November 1911 (other memorials can be seen in the colour section).

The disaster has been remembered every year since 1910 in local churches along with articles and reminiscences in the press. With 2010 being very special, a new monument is to be unveiled near Westhoughton church. A special service will be held at Westhoughton church with the Bishop of Manchester in attendance. An exhibition at Westhoughton Library will be staged, along with talks.

HULTON COLLIERY DISASTER.
TOMB OF THE 13 UNIDENTIFIED BODIES, WESTHOUGHTON CEMETERY.
P. Westhead, G. Gleaves,
Chairman, Ex-Chairman,
Westhoughton District Council.

Postcard issued after the completion of the grave of the first thirteen unidentified men and boys in Westhoughton Cemetery. Westhoughton Council officials past and present officiate. Later, a total of twenty-four unidentified bodies would be buried in the cemetery and a memorial erected. Eight were to be later identified from clothing, property and photographs. The remaining sixteen deaths were registered as unknown males. One body was never found.

Hulton Colliery Disaster,

DECEMBER 21st, 1910.

□

Unveiling of —
— Monument

IN

Westhoughton Cemetery,

NOVEMBER 25th, 1911.

□

Form of Service.

Ralph Seddon, Printer, Westhoughton.

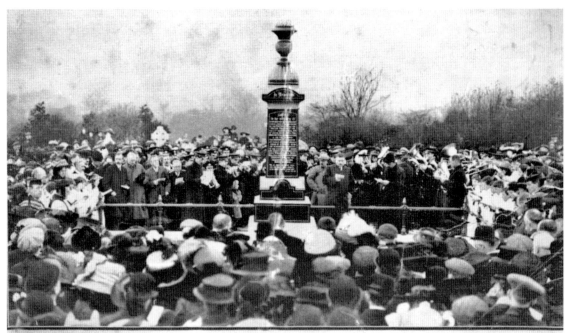

MONUMENT TO THE VICTIMS OF THE HULTON COLLIERY DISASTER.

A very large attendance at the official service for the new memorial in Westhoughton Cemetery, 25 November 1911.

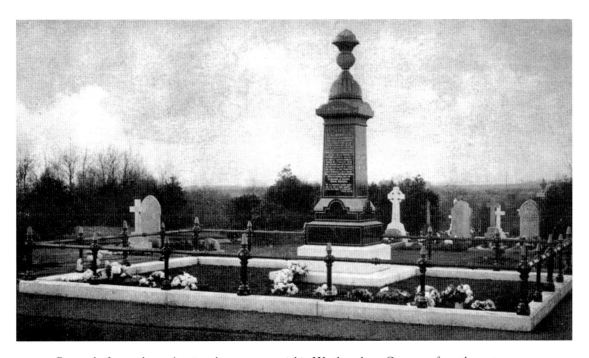

Postcard of around 1911 showing the new memorial in Westhoughton Cemetery from the east.

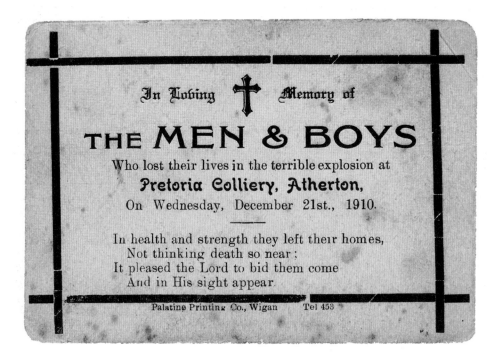

In Loving ✝ Memory of

THE MEN & BOYS

Who lost their lives in the terrible explosion at
Pretoria Colliery, Atherton,
On Wednesday, December 21st., 1910.

In health and strength they left their homes,
Not thinking death so near ;
It pleased the Lord to bid them come
And in His sight appear.

Palatine Printing Co., Wigan Tel 453

THE PRETORIA DISASTER

THREE hundred miners, brave and bold,
 Martyrs true as those of old,
Saw not as they walked along the road
That Death on his pale horse grimly rode ;
Nor, saw as passed they, through the cage door,
One go with them too, ne'er seen before.

Which of these men had he come to call ?
Not one or two, he had come for all,
One whistled as he thought of wife and home,
One smiled to think of the home to come,
And sturdy lads thought in pride and glee,
Of the Christmas Day so soon to be.

Not one of them knew that never on earth
They should greet the day of the Saviour's birth,
Nor thought that the dark and gloomy mine,
Was the gateway to the Life Divine,
Till God's voice rang out in mighty tone,
Come men, come up unto My throne.

On Jordan's banks, when God spake, they said
To one another, " It thundered."
So these, when they heard the explosion's din,
Said, "Run for your lives, ere the roof fall in."
Yet out of these three hundred men,
But one saw the light of day again.

Only one saved to tell the story,
How the others heard the call to Glory,
But angels saw Heaven's gates flung wide,
As the victorious army trooped inside—
Martyrs, not to the beast or stake,
But to daily work for duty's sake.

But Lord we cry, can'st Thou hear the moan,
Of the lonely ones left here alone ?
Canst Thou hear, from thy throne on high,
The orphan's sob, the widow's cry ?
Can'st Thou not see from Thy throne, on high,
Hearts that are broken with agony ?

The sound of grief has gone through our land,
And sympathy stretches forth her hand,
But only Thou, who hast dealt the blow,
Can comfort give ; this, Lord, we know.
Thou, who hast caused this blow to fall,
Do Thou, in thy mercy, help them all.
 Ella Connor.

Above: Fundraising memorial card by the Palatine Printing Co., Wigan. The company produced memorial cards and tissues for many colliery disasters.

Left: Memorial card with a poem by Ella Connor.

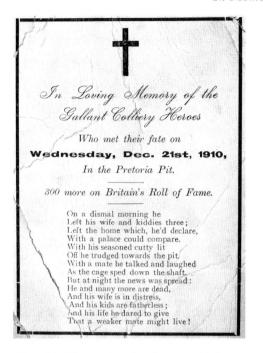

Above left: Memorial card, unknown publisher or author.

Above right: Memorial card written by John Hamer of Bolton, the one-penny proceeds going to the Mayor of Bolton's Fund.

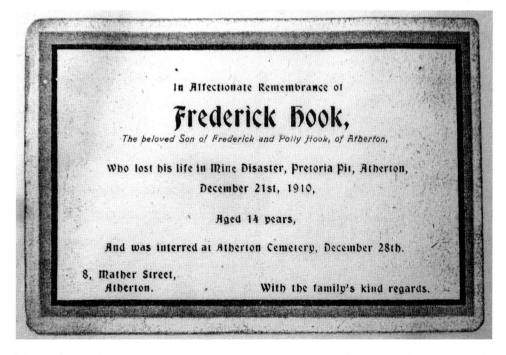

Memorial card for Frederick Hook, aged fourteen, of 8 Mather Street, Atherton. Frederick was brought to the surface on Christmas Day. He worked as a haulage lad on the North Jig to the North Plodder coal faces about 200 yards away. His injuries were due to the explosion itself and then carbon monoxide poisoning.

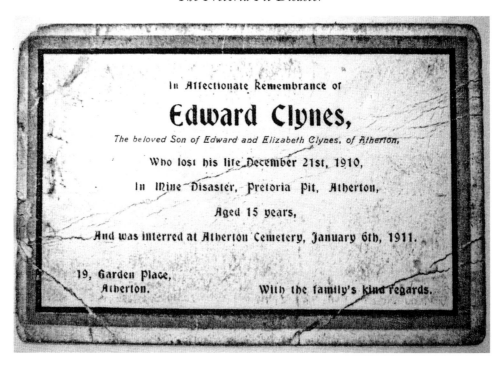

In Affectionate Remembrance of

Edward Clynes,

The beloved Son of Edward and Elizabeth Clynes, of Atherton,

Who lost his life December 21st, 1910,

In Mine Disaster, Pretoria Pit, Atherton,

Aged 15 years,

And was interred at Atherton Cemetery, January 6th, 1911.

19, Garden Place,
Atherton.

With the family's kind regards.

Independent Order of Rechabites,

BOLTON ADULT AND JUVENILE DISTRICT No. 7.

Hulton (Pretoria) Pit Disaster,

DECEMBER 21ST, 1910.

In Memoriam

THE Sixteen Adult Members and Eight Juvenile Members who lost their lives in the above disaster.

Above: Memorial card for Edward Clynes, aged fifteen, of 19 Garden Place, Atherton. He worked on the coal face in the Top Yard district, 800 yards west of No. 3 shaft. The return air road met the coal face where he worked. He must have met the full force of the coal-dust blast, which had travelled hundreds of yards gathering speed and power. His injuries were truly horrific and do not need to be described here.

Left: Sixteen members of the Bolton Independent Order of Rechabites (a temperance movement that dated back to the 1830s) died in the disaster.

The Decline of Hulton Colliery Co. Ltd

The Hulton Colliery Company (and Alfred Tonge's) involvement with management of financial aspects of the relief of the families was taken over by the Pretoria Pit Explosion Fund, set up in April 1912. The disaster ended the previously illustrious mining career (in Britain) of Alfred Tonge, who only two months later, on 28 June 1912, left for Glace Bay, Nova Scotia, Canada. This was a busy coal-mining district, and Alfred, no doubt through his professional and academic contacts, was given work with the Dominion Coal Company as a colliery superintendent (manager).

The Canadian Passenger Lists for 1865–1935, specifically for 28 June 1912, show the sailing of the *Virginian* to Quebec:

Alfred Tonge [aged] 42. Destination: Glace Bay [Nova Scotia]
Accompanied by Mrs Tonge, Francis Tonge

Alfred was asked, 'Ever been to Canada before?' 'No.' 'Intend to reside permanently in Canada?' 'Yes.'

To have been the colliery manager involved in a large disaster where very lax managerial practices had been exposed in the inquiry must have been unbearable in many respects, locally on a personal level and professionally within the industry, probably leading to his decision to emigrate. Five years later, events came back to haunt him when, in July 1917, at the New Waterford, Nova Scotia colliery explosion at least sixty-two men died. The mine superintendent (colliery manager) was one Alfred Tonge.

His career in mining survived, as we find him President of the Mining Society of Nova Scotia in 1920–21 and as a member of the Canadian Institute of Mining in 1947. He died in 1952 after returning to his old home at Chequerbent. We find James Tonge junior a director of the Ashton Moss Colliery Co. Ltd, East Manchester, in 1926.

The old pits north of the A6 (Manchester to Chorley Road) had been approaching exhaustion by the time of the sinking of Pretoria, gradually closing between 1900 and 1914 (Arley Nos 3 and 4 by 1904, Arley No. 2 by 1913, School Pit by 1914). The depression in industry in general in the 1920s with falling demand for coal led to the decision to close Bank No. 2 Pit in around 1921. Bank No. 1 Pit closed on 30 November 1927 along with Chequerbent Colliery. The end of mining within the Hulton estate came with the closure of Pretoria Pit in April 1934, the auction taking place in August.

CLOSURE OF PRETORIA PIT AND THE AUCTION

With the closure of Pretoria, the only pit left belonging to the company was Cronton Colliery, Halsnead, north-west of Widnes and south of today's M62. The Hulton Colliery Co. records held at the Lancashire Record Office show that boreholes were being sunk at Cronton from

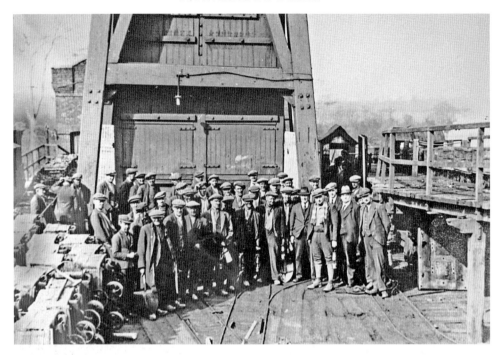

Pretoria Pit closed as a working pit in April 1934 (this photo dates to August 1934), probably due to exhaustion of coal reserves, which had never been particularly extensive, also limited by the extent of the Hulton Estate. The reserves were also bounded by the old workings of Peelwood and Chanters collieries, against which barriers of unworked coal had to be left. The men are stood on No. 3 Pit bank, the wooden headgear now fully encased for use with a surface fan. Tubs have been brought up for the auction. Some of the older men here probably survived the explosion in 1910.

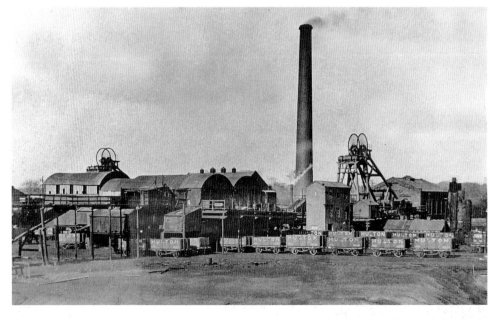

The colliery after the closure announcement in 1934, seen from the south east. From the left is No. 3 Pit, the screen sheds and No. 4 Pit. The woods of Hulton Park are in the distance. In the foreground are the waste tips created on sinking of the shafts, the later tips off the photograph to the left, fed by the elevated tubway.

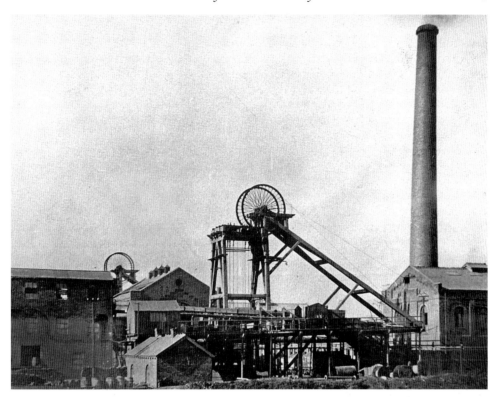

A close-up view of 1934 of No. 4 Pit headgear and engine house. The tall building to the left may be a tub tippler house, tubs being tippled by hand, unloading coal onto conveyors heading off to the picking belts.

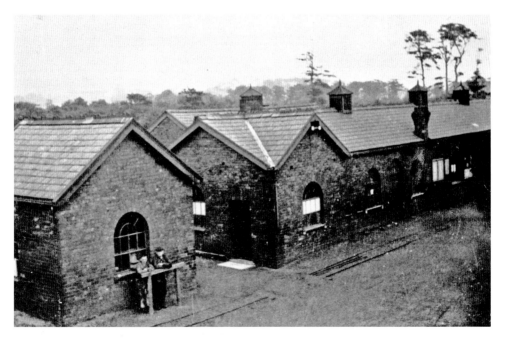

The colliery offices and lamp room photographed when the colliery was being demolished in summer 1934, Hulton Park woods behind.

around July 1907. An account appears in the financial records in June 1908 as the Cronton Sinking Account, possibly preparing for the actual work. Events at Pretoria and the miners' strike in 1912 may have delayed the decision to go ahead. The company eventually sank the three shafts at Cronton between 1914 and 1922. Many men who had worked at Pretoria were given work at Cronton. The colliery was nationalised in 1947 and closed in 1984.

On closure of Pretoria in April 1934, a rare occurrence took place, virtually the whole of the site's contents plus Pendlebury Fold brickworks were put up for auction by Edward Rushton & Kenyon on 22, 23, 24 and 25 August, even though the company was still operating Cronton Colliery. A ninety-eight-page catalogue has survived giving us a detailed inventory of just about everything that was on site at a colliery of the period. Much of the equipment listed would have been on site at the time of the disaster. The following more interesting items have been selected from it, including 1,984 x 5 cwt pit tubs:

No. 4 Pit Bank
50 x 5 cwt tubs with steel bottom, draw bar, flanged wheels 9" diameter and axles.
Automatic tub oiling apparatus.

No. 4 Pit Screen House
50 x 5 cwt tubs.
Two mechanised tub tipplers.
Steel plate shaker belt 25 feet long.
Endless wire coal picking belt 45 feet long.
Endless wire nuts picking belt 30 feet long.
Endless wire slack picking belt 40 feet long.
Revolving slack sorting riddle.
338 yards of steel bridge-rail tub track, some with wooden sleepers.

No. 4 Pit Winding Engine House
8 day clock.
Horizontal twin cylinder steam winding engine by Pearson & Knowles Coal & Iron Co. Ltd. Cylinders 36 inches diameter by 6 feet stroke. Wood lagged winding drum, 18ft diameter x 8ft 9" wide. Two cast iron engine beds 38ft long. Whitmore Patent Overwinder and Brake Gear with Slow Banking arrangement.
Two locked coil winding ropes, each 580 yards long.

Yard near No. 4 Pit
108 yards of tub track. 26 yards of bridge rail tub track.
Double decker iron pit cage with set of six suspension chains.
Timber built pit headgear, 64 feet high with four 18" square corner posts.
Two single grooved winding pulleys each 16 feet diameter for 1¼" ropes.
A 70 rung ladder.
A double decker pit cage with Ormerod's detaching hook.

Stone Dust House
Belt driven stone crusher by the Chemical Engineering Co. Ltd.

Compressor House
Ingersoll-Sergeant Horizontal belt driven air compressor, approx 8" cylinder diameter by 12" stroke. Driven by an 80 Hp AC motor, 440 volts, 575 rpm.

Boiler House
Three Lancashire boilers, two 30 feet long by 8 feet diameter and one 7' 6" diameter.
Yard near No. 4 winding engine house.
Rivetted vertical air receiver, 5 feet diameter by 20 feet high.
Two vertical egg-ended water tanks, one 6' 6" diameter by 34 feet high, the other 5' 6" by 33 ft.

Pump House
Two horizontal belt driven three throw [ram] pumps by Greenhalgh & Co (Atherton). 3½" by 6" rams.

No. 3 Pit Bank and Screen House

154 x 5 cwt tubs.

402 yards of tub track.

Two tub creepers, one 23 feet long, the other 31 feet.

8 cwt automatic tub weighing machine by J. Greenwood & Son.

Tub tippler by Pearson & Knowles, Warrington.

Steel plate shaker, 30 ft long.

Endless wire coal picking belt, 59 feet long.

Endless wire coal picking belt, 52 feet long.

Endless rubber conveyor belt, 41 feet long.

Washery

The Greaves Coal Washer, capacity 25 tons per hour, by Horace Greaves & Co of Derby.

No. 4 Winding Engine House

Pair of horizontal steam winding engines by Robert Daglish & Co, St Helens. Twin cylinders, 32" diameter by 6ft stroke. Wood lagged winding drum, 19ft diameter by 8ft wide.

Whitmore Patent Overwinder and brake gear.

Two locked coil winding ropes, each 1¼" by 580 yards long.

Timber pit headgear, 64ft high, four 18" square corner posts.

1¼" boarded tongue and groove casing to the top of the headgear [being the upcast shaft].

70 rung ladder.

Fan House

'Sirocco' fan by Davidsons of Belfast. Double inlet rope driven, 9ft diameter by 6ft wide. Capacity 225,000 cubic feet per minute.

Yard near fan house and power house

100 tons of 6ft long tub rail.

50 x 5 cwt tubs.

Yard to front of workshops

50 x 5 cwt tubs.

A stack of steel pit props.

388 yards of tub track.

1,500 x 5 cwt pit tubs [an amazing figure but typical of a colliery of the period].

Briquette House

Coal crusher and hopper. [Crushed coal was compressed into briquettes of the type still used today.]

Wagon Repair Shop

'Siskol' coal cutting machine [a percussive drill used to undercut the coal].

Smithy

200 lashing chains [used to attach tubs below ground to the wire rope haulage]

55 shackles, 26 coupling links and six rope cappings [for winding ropes]

Ormerod 10 ton detaching hook and two shackles.

Yard near No. 3 Pit and Saw Mill

Double decker iron pit cage.

130 x 5 cwt pit tubs.

Yard near Saw Mill and Smithy

Winding rope and reel, 1¼" diameter.

2 ton loco steam jib crane by Priestman of Hull. Jib 25ft long.

Single grooved winding pulley [for the headgears], 16ft diameter.

Power House

750kw three phase mixed pressure turbo alternator, Fraser & Chalmers, Erith, Kent.

350kw three phase turbo alternator, Parsons & Co.

300kw three phase turbo alternator, Parsons & Co.

300kw three phase turbo alternator, Parsons & Co., without armature.

The loco auctioned at Pretoria in August 1934 was one of three Class-X six-coupled Peckett saddle tanks. No. 4 was purchased in 1900, No. 5 in 1903 and No. 6 in 1907. Pictured here is No. 5 in later NCB days at Lea Green Colliery near St Helens. It is thought No. 4 was the loco auctioned, heading off to the Shelton Steel Works, Stoke on Trent.

Electrician's Shop
18 Cremer electric [miner's] lamp relighters each with magneto.
Acetylene generator.

Yard near Power House
Steam receiver 30ft by 7ft on 8 cradle supports.

Oil Store
Various coal drills and ratchets [pillar mounted hand coal or rock drills for shot holes]
Six rolls of brattice cloth [heavy-duty cloth used to direct the air around isolated parts of the workings].

Weigh House and Store Rooms
20 ton railway wagon weighbridge by Pooley & Son.
40 x 56lb weights.

Railway Sidings
8,539 yards of standard gauge rail track.
3,351 yards of standard gauge rail track at Pendlebury Fold sidings.

Mechanic's Shop
8 'Sylvester's' gablocks [used to withdraw props from a safe distance amongst many other uses].
75 coal drills and boring bars.

Loco Shed
Six wheel coupled saddle tank locomotive by Peckett & Sons. Two 16" diameter cylinders, 22" stroke, copper firebox. 162 steel tubes x 1¾" diameter. Wheels 3ft 10" diameter, 11ft wheelbase. New boiler and firebox 1925, new tubes 1932, wheels retyred 1934.

Lamp Room
5 Premier lamp unlocking magnets.
723 miner's oil lamps.

At the back of the Offices
Corrugated asbestos hut with shelving [explosives store].
48 powder [explosive] tins.

Appendices

APPENDIX 1: THE DEAD

Many lists exist in publications and web sites, and most contain mistakes. This list I know can be relied on to be accurate and appears courtesy Pam Clarke.

Thomas Aldred	age 14	Haulage Hand	Westhoughton
William Anderton	age 15	Haulage Hand	Westhoughton
William Lees Ascroft	age 14	Haulage Hand	Chequerbent, Westhoughton
William Ashton	age 22	Collier	Daubhill
Arthur Aspden	age 21	Collier	Westhoughton
John Thomas Aspden	age 37	Collier	Westhoughton
Walter Aspden	age 28	Drawer	Daisy Hill, Westhoughton
Joseph Edward Atherton	age 14	Haulage Hand	Westhoughton
John Austin	age 37	Collier	Chequerbent, Westhoughton
James Baker	age 25	Collier	Daubhill
Fred Balforn	age 30	Drawer	Westhoughton
Job Ball	age 52	Dataller	Daubhill
Enoch Arthur Bates	age 23	Drawer	Chequerbent, Westhoughton
Joseph Grundy Battersby	age 16	Haulage Hand	Westhoughton
James Baxter	age 32	Dataller	Chequerbent, Westhoughton
John Baxter	age 30	Collier	Chequerbent, Westhoughton
John Baxter	age 57	Collier	Daubhill
Samuel Baxter	age 24	Collier	Over Hulton
William Bellew	age 19	Drawer	Westhoughton
Henry Bennett	age 20	Drawer	Westhoughton
Israel Bennett	age 23	Collier	Westhoughton
Thomas Bennett	age 22	Collier	Westhoughton
William Bennett	age 17	Drawer	Westhoughton
James Berry	age 21	Fitter	Westhoughton
Henry Blundell	age 38	Collier	Westhoughton
George Boardman	age 23	Conveyor Attdt.	Westhoughton
John Boardman	age 33	Collier	Westhoughton
Walter Boardman	age 28	Collier	Westhoughton
William Alfred Bond	age 28	Collier	Westhoughton
John Bradley	age 20	Drawer	Westhoughton
William Bradley	age 50	Collier	Westhoughton
William Bromby	age 37	Collier	Daubhill
William Thomas Brown	age 39	Collier	Daisy Hill, Westhoughton
Adam Bullough	age 28	Collier	Atherton
John Bullough	age 55	Collier	Atherton
Fountain Byers	age 33	Pusher-on	Westhoughton
Alfred Calderbank	age 48	Back Fireman	Westhoughton
Robert Calderbank	age 23	Dataller	Westhoughton
Thomas Alfred Calderbank	age 23	Collier	Westhoughton

William Calderbank	age 21	Drawer	Westhoughton
Cyril Cattell	age 14	Haulage Hand	Daubhill
William Catterall	age 40	Collier	Atherton
Jesse Chadwick	age 23	Collier	Daubhill
Orlando Chadwick	age 42	Collier	Westhoughton
Arthur Chetwynd	age 21	Drawer	Westhoughton
James Clarke	age 24	Collier	Chequerbent
Richard Clayton	age 52	Fireman	Westhoughton
Edward Clynes	age 15	Lasher-on	Atherton
Ambrose Coffey	age 24	Collier	Daisy Hill, Westhoughton
Frederick Coffey	age 30	Collier	Daisy Hill, Westhoughton
John Lawrence Coffey	age 28	Collier	Wingates, Westhoughton
William Connolly	age 16	Dataller	Wingates, Westhoughton
Thomas Henry Coop	age 28	Conveyor Attendt.	Westhoughton
Robert Cope	age 19	Haulage Hand	Daubhill
Robert Cowburn	age 16	Haulage Hand	Daubhill
Samuel Cowburn	age 55	Collier	Daisy Hill, Westhoughton
William Cowburn	age 40	Collier	Daubhill
Mark Critchley	age 22	Hooker-on	Westhoughton
Samuel Critchley	age 29	Collier	Westhoughton
Walter Crook	age 16	Haulage Hand	Atherton
Ralph Croston	age 25	Drawer	Westhoughton
William Croston	age 38	Collier	Wingates, Westhoughton
Robert Clifford Curwen	age 19	Student-Mining	Chequerbent
Joseph Darlington	age 28	Collier	Atherton
Benjamin Aaron Davies	age 23	Collier	Westhoughton
William Dawson	age 47	Dataller	Astley Bridge, Bolton
Sydney Delafield	age 25	Collier	White Horse, Westhoughton
Thomas Delafield	age 23	Collier	White Horse, Westhoughton
Fred Dootson	age 27	Collier	Westhoughton
Henry Dootson	age 24	Drawer	Atherton
John Thomas Dootson	age 26	Collier	Westhoughton
Samuel Dootson	age 30	Collier	Wingates, Westhoughton
Dennis Dorcey	age 14	Lasher-on	Westhoughton
Anthony Doxey	age 18	Drawer	Chequerbent, Westhoughton
Harry Doxey	age 23	Drawer	Chequerbent, Westhoughton
Samuel Doxey	age 25	Collier	Chequerbent, Westhoughton
William Doxey	age 51	Timberman	Chequerbent, Westhoughton
Peter Duffy	age 25	Pit Worker	Bolton
Thomas Dunn	age 34	Collier	Daisy Hill, Westhoughton
William Dyke	age 39	Collier	Daubhill
James Eccleston	age 31	Collier	Tyldesley
James Eccleston	age 60	Collier	Atherton
William Eccleston	age 20	Drawer	Atherton
Leonard Emmett	age 18	Drawer	Westhoughton
Thomas Emmett	age 31	Dataller	Chequerbent, Westhoughton
Roland Evans	age 32	Tunneller	Westhoughton
William Evans	age 26	Collier	Daubhill
Richard Fairhurst	age 47	Collier	Daubhill
James Farrimond	age 15	Haulage Hand	Westhoughton
Samuel Farrimond	age 37	Collier	Westhoughton
Thomas Farrimond	age 40	Collier	Westhoughton
Thomas Faulkner	age 16	Haulage Hand	Wingates, Westhoughton
Thomas Charles Faulkner	age 25	Drawer	Daubhill
James Feely	age 31	Dataller	Westhoughton
John Flood	age 27	Drawer	Chequerbent, Westhoughton
Walter Foster	age 28	Conveyor Attendt.	Westhoughton
Orlando Gerrard	age 21	Fitter	Westhoughton
Thomas Gibbs	age 26	Drawer	Westhoughton
Herbert Gibson	age 18	Drawer	Westhoughton
Simeon Gibson	age 16	Lasher-on	Westhoughton

Thomas Gill	age 22	Drawer	Daisy Hill, Westhoughton
William Gore	age 42	Collier	Chequerbent
Richard Goulding	age 34	Collier	Westhoughton
William Goulding	age 35	Collier	Westhoughton
Edward Halliwell Green	age 22	Drawer	Westhoughton
James Green	age 34	Collier	Westhoughton
Peter Green	age 41	Collier	Daisy Hill, Westhoughton
Richard Green	age 53	Collier	Daubhill
Thomas Green	age 28	Collier	Westhoughton
William Green	age 31	Lasher-on	Deane, Bolton
Joseph Greenall	age 34	Collier	Westhoughton
Thomas Greenall	age 36	Collier	Westhoughton
Thomas Greenhalgh	age 61	Back Fireman	Westhoughton
Thomas Greenhalgh	age 24	Collier	Wingates, Westhoughton
Albert Griffiths	age 27	Collier	Daubhill
David Grundy	age 48	Collier	Little Hulton
Albert Hardman	age 17	Conveyor Attendt.	Westhoughton
Samuel Hardman	age 19	Drawer	Westhoughton
John Robert Hargreaves	age 27	Drawer	Atherton
Edward Harris	age 14	Lasher-on	Wingates, Westhoughton
Nicholas Hartley	age 44	Collier	Wingates, Westhoughton
Gerald Hastie	age 19	Conveyor Attendt.	Chequerbent, Westhoughton
Thomas Hastie	age 21	Conveyor Attendt.	Chequerbent, Westhoughton
Frederick Hayes	age 43	Collier	Westhoughton
William Hayes	age 28	Collier	Westhoughton
Edward Haynes	age 35	Drawer	Daubhill, Bolton
William Hesketh	age 26	Conveyor Attendt.	Westhoughton
John Edward E. Hewitt	age 45	Electrician	Atherton
James Higham	age 60	Haulage Engineman	Westhoughton
Joseph Higham	age 23	Drawer	Westhoughton
John Higson	age 44	Collier	Daubhill
Peter Higson	age 46	Dataller	Deane, Bolton
William Higson	age 23	Dataller	Daubhill
James Hilton	age 25	Collier	Chequerbent, Westhoughton
Joseph Hilton	age 54	Collier	Middle Hulton
Montague Boardman Hilton	age 29	Dataller	Bolton
Percy Hilton	age 25	Dataller	Daubhill
William Hilton	age 26	Drawer	Daubhill
Fred Hindle	age 22	Dataller	Atherton
James Hodgkiss	age 31	Collier	Chequerbent, Westhoughton
Lewis Hodgkiss	age 15	Haulage Hand	Chequerbent, Westhoughton
Lewis Hodgkiss	age 39	Fireman	Chequerbent, Westhoughton
Stanley Hodgkiss	age 14	Haulage Hand	Chequerbent, Westhoughton
John Hodson	age 35	Collier	Westhoughton
James Edward Hogan	age 15	Haulage Hand	Westleigh
Henry Holden	age 31	Collier	Atherton
James Holden	age 15	Haulage Hand	Westhoughton
Edward Hollingsworth	age 33	Collier	Daisy Hill, Westhoughton
William Hollingsworth	age 31	Collier	Daisy Hill, Westhoughton
Albert Holt	age 28	Collier	Daubhill
Frederick Hook	age 14	Lasher-on	Atherton
Thomas Hope	age 15	Haulage Hand	Westhoughton
Joseph Horrocks	age 19	Conveyor Attendt.	Westhoughton
Thomas Horrocks	age 49	Collier	Chew Moor, Westhoughton
John Hosker	age 16	Dataller	Hindley Green
Elias Houghton	age 23	Collier	Chequerbent, Westhoughton
Frederick Stanley Houghton	age 13	Haulage Hand	Chequerbent, Westhoughton
John Houghton	age 46	Collier	Wingates, Westhoughton
John Thomas Houghton	age 46	Collier	Chequerbent, Westhoughton
Thomas Houghton	age 17	Drawer	Chequerbent, Westhoughton
Edward Houseman	age 15	Haulage Hand	Chequerbent, Westhoughton

Albert Howarth	age 16	Haulage Hand	Westhoughton
Thomas Howcroft	age 34	Collier	Deane, Bolton
Thomas Howcroft	age 25	Collier	Haulgh, Bolton
Stephen Hulme	age 29	Collier	Daubhill
John Hundy	age 53	Head Fireman	Daubhill
Samuel Hundy	age 39	Back Fireman	Atherton
James Hurst	age 50	Collier	Wingates, Westhoughton
Thomas Hurst	age 55	Collier	Wingates, Westhoughton
Thomas Hurst	age 19	Drawer	Daubhill
Thomas Hurst	age 49	Collier	Daubhill
Richard Jolley	age 24	Collier	Westhoughton
Thomas Jolley	age 49	Collier	Deane, Bolton
William Thompson Jolly	age 25	Collier	Westhoughton
Joseph Jones	age 24	Drawer	Westhoughton
William Kay	age 30	Collier	Wingates, Westhoughton
Edward Kenwright	age 28	Collier	Daisy Hill, Westhoughton
Thomas Laughna	age 23	Collier	Deane, Bolton
Frederick Lee	age 36	Collier	Westhoughton
Josiah Lee	age 23	Drawer	Atherton
James Leigh	age 14	Lasher-on	Daubhill
John Leigh	age 42	Collier	Daubhill
Peter Leigh	age 50	Collier	Westhoughton
Walter Leigh	age 21	Drawer	Westhoughton
Joseph Leyland	age 24	Collier	Daubhill
Richard Light	age 45	Collier	Wingates, Westhoughton
James Livesey	age 17	Drawer	Westhoughton
John Livesey	age 15	Haulage Hand	Westhoughton
Richard Nelson Longmate	age 29	Collier	Daubhill
Peter Longworth	age 23	Collier	Daubhill
Albert Lonsdale	age 37	Collier	Wingates, Westhoughton
James Lovett	age 28	Collier	White Horse, Westhoughton
Joseph Lovett	age 50	Dataller	White Horse, Westhoughton
Wright Lovett	age 16	Lasher-on	White Horse, Westhoughton
Andrew Lowe	age 23	Drawer	Daisy Hill, Westhoughton
Abel Mangnall	age 22	Collier	Wingates, Westhoughton
Walter Mangnall	age 30	Collier	Westhoughton
William E. G. Markland	age 17	Conveyor Attendt.	Chequerbent, Westhoughton
Martin Marrin	age 30	Collier	Westhoughton
Robert Marsh	age 20	Drawer	Westhoughton
Thomas Marsh	age 55	Collier	Westhoughton
Thomas Martin	age 23	Dataller	Westhoughton
Daniel Mather	age 23	Collier	Westhoughton
Edward Mather	age 35	Collier	Daisy Hill, Westhoughton
Richard Mather	age 49	Collier	Westhoughton
Joseph McCabe	age 22	Drawer	Wingates, Westhoughton
Matthew McCabe	age 24	Drawer	Wingates, Westhoughton
Michael McCabe	age 19	Drawer	Wingates, Westhoughton
James McDonald	age 26	Collier	Westhoughton
William Mead	age 49	Collier	Daubhill
William H. Middlehurst	age 48	Collier	Daubhill
Harry Miller	age 32	Collier	Bolton
James Miller	age 28	Collier	Wingates, Westhoughton
Joseph Miller	age 30	Collier	Wingates, Westhoughton
James Mills	age 26	Drawer	Wingates, Westhoughton
Michael Molloy	age 26	Dataller	Westhoughton
Thomas Wilcock Molyneux	age 26	Collier	Westhoughton
John Monks	age 19	Drawer	Westhoughton
Percival Monks	age 36	Collier	Westhoughton
James Morris	age 30	Collier	Westhoughton
John Morris	age 22	Haulage Hand	Westhoughton
John Morris	age 36	Collier	Daisy Hill, Westhoughton

Joseph Morris	age 13	Lasher-on	Daisy Hill, Westhoughton
Robert Morris	age 43	Collier	Westhoughton
William Morris	age 34	Collier	Daisy Hill, Westhoughton
Peter Moss	age 15	Haulage Hand	Atherton
William Edward Naylor	age 15	Lasher-on	Westhoughton
Albert Norman	age 36	Collier	Westhoughton
David Nuttall	age 23	Collier	Westhoughton
John James Oakes	age 13	Lasher-on	Chequerbent, Westhoughton
Thomas Owens	age 27	Collier	Westhoughton
John Parr	age 51	Collier	Daubhill
Harry Partington	age 19	Drawer	Westhoughton
James Partington	age 42	Collier	Daubhill
Joseph Partington	age 25	Collier	Westhoughton
Samuel Partington	age 16	Lasher-on	Atherton
Thomas Partington	age 24	Collier	Westhoughton
Thomas Partington	age 19	Collier	Daubhill
William Partington	age 40	Hooker-on	Westhoughton
James Pauldin	age 21	Collier	Daubhill
Enoch Pemberton	age 29	Collier	Westhoughton
Fred Pemberton	age 16	Lasher-on	Chequerbent, Westhoughton
John Lowden Pemberton	age 21	Drawer	Westhoughton
Harold Pendlebury	age 16	Haulage Hand	Wingates, Westhoughton
George Henry Perks	age 19	Drawer	Westhoughton
George Percy Potter	age 16	Drawer	Daisy Hill, Westhoughton
James Potter	age 15	Haulage Hand	Daisy Hill, Westhoughton
William Potter	age 39	Collier	Daisy Hill, Westhoughton
Herbert Prescott	age 24	Drawer	Westhoughton
John Prescott	age 23	Drawer	Westhoughton
Henry Price	age 22	Collier	Daubhill
James Price	age 42	Collier	Atherton
Fred Ratcliffe	age 21	Drawer	Westhoughton
Isaac Ratcliffe	age 23	Night Fireman	Chequerbent, Westhoughton
Thomas Ratcliffe	age 40	Collier	Westhoughton
William Ratcliffe	age 31	Collier	Westhoughton
Benjamin Riding	age 19	Drawer	Westhoughton
Willie Riding	age 22	Collier	Westhoughton
William Rigby	age 60	Collier	Atherton
Albert Roberts	age 15	Lasher-on	Westhoughton
John Roberts	age 27	Collier	Westhoughton
Robert Roberts	age 21	Collier	Westhoughton
Edward Rushton	age 36	Undermanager	Chequerbent, Westhoughton
John Rushton	age 31	Collier	Walkden
George Sargeant	age 28	Collier	Westhoughton
Edward Saunders	age 18	Haulage Hand	Atherton
John Saunders	age 13	Lasher-on	Atherton
Fred Schofield	age 20	Collier	Chequerbent, Westhoughton
James Schofield	age 35	Collier	Daubhill
William Schofield	age 32	Collier	Chequerbent, Westhoughton
Joseph Scoble	age 53	Dataller	Westhoughton
James Seddon	age 22	Collier	Wingates, Westhoughton
James Seddon	age 22	Collier	Westhoughton
John Wilfred Seddon	age 19	Drawer	Westhoughton
Joseph Seddon	age 18	Drawer	Daubhill
Matthew Seddon	age 24	Collier	Daubhill
Matthew Seddon	age 50	Collier	Daubhill
Richard Seddon	age 24	Dataller	Westhoughton
Albert Shambley	age 17	Drawer	Daisy Hill, Westhoughton
William Shambley	age 28	Collier	Daisy Hill, Westhoughton
George Sharples	age 60	Collier	Wingates, Westhoughton
Richard Sharples	age 33	Collier	Deane, Bolton
Ralph Shaw	age 35	Collier	Daubhill

Daniel Simmons	age 21	Drawer	Westhoughton
Mark Skeldon	age 28	Collier	Wingates, Westhoughton
Albert Smith	age 25	Collier	Daubhill
Isaac Smith	age 30	Drawer	Westhoughton
John Smith	age 43	Dataller	Middle Hulton
Thomas Smith	age 53	Collier	Wingates, Westhoughton
William Smith	age 46	Collier	Wingates, Westhoughton
Oliver Southern	age 21	Drawer	Westhoughton
William Southern	age 29	Collier	Westhoughton
Fred Southworth	age 22	Collier	Daubhill
Richard Lawrence Spencer	age 27	Drawer	Westhoughton
Fred Teasdale	age 46	Collier	Westhoughton
Daniel Thomas	age 35	Collier	Westhoughton
Edward Thomas	age 26	Collier	Daubhill
William James Thomas	age 28	Fireman	Chequerbent, Westhoughton
Paul Thomasson	age 43	Collier	Daubhill
Richard Thomasson	age 51	Collier	Daubhill
Samuel Thornley	age 25	Collier	Wingates, Westhoughton
Richard Tonge	age 14	Haulage Hand	Westhoughton
John Topping	age 53	Collier	Daubhill
Joseph Topping	age 23	Collier	Daubhill
John Edward Tumblety	age 20	Dataller	Daisy Hill, Westhoughton
George Tunstall	age 56	Collier	Westhoughton
George Tunstall	age 16	Haulage Hand	Westhoughton
Moses Turner	age 21	Haulage Hand	Daisy Hill, Westhoughton
William Turton	age 60	Fireman (Chq. Pit)	Chequerbent, Westhoughton
John Tyldesley	age 53	Collier	Wingates, Westhoughton
John Tyldesley	age 25	Collier	Wingates, Westhoughton
Joseph Tyldesley	age 17	Drawer	Wingates, Westhoughton
Thomas Hurst Tyldesley	age 23	Drawer	Wingates, Westhoughton
William Tyldesley	age 28	Collier	Wingates, Westhoughton
James Tyrer	age 48	Collier	Daisy Hill, Westhoughton
Albert Unsworth	age 17	Haulage Hand	Daubhill
James Unsworth	age 30	Collier	Daubhill
Jehu Unsworth	age 43	Collier	Daubhill
William Unsworth	age 23	Drawer	Westhoughton
Herbert Vickers	age 22	Drawer	Westhoughton
Walter Vickers	age 30	Collier	Daubhill
John Waring	age 14	Lasher-on	Wingates, Westhoughton
Samuel Wharmby	age 26	Drawer	Westhoughton
Charles Wharton	age 36	Collier	Daubhill
Benjamin While	age 20	Collier	Atherton
Robert Whittaker	age 32	Collier	Chequerbent, Westhoughton
William Wignall	age 14	Lasher-on	Daisy Hill, Westhoughton
John Wild	age 17	Dataller	Daubhill
Richard Wild	age 44	Dataller	Daubhill
Thomas Wild	age 15	Dataller	Daubhill
George Williams	age 24	Drawer	Atherton
John Andrew Wise	age 44	Collier	Westhoughton
James Ernest Withington	age 13	Haulage Hand	Westhoughton
Fred Wolstencroft	age 39	Collier	Daubhill
Alfred Edward Woods	age 15	Haulage Hand	Westhoughton
Arthur Woods	age 14	Lasher-on	Westhoughton
Percy Woodward	age 18	Dataller	Daisy Hill, Westhoughton
Samuel Woodward	age 34	Collier	Westhoughton
Thomas Woodward	age 32	Drawer	Westhoughton
Walter Woodward	age 41	Carpenter	Daisy Hill, Westhoughton
James Worthington	age 59	Collier	Daubhill
Thomas Worthington	age 36	Dataller	Chequerbent, Westhoughton
Harry Wyper	age 21	Collier	Westhoughton
Thomas Yates	age 30	Drawer	Wingates, Westhoughton

APPENDIX 2: BLAST FORCE DIAGRAMS

The official inquiry included detailed drawings of the evidence of force and its direction in roadways. These drawings really bring home the power of the coal-dust blast, with tubs being ripped apart, a man being blown inside another tub, metal bars being bent, large pieces of cast-iron piping embedded in props, even wire haulage rope being ripped apart into its strands.

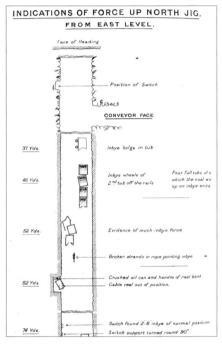

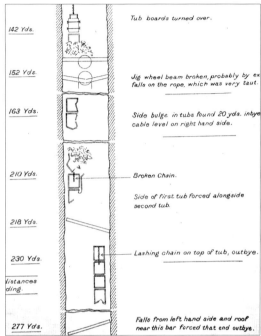

Above right: The North Jig roadway linking with the East level, lower section.

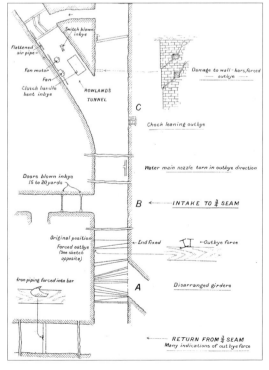

APPENDIX 3: NORTH WEST SOUND ARCHIVE

Clitheroe Castle

Recordings recalling, remembering or mentioning the Pretoria Disaster and other local collieries are held at Clitheroe. Members of the public can listen to these at Clitheroe or order (at very reasonable cost) copies of recordings. A CD has been produced with a selection of recordings (including transcriptions) around the Pretoria disaster, which is well worth purchasing.

Pretoria colliery disaster (1910). Anon. (Born 7 Nov 1889. Ref. 1980.0075). Vivid account given by a man who was underground in an adjacent district at the time of the explosion. Describes in detail the rescue operation, the effect of poisonous gases. Also describes coal mining in the area of Chequerbent in the Royal Arley mine. 50 mins.

Pretoria colliery disaster (1910). Ref. 1980.0149. Mrs Eatock talks about the Pretoria colliery disaster (1910). 20 mins.

Pretoria colliery disaster (1910). Ref. 1980.0202. Mrs Monks recalls the aftermath of the Pretoria colliery disaster in 1910 and how it affected her friends, family and the mining community, the official enquiry into the disaster, compensation for victims' families. 11 mins.

Pretoria colliery disaster (1910). Ref. 1980.0205. Mrs Monks continues her recollections of the disaster. Recalls her brother's death at Pretoria. Effect of gas on his body and the compensation paid to families of victims. 6 mins 7 secs.

Pretoria colliery disaster (1910). Ref. 1980.0203. A lady recalls the disaster and its effect on the community, her teaching career, effect of disaster on wedding day, official enquiry, results of enquiry and the lack of compensation. 6 mins 25 secs.

Pretoria colliery disaster (1910). Ref. 1980.0204. Martin Stenson, b. 1883, Ireland. Recalls rescue procedure and equipment used to bring trapped miners both dead and alive to the surface. He describes compensation, mining safety and his opinion on whether a memorial should be erected in memory of those killed in disaster. 7 mins 40 secs.

Pretoria colliery disaster fund (1910). Ref. 1986.0022. Mr Hough of Bolton recalls dealing with and administering the Pretoria colliery disaster fund, also some recollections about 1926 and the depression, mentions the Labour Party, trade unions and the payment of strikers from union funds. 20 mins.

Pretoria colliery disaster (1910). Recollections of a man trapped underground in a mining disaster. Ref. 1988.0048. Experiences at the time of the Pretoria disaster (1910). 6 mins 5 secs.

Pretoria colliery disaster (1910). Harry. Born 19 June 1887 Atherton. Ref. 1988.0160a. Alice and Harry recall Pretoria pit disaster and pit life generally. Harry tells of being at pit top 21 December 1910, removing bodies to the surface to the temp mortuary. Pit ponies, parading them in Atherton. Accident when drawing off pit props. 15 mins 31 secs.

Pretoria colliery included. Martin Stenson. Born Ireland 1883. Ref. 1997.0071. Age twelve worked at Langtree pit [Standish]. Describes his work including as a 'lasher-on' [attaching tubs to the haulage rope]. Worked at Pretoria pre-explosion. Describes pit ponies, coal face, dress in the pits, mealtimes, the work of a fireman, accidents and rescues, colliery ventilation and drainage, coal cutting machines. 90 mins.

Recollections. Martin Stenson. Born Ireland 1883. Ref. 1997.0080. Describes various mining terms, pit management structure, shot firing, moving waste, drainage & pumping, detecting gas and dispersing it. Talks about lung diseases, pit ponies, geological faults in Pretoria and Chequerbent areas. 100 mins.

Recollections. R. Shaw. Born 1900. Ref. 1997.0078a. Describes conditions in the workhouse 1946. Remembers poor law & hunger marches. 1946 became socialist councillor. Recalls Pretoria pit disaster, 1911 strike, baths at pit head, mechanisation after WWI. Worked at Nelson [Tyldesley] and Chanters [Atherton] pits. Describes working conditions.

Recollections. T. Wood. Born Ashton-in-Makerfield. Ref. 1997.0159. Describes his first day at work in the mine 1913. Recalls working with his father in a number of pits. Joined Royal Navy WWI, released 1919.

Recalls the 1921 strike. Recalls the Pretoria pit explosion, work clothes, accidents, women working at the pit head, playing pitch and toss. 70 mins.

Recollections, poem. Mr Rigby. Born 1901. Ref. 1998.0122. Poem written by father in aid of 1921 coal strike fund. Recalls the Pretoria disaster. 1916 worked at Pretoria pit. Describes cage winding, pit head baths, superstitions, 1926 general strike, women at pit head. WWI zeppelin raid, nationalisation. 65 mins.

Recollections. Mr Blears. Ref. 1998.0125. Describes visits to Blackpool interwar years, nationalisation of the coal industry. Describes working clothes as a coal-bagger. Coal picking during the 1926 general strike. Describes various forms of tobacco, WW2 air raids. Joined mines rescue brigade after the Pretoria disaster. 45 mins.

Recollections. (Female, born 1901.) Public houses in Westhoughton. Her father died in the Pretoria pit disaster. Lived at the Three Pigeons [pub adjacent to Victoria Colliery, Deane] from 1956–59. Bowling competitions, darts, spirit bond.

Recollections. (Male, born 1917.) Ref. 108a. Childhood, coal mining, public life, describes father's job as a collier, mother's job in the mill and his schooldays. Describes his working life in pits pre-nationalisation and after. Social life of the days for men and women discussed. Early days young people employed as cheap labour.

Recollections. (Male, born 1917). Ref. 108b. Childhood spent in Chequerbent, had nine children. Describes infant mortality in family, working in the pits, the death of grandfather in Pretoria pit disaster, the 1926 general strike, poverty and distress amongst the working classes.

Recollections. (Male, born 1905.) Ref. 111. Mining in Tyldesley, coal strikes. Describes his work as a helper in the pits at Nelson [Tyldesley], Arley [possibly Chanters] and Pretoria pits. Talks about the hardships experienced during the 1921 strike at Nelson pit, the general strike, the closure of pits in the 1920s–30s. Remembers the 1912 strike and seeing the Lancers in attendance.

Recollections. (Female, born 1898.) Ref. 117. Early life, homelife, father a collier, a founder member of the Wingates Temperance Band. Pretoria pit disaster. WWI, brothers conscripted.

Recording. Heroes of the Mine / The Toilers. Ref. 1993.0037. 78 rpm disc. 'Heroes of the Mine' refers to the Pretoria colliery disaster.

No Carols This Christmas. Ref. 1993.0089. Memories, poems and songs of the Pretoria disaster. 25 mins 15 secs.

APPENDIX 4: CAPITALISING ON THE DISASTER

A postcard was produced by the Economic Printing Co., Pershore Street, Birmingham, soon after the disaster. This card attempted disgracefully to cash in on the nation's feelings and possibly suggested that the proceeds would be going to the relief fund. The pit shown on the card was Maypole Colliery, Abram, Wigan, where sevety-five men and boys had died on 18 August 1908. No doubt the images shown on the card were not men from Pretoria Pit either. The message written on the reverse states, 'Went to look at these pits on Saturday following the Disaster. There were hundreds of people there. Joseph Colliery December 24th 1910.' Looking at the writing and correction, this was probably written by a boy who had visited the site. The card is unused.

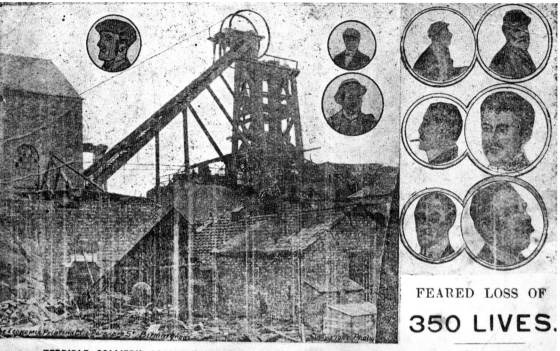

FEARED LOSS OF

350 LIVES.

TERRIBLE COLLIERY ACCIDENT. PRETORIA PIT. ATHERTON. LANCASHIRE. DEC. 21st. 1910.

A cheap postcard produced in Birmingham, either to make money on the back of the fundraising efforts or for genuine reasons. It is strange that the card shows Maypole Colliery, Abram, which had suffered an explosion in 1908 and that the men seem to be chosen at random. The figure shown is also obviously incorrect.

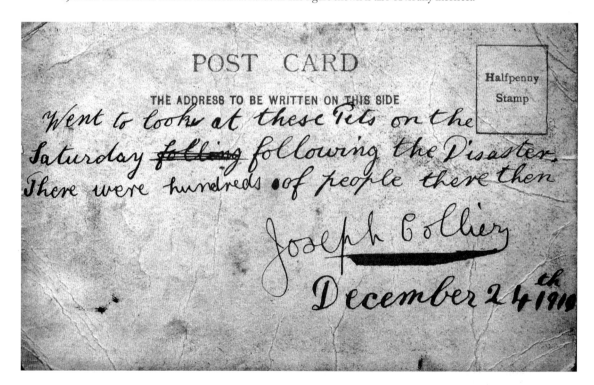

The reverse of the Birmingham postcard indicating that it was probably bought locally, possibly by a young boy.

Bibliography and Sources

General research material on coal mining in Lancashire and Cheshire compiled by Alan Davies, 1970
 onwards from many sources.
Research carried out by Pam Clarke and Peter Wood.
Bolton Museum & Archives
Hulton Colliery Co. v Laburnum Spinning Co and Others. Plans, 1913.
Lancashire Record Office
Westhoughton Library Pretoria Disaster Collection

HULTON COLLIERY COMPANY NCHu
Hulton and Cronton collieries
NCHu/1 Income ledgers
NCHu/2 Accounts ledgers
NCHu/3 Expenditure journals
NCHu/4 Stores payment journal
NCHu/5 Monthly profit and loss account
NCHu/6 Output, pay and cost books
NCHu/7 Agents' reports
NCHu/8 Tax and rates book
NCHu/9 Pit disaster enquiries
NCHu/10 Price Lists

Anderson, Donald, *Coal – A Pictorial History of the British Coal Industry* (David & Charles, Newton Abbot,
 1982).
Arnot, R., *The Miners, A History of the Miners Federation of Great Britain, 1889-1910* (Allen & Unwin,
 London, 1949).
Benson, Neville and Thompson, *Bibliography of the British Coal Industry* (Oxford UP, 1981).
Brown, William, Sgt (1911) Identification list of the victims of the Pretoria Pit disaster 1910.
Bulman, H. F., *Coal Mining and the Coal Miner* (Methuen & Co., London, 1920).
Bulman, H. F. and R. A. S. Redmayne, *Colliery Working and Management*, (3rd edn, 1912).
Catalogue of Plans of Abandoned Mines (HMSO, 1928).
Colliery Year Book & Coal Trades Directories (statistical section) 1963.
Davies, Alan, *The Wigan Coalfield* (Tempus, 1999-2009).
Davies, Alan, *The Pit Brow Women of the Wigan Coalfield* (Tempus, 2006).
Davies, Alan, *The Atherton Collieries* (Amberley, 2009).
Davies, Alan, *Coal Mining in Lancashire & Cheshire* (Amberley, 2010).
Duckham, Helen and Baron, *Great Pit Disasters – Great Britain, 1700 to the present day* (David & Charles,
 Newton Abbot, 1973).
Dunn, Matthias, *A Treatise on the Winning and Working of Collieries* (2nd edn, Newcastle upon Tyne, 1852).
Galloway, R. L., *Annals of Coal Mining and the Coal Trade*, 2 vols (1898, Repr. David & Charles, 1971).
Griffin, A. R., Dr, *Coal Mining* (Longman, 1971).
Hatton, W. A., Dr [the Hulton Colliery Co. surgeon], 'The Hulton Colliery explosion' (*British Medical
 Journal*, 20 May 1911).

Hayes, Geoff, *Collieries in the Manchester Coalfields* (Landmark, 2004).

Hickling, George, *Lancashire Sections of Strata* (Lancs & Cheshire Coal Association, 1927).

Historical Review of Coal Mining, Mining Association, Fleetway, c.1924.

Howarth, Ken, *Dark Days* (Greater Manchester County Council, 1978).

Lancashire and Cheshire Antiquarian Society, 1899, H. T. Crofton, Lancashire & Cheshire Coalmining Records

Lancashire and Cheshire Miners Federation minutes.

Lane, J. and D. Anderson, *Mines and Miners of South Lancashire 1870–1950* (Donald Anderson, 1980).

Macfarlane, D., *Ventilation Engineering* (Davidson & Co. Ltd, Belfast)

Memoirs of the Geological Survey (HMSO, London).

NCB Anderton House, Lowton archives (until *c.* 1989)

North Western Coalfields Regional Survey Report, Ministry of Fuel & Power (HMSO, 1945).

Pamely, Caleb, *The Colliery Manager's Handbook* (Crosby Lockwood, c.1904).

Percy, C. M., *Mining in the Victorian Era* (Thos Wall & Sons, Wigan, 1897).

Pope, Samuel (1911) Report on the explosion which occurred at the No. 3 Bank Pit, Hulton Colliery on the 21st December, 1910. II. Report on the proceedings at the inquest (HMSO, London, 1911).

Raistrick, A. and C. E. Marshall, *The Nature & Origin of Coal & Coal Seams* (Engish Univ Press, 1939).

Redmayne, R. A. S., *Men, Mines and Memories* (Eyre & Spottiswood, 1942).

Redmayne, R. A. S., Modern Practice in Mining series (Longmans Green & Co., 1911).

Redmayne, R. A. S. (1911) Report on the explosion which occurred at the No. 3 Bank Pit, Hulton Colliery on the 21st December, 1910. I. Report of a formal investigation under section 45 of the Coal Mines Regulation Act, 1887, into the causes and circumstances of the explosion (HMSO, London, 1911).

Sinclair, J., *Coal Mining Law* (Pitman, 1958).

The Coal Mines Regulation Act, 1887 (HMSO, London 1887).

The History of the British Coal Mining Industry, Vol. 3 1830–1913. (R. Church, Oxford UP, 1986).

Townley, Appleton, Peden and Smith, The Industrial Railways of the Wigan Coalfield series, parts 1 and 2, The Manchester Coalfield (Runpastm 1994, 1995).

The Children's Employment Commission (Mines) 1842 (HMSO, London, 1842).

Transactions of the Institute of Mining Engineers.

Transactions of Manchester Geological Society.

Transactions of the National Association of Colliery Managers.

Walker, S. F., *Coal Cutting by Machinery* (Colliery Guardian, London, 1902).

Whittaker, J., *Colliery Explosions and Recovery Work* (Pitman, London, 1927).

Bolton Evening News
Manchester Evening News
The War Cry
Colliery Guardian
Atherton Journal
Leigh Chronicle
The Times